Seeing Ghosts

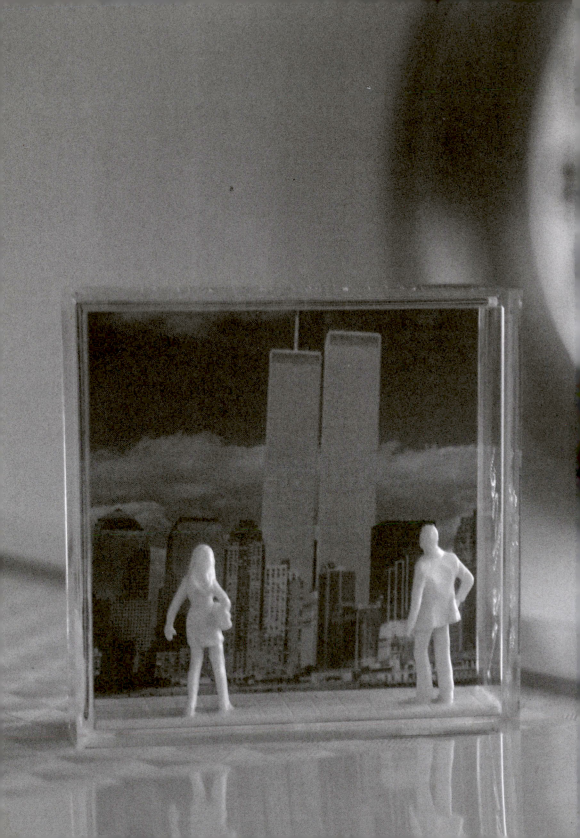

Karen Engle

Seeing Ghosts

9/11 and the Visual Imagination

McGILL-QUEEN'S UNIVERSITY PRESS

Montreal & Kingston · London · Ithaca

© McGill-Queen's University Press 2009

ISBN 978-0-7735-3540-4 (cloth)
ISBN 978-0-7735-3541-1 (paper)

Legal deposit second quarter 2009
Bibliothèque nationale du Québec

Printed in Canada on acid-free paper that
is 100% ancient forest free (100% post-
consumer recycled), processed chlorine free.

This book has been published with the help
of a grant from the Canadian Federation
for the Humanities and Social Sciences,
through the Aid to Scholarly Publications
Programme, using funds provided by the
Social Sciences and Humanities Research
Council of Canada.

McGill-Queen's University Press acknowl-
edges the support of the Canada Council for
the Arts for our publishing program. We also
acknowledge the financial support of the
Government of Canada through the Book
Publishing Industry Development Program
(BPIDP) for our publishing activities.

Library and Archives Canada Cataloguing
in Publication

Engle, Karen, 1974–
Seeing ghosts : 9/11 and the visual
imagination / Karen Engle.

Includes bibliographical references
and index.
ISBN 978-0-7735-3540-4 (bound)
ISBN 978-0-7735-3541-1 (pbk)

1. World Trade Center (New York,
N.Y.)–Pictorial works. 2. September 11
Terrorist Attacks, 2001. 3. September 11
Terrorist Attacks, 2001–Pictorial works.
4. Terrorism–New York (State)–New
York–Pictorial works. 5. Documentary
photography–Political aspects. 6.
Documentary photography–Social aspects.
I. Title.

HV6432.7.E525 2009
974.7'1044
C2008-907827-6

This book was designed and typeset by
studio oneonone in Sabon 10/13.5

Image on page ii: Artwork by Marc Cohen.
Photograph by studio oneonone

Contents

Acknowledgments / vii

Introduction: The Perfect Image of the Lost / 3

One Tumbling Woman / 9

Two Falling Man / 28

Three Postcard Memories / 51

Four The Face of a Terrorist / 78

Five Mourning at Work, or Making Sense of 9/11 / 113

Notes / 141

References / 163

Index / 181

Acknowledgments

The Social Sciences and Humanities Research Council of Canada gave me the space and the time to produce the dissertation out of which this book was born. In the gap between the completion of that early draft (2005) and today (fall 2008), many people have contributed to the realization of this project. I offer thanks to my grandmother, Evelyn Heal, whose generosity has enabled me to include so many images in this text and whose own life has provoked my curiosity about questions of memory and remembrance; Nola and Don Engle, who quite simply just knew that I could do this; my dear friend Bruce McKinnon (1974–2007), whose life and death have anchored my research beyond all measure; Derek Sayer, who challenged me to do the thing properly or not at all (I am grateful); Yoke-Sum Wong, for her suggestions, friendship, and brilliant conversation over the years; Mebbie Bell, for her friendship, thousands of hours of telephone support, and supreme copy-editing skills (I am in your debt); Allen Shelton, who has helped me to remember the sound of my own voice; and Patrick, who has read every word five times over. This book is for Patrick.

I am grateful to everyone at McGill-Queen's University Press for guiding me through every stage of the publishing process.

I further acknowledge the journal *Theory, Culture and Society* for allowing me to reprint in chapter 5 a revised version of an essay

that first appeared as "Putting Mourning to Work: Making Sense of 9/11," *Theory, Culture & Society* 24, no. 1 (2007): 61–88. I would also like to acknowledge the permission of the journal *Cultural Studies–Critical Methodologies* to reprint in chapter 4 a revised version of an essay that first appeared as "The Face of a Terrorist," *Cultural Studies-Critical Methodologies* 7 (2007): 397–424.

I have made every effort to identify, credit appropriately, and obtain publication rights from copyright holders of illustrations in this book. Notice of any errors or omissions in this regard will be gratefully received and correction made in any subsequent editions.

Seeing Ghosts

The history that showed things "as they really were" was the strongest
narcotic of the century. Walter Benjamin

Fear drives you to reduce something strange to something familiar so
you no longer marvel at it. And then the familiar itself becomes more
difficult to see as strange. Is that what the trick takes, I wondered,
to abut the here-and-now with the back-then and over-there so you
see your world anew? Michael Taussig

Introduction The Perfect Image of the Lost

I wasn't there. I did not experience the day, or the immediate aftermath, first-hand. Because of this, the ensuing pages are anchored in a fundamental absence. I say absence, not blindness. This is a book about ghosts and memory and history in the wake of 11 September 2001. More specifically, it is a book about how the event has been visually remembered and the ways that history pulses through this contemporary memory, breathing life into it.

With respect to 11 September 2001, the question of the *visual* is especially significant. Artist Damien Hirst provocatively asserted that the attacks were designed to be viewed: "The thing about 9/11 is that it's kind of an artwork in its own right. It was wicked, but it was devised in this way for this kind of impact. It was devised visually" (Allison 2002). Within one year of the terrorist attacks, we were told that 9/11 had become "the most documented event in human history" (cited in Boxer 2002). David Levi Strauss reports: "On September 11th, more people clicked on documentary news photographs than on pornography for the first (and only) time in the history of the Internet" (2003, 184). In Canada we were inundated for weeks with images of the collapsing towers, New Yorkers running scared, and the sight of families affixing missing-person posters to buildings and postboxes all over the city, while rescue crews disappeared into the rubble of Ground Zero. Seeing, in this case, became a kind of repetition compulsion the likes of which Freud describes in his studies of trauma and hysteria.

For Freud, the compulsion to repeat indicates a latent trauma that must first be experienced directly in order to be exorcised. Talk it out. This is all well and good (if impossible) for individual patients suffering from individual traumas, but what of a nation or collectivity whose experience of a traumatic event can only ever be indirect? In a way, we haven't come much further than Freud's original articulation, for contemporary culture's answer to this question of indirect experience usually involves representation. Walter Benjamin put it this way: "Every day the urge grows stronger to get hold of an object at close range in an image [*Bild*], or, better, in a facsimile [*Abbild*], a reproduction" (2002, 105, original emphasis). To exorcise trauma, we are enjoined to picture it.

In his discussion of mimesis, Michael Taussig gives us a way to think about experience and reproduction. Significantly, he begins *Mimesis and Alterity* (1993) with a meditation on the invention of photography, and he suggests that the camera's appearance on the scene of history "re-charged … the mimetic faculty" (xiv). Angela Carter's fin-de-siècle novel *Nights at the Circus* (1993) provides us with a picture of this recharging through the figure of Herr M., a nineteenth-century medium-photographer-con-artist, and Mignon, the waif posing as the dead for credulous grieving relatives. Herr M.'s is a simple con: contact recently bereaved family members whose daughters have passed on after a prolonged illness, invite them to a séance, photograph the spectre when she appears, and provide the family with an enduring image of the lost child:

His L-shaped drawing-room had lace curtains looped over the archway to the foot of the L, beside the green-glazed jardinière on which stood a Boston fern. Pointing towards this alcove was Herr M.'s mahogany camera, like a little wooden room itself. Behind the camera stood the round table at which Herr M. joined the hands of the

parents as solemnly as if he were marrying them and begged them, in an urgent whisper, to stay stock-still. Although their line of vision was somewhat obscured by the camera, they always did as they were bid, never craned or peered, too much in awe ... Herr M. went round dimming the rest of the lights ... They sat at a table, held hands and hoped. 'Come when I knock on the table, little one.' Mignon, in her nightgown, slipped into the alcove from behind the bookcase. She carried an electric torch under her nightgown so that her outline glowed. It was as simple as that. Lit from beneath, clouded with incense, half hidden by the lace curtains, the reticulated fronds of fern and the bulk of the camera, she could have been any young girl ... Herr M. ducked his head under the hood of the camera. In the unexpected thunder and lightning of the flash, Mignon's face looked to each one who saw it the perfect image of the lost. (137)

The only caveat for the thankful relatives, now in possession of this perfect image, is that they show no one the photograph, "or else her face will disappear!" (138). The camera flash promises a return of the lost object but a return with a catch. For Herr M. knows that exposure of the con through the revelation of Mignon's reproduction will result in the loss of the object's specificity, not to mention the death of his business. Simply put: the scientific explanation of the mystery of the daughter's return will kill the magical element contained in the photographic image.

But Carter is far more attuned to the power of mimesis than the laws of scientific rationality have ever been. For Herr M. *is* exposed and his photographs of the dead *are* revealed as mere hoaxes, yet in the face of Herr M.'s confession, many of his former clients refuse to believe in the con: "They took the cherished photographs out of those lavender-scented bureaux drawers in which they shared an old glove-

box with, perhaps, a first curl in an envelope, or a rattle of cast milk teeth, and, however hard they scrutinized the glossy prints, they never saw Mignon's face but saw another face ... And still Mama sleeps with the picture under her pillow" (139). Despite the rational knowledge that she was hoodwinked, the photograph retains its magical quality for Mama, and her connection to the lost daughter via the object remains unspoiled. Here, it seems to me, lies some of the unrecuperable mystery of the image that Taussig (1993) describes. A subject can be fully aware of a photograph's history, be it cropped, retouched, or altogether faked, and nevertheless be moved by some magical something within it (see Stewart 1996, 24–6).[1]

Taussig's desire to make a space for magic echoes my own ongoing preoccupation with the banality of what every other undergraduate student *still* tosses off as "social constructionism." He marvels that the radical opening generated through the initial thoughts of construction (here he is referring to post-1950s scholarship) has been all but foreclosed through the passively deterministic view that "culture made me do it" (which is, really, just another way of saying, "biology made me do it"). Can we recoup something of that radicalism by making a space for poeisis and magic? This book is one attempt to engage Taussig's challenge.

On Method

Statements of methodology make me nervous. I think of Luce Irigaray's response to the question of her own methodology, posed during her doctoral defence: "A delicate question. For isn't it method, the path to knowledge, that has always also led us away, led us astray, by fraud and artifice" (1985, 150). Or Walter Benjamin: "It is undoubtedly useful to plan excavations methodically. Yet no less indispensable is the cautious probing of the spade in the dark loam" (2005b, 576). Or

Taussig's terse but evocative, "Method was like a drug" (1997, 9). One must be able to respond to the materials, not make the materials respond to the method.

My material here is visual, and I chose images that struck me, punctum-like. They were images that haunted me and of which I wanted to make some sense. But "sense" in this sense is not simple: how do you explain a revealed hoax that continues to entrance? Does Roland Barthes (1981) ever neutralize the wounding photograph of his mother? The "sense" I am reaching for here has much more in common with Benjamin's aesthesis than with Émile Durkheim's *Rules of the Sociological Method* (1982).[2] It is about affect and violence and the bubbling up of historical memory. It is about seeing "the magic of the state" in terms of appearance and disappearance, of seeing how the twin towers were made to stand in for America, and then of understanding how the towers have since rematerialized at various sites of global contest.[3] It is about seeing through the con and *still*, nevertheless, being drawn into its magic.

Benjamin began excavating one way through this kind of seeing, through aura and affect and the photography of history – through memory unfurling like a fan and an angel impotently watching a series of devastations. Jacques Derrida probed for another opening through presence and absence and the language of erasure. Somewhere between collection and assemblage, this book makes use of both Derrida's and Benjamin's reverence for haunting. From tabloid journalism to sculpture to photography, *Seeing Ghosts* explores the imbrication of the visual with mourning and the making of history. It considers the state in relation to both official and popular representations of September 11, and it examines the relation between kitsch and disaster. In a sense, its methodology is also its purpose: "to abut the here-and-now with the back-then and over-there so you see your world anew" (Taussig 1997, 9). Picture it.

As "the perfect image of the lost," Mignon comes when bidden and disappears on command. She is the scene we are watching, although our capacity to see is hampered by the very medium that captures her. Her perfection lies in her ability to stand in for any number of dead children, to reduce their singularity to a single portrait of death, and her spectral body becomes a symbol, emptied of specificity yet amplified with potency. She highlights one of the dangers of symbolization: the sacrifice of complexity. Just as Mignon becomes detached from her own bodily context, circulating through the narratives, memories, hopes, and fears of others, the twin towers have been bidden to stand in for any number of causes and losses over the past seven years. *Seeing Ghosts* traces these spectral emergences.

One Tumbling Woman

It appeared on the lower concourse of Rockefeller Center in September 2002 (fig. 1). A woman's body, fixed in bronze, tumbles irrevocably to the ground. Head smacking, legs thrown overhead, arms helpless to protect her from the force of impact, she appeared there in violent stasis. Unlike the others to whom she referred, her body did not crumble, break, or disintegrate. But her impact was nevertheless too much. Too many bodies had already fallen, so this one, this single bronzed nude fixed in a state of perpetual collision against concrete, was judged too much to bear. Shrouded like so many corpses would have been, had they survived, she was unceremoniously carried off. Unlike the ones who preceded her, the ones of flesh and bone, she was not crushed under several thousand tons of smouldering steel. Nonetheless, she too, like them, has disappeared from public view.

The monument in question was created by Eric Fischl, a New York artist whose pieces are often identified as controversial and graphic. *Tumbling Woman* was displayed alone in Rockefeller Center, her potential for shock perhaps strengthened by her singularity, but she is in fact one in Fischl's series of five bronze women, all falling similarly to their deaths. Her horrifying singularity was thus reproduced and multiplied by an artist seeking to commemorate a day of terror and loss. Five bodies falling yet only one exhibited, and then removed – strange

mathematics of addition, subtraction, and erasure, an operation producing only the ghostly sense of an absent presence and uncanny visions of tumbling bodies on the move, without a final resting place.

So I will simply state: I do not know how to identify her. Perhaps because she does not finish, *elle n'est pas finie*.[1] Because she is eternally caught in a moment between life and death, I find myself constantly retracing her movements, trying to understand the reactions of horror and outrage that were levelled against her presence on a pedestrian walkway in midtown Manhattan.

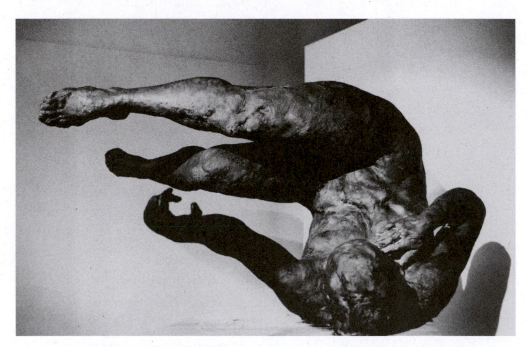

Fig. 1 Eric Fischl (1948–), *Tumbling Woman*, 2002.
Bronze, 37 x 74 x 50 inches. Edition of 5.

I think of her as a narrative. She looks like one of Michelangelo's red chalk drawings of the Libyan Sibyl – body with the musculature of a man, breasts sculpted almost as an afterthought. The paradoxical evocation of violent movement recalls earlier productions of sculptural agony, such as Giovanni Bologna's *Rape of the Sabine Women* – a horrifically beautiful piece commemorating a terrible moment in Roman history. Like Bologna's sculpture, *Tumbling Woman* tells her own war story. Her Sibylline features suggest a narrative not unlike that of Cassandra – the doomed prophetess of Aeschylus's *Agamemnon* – its premonitory warnings of insecure foundations and irreducible grief terrible to hear and impossible to comprehend.[2]

When I see her in photographs, as now I must, I catch myself composing and recomposing the final moments before her fall. I imagine her up there, looking down, so far down at people small and distant, while all around her the sounds of walls collapsing, the sight of people paralyzed or panicked, the acrid smells of smoke, fuel, and God knows what else are so proximate that they begin to take on a quality of hyper reality and, in doing so, to become strangely remote. Time must stop for a moment. I imagine her stepping back – stepping back from herself to make the space she needs to jump. Consequently, when she does leap, she has already left her body. She watches herself do it from afar and barely registers the loss of footing beneath her. She has fallen into a dream from which she will never wake.

But sometimes it doesn't happen like this. Sometimes she's so confused by the noise and dazed by the smoke that she cannot gather enough of herself together to become absent. She can't breathe. All she can think is that she can't breathe. She looks up and sees the window, already smashed by an earlier jumper, and thinks that if she can just get to the air on the other side, she'll be able to think clearly. She stumbles toward the opening and leans out, gasping for relief, when someone inside trips and falls over her legs. She is jolted. Her hands slip.

She loses hold of the window and her legs scramble to find concrete, but there is only air. The air she sought for succour has turned into so much wind screaming past her as she falls fast and hard into a nightmare from which she will never wake.

And sometimes, sometimes she is so terrified up there that she wants to jump, but she can't bring herself to do it. She turns to a man crouched beside her, a man she has worked with for years in adjoining cubicles, and asks him to do what she can't …

Graphic 1

As a commonplace, the judgment that something is "graphic" typically refers to a scene, whether narrative or filmic, deemed somehow excessive, indecent, or unwarranted – the ear-cutting scene in *Reservoir Dogs*, the sound of the woodchipper in *Fargo*, excerpts from de Sade's *Justine*. That which is deemed too graphic to be seen, and will not be permitted to create a scene, suggests that obscenity is hanging around somewhere close by. Behind the scenes.

Hearken back to an ancient meaning for obscene: *ob-scenus*, from the Latin, synonymous with "foul," "repulsive," and "filthy." Literally, however, the word translates as "off stage" or "out of sight." Of course, in those bloody Greek dramas, famed for never showing the graphic bits onstage, the obscene elements were always just that: obscene/offstage. Violence was recounted after the fact for the eager viewer, who could drink in bloodlust through narrative. In New York, several thousand years later, an ancient trope repeats itself. The monument is too graphic, and the curious are prohibited from seeing her – except of course through the words of angry journalists.

True to form, and almost too good to be true for purposes of analysis, the various judgments of the "too graphic" *Tumbling Woman* – offensive and inappropriate monument, scandalous "postmodern"

art, among others – all link up and refer back to what Jacques Der-
rida has carefully traced as the bastard heritage of the *graphé*, which,
according to his analysis, has forever and eternally been too graphic.[3]
As Derrida so eloquently argues, that which is associated with the
graphic is fundamentally associated with the improper – that con-
dition or state of exteriority and distance from truth, self-presence,
and Being. Georges Bataille writes that "obscenity" is our word for
designating a lack of self-possession: "Obscenity is our name for the
uneasiness which upsets the physical state associated with self-pos-
session, with the possession of a recognized and stable individuality"
(1986, 18). Her lack of a claim on either life or death depicts a state
utterly out of the control of the living, either for rescue workers or
for the embalmers and funeral planners. When charged with obscen-
ity, she is at the same time identified as being improper: not equal to
the task of sober remainder or reminder of this day. There is both too
much and too little of her that remains, left over, after her jump and
before her death.

Graphic 2

Of course, I know she isn't real. She never fell from on high; she was
built in a studio, put on display, and then removed under cover of cloth.
Censured as unfit; judged "too graphic." Her alleged indecency was ex-
posed by the act of enshrouding her like a corpse, marking her at once
as something shameful to be concealed and something dead. Shame and
death – that old pair persistently shows up in representations of arche-
typal woman, right back to the mythic first woman of the West: Eve.
Another woman who fell, albeit from a different kind of grace.

It would be more than facile to pause here and suggest that the
sculpture was judged inappropriate because it depicted a *naked* woman
on her way to death. But one journalist in particular paves the way to

such a reading:⁴ "A violently disturbing sculpture popped up last week
in the middle of Rock Center's busy underground concourse – right in
front of the ice-skating rink. It depicts a naked woman, limbs flailing,
face contorted, at the exact moment her head smacks pavement fol-
lowing her leap from the flaming World Trade Center" (Peyser 2002a).
Such sly anthropomorphism in the space of one short paragraph, when
"a violent sculpture" is humanized into "a naked woman." This ter-
rible transubstantiation not only shocks; it assails. The bare bronze is
accused of attacking her viewers: "IS THIS art? Or assault?" (Peyser
2002a). Three separate newspaper headlines over the period of one
week respectively christen her: "Shameful," "Sick," and "Tacky"
(Peyser 2002a, 2002b, 2002c). Then she is covered up to protect the
unsuspecting from viewing her indecency, like the placement of porn
magazines on top shelves of convenience stores.⁵

The same journalist responsible for fuelling much of the outrage to-
ward *Tumbling Woman* congratulates herself on its removal, defend-
ing her actions in the name of caring protection of the people: "This is
not censorship, but sensitivity. No one is banning this piece. But com-
mon sense dictates that some works are not appropriate to be thrust in
your face, in such a public place as Rockefeller Center" (Peyser 2002b).

Through this paternalistic and infantilizing rhetoric, readers are ad-
monished that they need help in determining propriety; and the im-
proper, once identified, must be expelled from the centre. This stance
recapitulates an age-old platonizing impulse to identify and expel the
(so-called) vulgar – to protect the community from obscenity by kick-
ing it out of the centre and resuming a disciplined patrol of the perime-
ter lines around public space.

But as Derrida writes, this desired demarcation of insides from out-
sides has never been fully realized; the outsides can always be located
within the innermost interior of the insides: "The outside, 'spatial' and
'objective' exteriority which we believe we know the most familiar

thing in the world, as familiarity itself, would not appear ... without the nonpresence of the other inscribed within the sense of the present, without the relationship with death as the concrete structure of the living present" (1974, 70–1).

Absolutely necessary to the vital statistics of the metaphysical system, the so-called outside/improper element must be ritually identified and expelled. At the same time, enough of this element must be retained safely within the system. Remaining under perverse protection as an internal outlaw, its negativity functions as an outline, or supporting frame, that gives the proper its shape and meaning. Similarly, *Tumbling Woman* was left inside the (Rockefeller) Center yet covered up for decency's sake prior to her final expulsion. Highlighting her impropriety while concealing the fine details, this temporary veiled exposure suggests another strategy for interrogating her graphic "truth." Bear with me.

The dangers signalled by the deployment of the term "truth" are legion, but if I can retrace my steps carefully enough, I will have been able to avoid tumbling into yet another metaphysical void. Truth enters here not in its usual sense, as absolute proximity and self-presence. Rather, the covered-up sculpture performs a visual recapitulation of a much more complex and resistant articulation of truth: the perpetual coupling of revelation with concealment.

This coupling is not a harmonious union; neither a unilateral victory nor a conciliatory amalgamation of the duelling parties ever takes place. Truth is a battleground for a war that never ends. Martin Heidegger describes this conflict as an essential and originary condition of strife: "Concealing denial is intended to denote that opposition in the essence of truth which subsists between clearing and concealing. It is the opposition of the original strife" (1993, 180).

Truth is not peaceful – or pure. Nor is it self-continuous or self-consistent with itself.

Operating much like Heidegger's articulation of *alētheia* – the Greek term for the unconcealing of beings – the act of covering up a sculpture in plain sight illustrates that there is something to see but that it is veiled and indistinct.[6] This paradoxical condition of hidden presence highlights Heidegger's complex articulation of truth: truth, in its essence, is untruth (1993, 180). Far from defining truth as its simple opposite – *falsehood* – Heidegger complicates the matter by injecting concealment and dissembling into its very core: "Each being we encounter and which encounters us keeps to this curious opposition of presencing, in that it always withholds itself at the same time in a concealment" (178).

The truth of the matter, as Heidegger argues, is that truth dissembles. Uncloaking this bronze and exposing her to light in order to prove or disprove an essential impropriety will only generate an ouroborosean narrative. We must avoid making these determinations at all costs, for they destine us to ride the circle line of the metaphysics of presence ad infinitum. The question of correctness of representation, or of properly interpreting the details of Fischl's intentions, is specious.[7] Far better to track the movements of *alētheia* between the lines of exposure and concealment, presence and absence. Within these interstitial spaces, a fundamental trembling is detected, its reverberations effectively unsettling the borderlines between life and death.

Graphic 3

In her freeze-frame focus between life and death, the *Tumbling Woman* enacts an infernal articulation between absence and presence. This arrested moment, or movement between, hints at something far more terrible than death – something perpetual and incomplete. It is this point, or caesura, to which I keep returning. She is not yet finished – *elle n'est pas encore finie*. In this perpetual state of being on

the way to death, this falling bronze forces us – her viewers – to return eternally to this moment before finality. Like her, we are never able to finish with it all; we cannot bury a thing that has not yet been identified as dead, a thing that has not yet finished with us.

This is the terrible legacy of the event referred to as "9/11." The twin work of mourning and the writing of history has been stalled for an indefinite period of time. We write history, according to Michel de Certeau (1988), in order to make the present habitable: "writing makes the dead so that the living can exist elsewhere" (101). A kind of burial rite, "historiography receives the dead that a social change has produced" (101). However, this history is not concerned simply with laying the past to rest. Making the present habitable also involves a domestication of the future, a bringing of the future home to us through a controlled writing of the past. De Certeau describes this operation as producing a sense of "a something which must be done," and he argues that this belief is fundamental to the daily functioning of a Western society (101).

The recording of the facts that we do have – planes crashing at 8:46 A.M. and 9:03 A.M. respectively, the number of tons of steel removed from Ground Zero, the number of firemen killed, and so forth – has gone a long way to providing this sense of a task to be accomplished. President George W. Bush's government has answered the call, stating the goal to be a double desire for vengeance and the permanent eradication of global terrorism.[8] The horror of the losses sustained on September 11 cannot be overstated. But the accounting procedures undertaken by the US government and its allies are governed by vague guidelines that are given to modifications as necessitated by policy change in military focus and spending.[9]

Added to the unending accounting practices currently raging overseas, the US continues to deal with its own incapacity to tally up the dead.[10] How many bodies have never been found, despite all the sift-

ing through ash and debris for DNA evidence at the Fresh Kills land-
fill on Staten Island? We hear of individuals removed from the official
victim list since their presence in the towers cannot be confirmed with
absolute certainty. The dead are not only not buried; in some cases,
they are not even recognized as dead.

But there is even more at stake than an inability to count and name
the dead. We can begin to grasp this other horror only by looking again
at *Tumbling Woman*'s singular in-between position: not only sus-
pended between life and death but also petrified between past, pres-
ent, and future. She is not located in a simple past; she does not allow
viewers to approach her as narrating a completed historical event.
Convulsing all three of the tenses that we call time into a single frozen
moment, she not only forces us to question how we remember that
one day but also exposes an inapprehensible future, incomprehensible
horrors still to come. She has not yet finished dying, and the future be-
tween her impact and her death remains open. This is the history we
cannot yet begin to imagine.

Consequently, the haunting that has arisen since 9/11 to trouble
our minds and borders is not the (simple) recognition of remains – of
absence intertwined with presence – of which Derrida writes in so
many of his works on mourning.[11] Coming from the future, this haunt-
ing "resists even the grammar of the future anterior" and indicates that
we are not in a position to articulate what will have happened from
all this (cited in Borradori 2003, 97). We can begin to illustrate this by
referring to two of the military-politico events that have been initiated
since that day and have not yet seen their conclusion: the wars in
Afghanistan and Iraq.

But there is still more, more than can be contained within the bor-
ders of the so-called Axis of Evil: bombings in every part of the world,
new policies for immigration and border crossings, deportations, de-
tainees, ghost ships. These days, we are told in the West, the threat of

global, random violence is more accurately thought of as a promise, not a possibility. Derrida himself recited this promise in his collaboration with Jürgen Habermas: "What happened, even though this has not been said with requisite clarity … is that, for the future and for always, the threat that was indicated through these signs might be worse than any other … From now on, the nuclear threat, the 'total' threat no longer comes from a state but from anonymous forces that are absolutely unforeseeable and incalculable" (cited in Borradori 2003, 97). Tell that to the civilians in Afghanistan or Iraq who are daily threatened by a known and powerful state.

Because of this promise of a violence to come – now an accepted commonplace – we must pursue terror to the ends of the earth. But the assertion of this commonplace, which very quickly acquired the character of repetition compulsion in the immediate aftermath of 9/11, enacts its own violence. To accept that this promise of violence is *new* and something up-til-now *unseen* and *unexperienced* requires that entire histories of colonization, government coups, American militia-training, and so on be utterly effaced – excised from memory. This is the terror alluded to by *Tumbling Woman*'s liminal state. Her horror as a monument – an object of commemoration and remembrance – rests in her revelation that we have not yet seen all that remains to be remembered and that we will fail to see everything that has taken place. In this light, she looks almost as though she has been blasted, like Walter Benjamin's "angel of history," into the future not by the winds of progress but by the force of the past (fig. 2). Like him, she is facing backward; unable to see that which is yet to come, she can only watch the wreckage of history pile up at her feet (Benjamin 1968a).

I can repeat the dramatization of her fall again and again. I can cite and compulsively recite the phrase *since 9/11* in order to designate some new world order. But I am still stuck in this terrible suspension where any desire to put this event to death through the work of mourn-

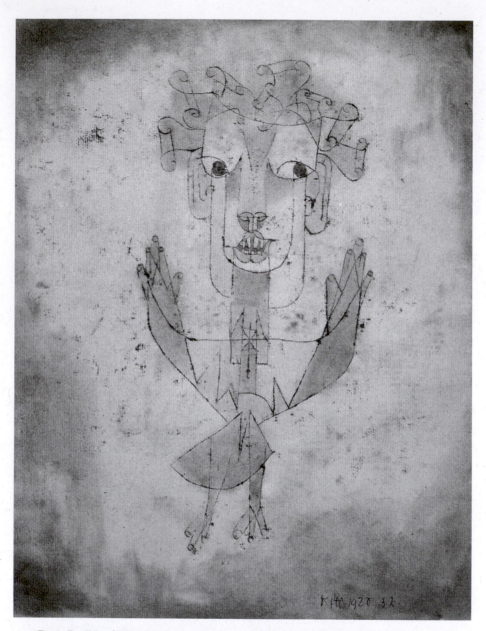

Fig. 2 Paul Klee (1879–1940), *Angelus Novus*, 1920. India ink, colour
chalks, and brown wash on paper. Gift of Fania and Gershom Scholem,
John and Paul Herring, Jo Carole and Ronald Lauder, Collection, Israel
Museum, Jerusalem. Photo © Collection, Israel Museum/by David Harris.
© Estate of Paul Klee/SODRAC (2008)

ing or the writing of its history is impossible. Rather than silencing this impossible mourning, *Tumbling Woman* brings it into focus. Complicating remembrance by invoking an unknown future, the monument's unrealized death similarly prevents her spectators from relegating her to a strictly historical past.

Monument Building

But it is not even as simple as all this. Something has been happening all along here, following an undeclared assumption early on, and I cannot pretend to have finished with the preceding line of inquiry without attempting a kind of accounting.

I have identified this sculpture as a monument, as though it were self-evident, as though we all agreed on this determination, and as though the implications of this naming were clear and straightforward. The meaning of the word, however, is far from stable; a *monument's* significations must be linked with the specific historical and political context in which it is built. Over the course of the twentieth century, in particular, the concept of memorializing events through the erection of monumental structures became a matter of intense scrutiny. And, as anyone who has followed the various memorial competitions for Ground Zero can attest, the debate over what constitutes a proper monument continues to rage with no sign of desisting.

Traditionally, monuments celebrate. Exemplifying heroism, strength, virility, and victory, they function at the level of myth. Representing a nation's greatness to itself, "monuments have long sought to provide a naturalizing locus for memory, in which a state's triumphs and martyrs, its ideals and founding myths, are cast as naturally true as the landscape in which they stand" (Young 1999, 6). Such elaborate architectural glorifications do not simply serve as guidelines for remembering past battles, nor do they merely attempt to "valorize the suffering in

such a way as to justify it" (6). It is not only the past that is sculpted and molded into these structures but also the future. By fixing an image of the past and placing it in a public square for the hoi polloi, the ruling power sends out a call to its subjects: *see, remember, obey.*

J.B. Jackson (1980) identifies this disguised attempt to lay claim to the future as the ritual signing of a contract. By reminding the spectator of past wars and triumphs, monuments simultaneously obligate the viewer to promise future obedience and fealty to the state or sovereign: "The monument, in short, is a guide to the future: just as it confers a kind of immortality to the dead, it determines our actions in the years to come" (92). What a strategic memory game! Riffing on Nietzsche's assertion that pain is the best mnemonics, these monuments ask us to remember past pain in order to avoid experiencing future agony: "That is why every new revolutionary social order, anxious to establish its image and acquire public support, produces many commemorative monuments and symbols and public celebrations ... not to please the public but to remind it of what it should believe and how it is to act" (92). The German and Soviet erections during the 1937 Paris Exhibition, designed by Albert Speer and Boris Iofan respectively, exemplify this classic monumental style of power and virility (figs 3 and 4).

With the twentieth century's increasingly technologized war games – and the resulting overflow of bodies, gore, and wreckage – the traditionally celebratory function of monuments came under focused attack. Criticisms of their physical massiveness – construed as emblematic of the ruling authority's quest for absolute power – are coupled with complex meditations on remembrance.[12]

The "monumental history" epitomized by these traditional structures is indicted for fixing official memory while burying the remains of alternative narratives.[13] Effecting a perpetual and silent betrayal,

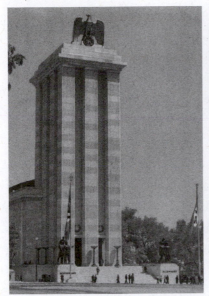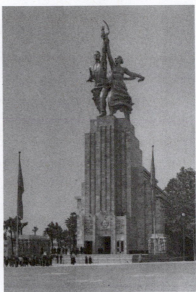

Figs 3 & 4 *Exposition Internationale Arts et
Techniques appliqués à la vie moderne, Paris 1937:
Album official*. Paris: La Photolith, 1937.

these structures cite an official version of history while endorsing a
kind of forgetfulness among the observing citizens, who, in turn, begin
to forget that there is always something else that remains for remem-
brance, something not contained by the stone and plinth of a formal
structure: "It is as if once we assign monumental form to memory, we
have to some degree divested ourselves of the obligation to remember"
(Young 1999, 6). Confronted with the twentieth century's unparalleled
experience of carnage in warfare, and the resulting interrogations of
ceremonial history, artists and governments were faced with the task
of representing history in monumental structures without regressing

to monolithic narratives. How is it possible, they asked, for a monument to enable remembrance?[14]

The question opens out onto an abyss, where the very category of memory threatens to erupt. What is a monument, after all, if not a memorial – an *aide-mémoire*? Robert Musil's deft analysis in his *Posthumous Papers of a Living Author* (2006) glibly links this question of monuments and remembrance to a fundamental confusion within language: "Aside from the fact that you never know whether to refer to them as monuments or memorials, monuments do have all kinds of other characteristics. The most salient of these is a bit contradictory; namely, that monuments are so conspicuously inconspicuous. There is nothing in this world as invisible as a monument" (64). Highlighting an as yet indeterminate difference between two terms typically regarded as interchangeable, Musil posits the paradox of visible invisibility.

According to the *Oxford English Dictionary*, the two words are not identical, although they do cross and recross each other across etymological time.[15] *Memorial* is principally defined as "preserving the memory of a person or thing; often applied to an object set up, or a festival (or the like) instituted, to commemorate an event or person."[16] Deriving from the Latin *memoriālis*, the word also retains a strangely legal sense, giving to *writing* a more prominent role.

Repeatedly across languages, *memorial* is paired with writing, denoting remembrance in legal terms: "reminder, something which recalls something to mind, legal document; memorandum book; historical record."[17] Drawing on Derrida's articulations of writing as spacing, the presence of writing within memory automatically indicates absence, death, and haunting: "**Spacing** ... is always the unperceived, the non-present, and the nonconscious ... It marks **the dead time** within the presence of the living present, within the general form of all presence" (1974, 68–9, original emphasis). Despite its associations with legal writing, *memorial* reflects the spaces between – the gaps in memory and writing that

work against totalitarian formations at every step. In this way, *memorial* keeps in close contact with the Greek figure Mnemosyne, known also as Alētheia. Containing oblivion – *lethe* – within her, Alētheia signifies the concealing and revealing work of memory: we remember traces only – the remains of what we have forgotten.

The word *monument*, by contrast, emphasizes concrete representations of the past: effigies, mausoleums, graveyards, and tombs for the dead. Deriving from the Latin *monumentum* and *monimentum*, the word refers primarily to "tombs, sepulchers, statues, buildings, or other structures erected to commemorate a famous or notable person or event."[18] These are Musil's visibly invisible structures melting into the background of everyday life, their capacity for inducing remembrance consequently sacrificed in the interests of preserving official history.

Even though architectural structures have come to dominate our definitions of *monument*, the word comprises "anything that preserves a memory of something,"[19] including written records or a great work of literature. Writing, in other words, cuts a figure within both monuments and memorials.[20] This presence of writing, with its connections to oblivion, absence, and haunting, highlights a possibility for remembrance in monument building.

Contemporary monument makers are preoccupied with reinscribing remembrance as *arché*-writing – death, oblivion, absence, forgetfulness – into monument building. The resulting structures challenge not only traditional purposes but also the recognizable *monumental* forms. In his study of Holocaust memorials, James Young (1999) names these productions "counter-monuments." From Horst Hoheisel's proposal to blow up the Brandenburg Gate to Rachael Whiteread's negative space library installation, the emphasis is on the impossible: making absence visible (fig. 5). Putting a twist on Musil's *visible invisibility*, these artists seek to bestow tangibility to loss, giving us the negative space around absence as a means of resurrecting the traces of memory.

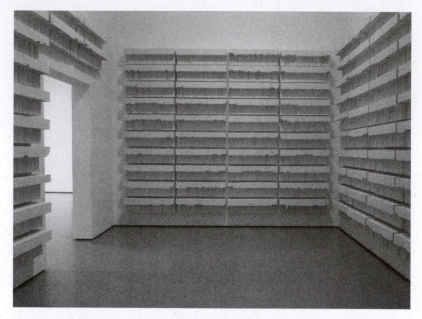

Fig. 5 Rachel Whiteread (1963–), *Untitled (Paperbacks)*, 1997.
Plaster and steel, 14′ 9¹/₈″ x 15′ 9″ x 20′ 8³/₄″ (450 x 480 x 632 cm).
Gift of Agnes Gund and Committee on Painting and Sculpture Funds,
Museum of Modern Art, New York. Courtesy of the artist and Luhring
Augustine, New York. Digital Image © Museum of Modern Art/Licensed
by SCALA/Art Resource, New York.

Recounting the ongoing debate in Germany over memorializing the
Holocaust, Young compellingly suggests that perhaps the most impor-
tant aspect of the counter-monument is its perpetual unfinishedness.
Due either to the never-ending competitions that seek an appropriate
proposal or to the design of the monuments themselves, "the surest
engagement with Holocaust memory in Germany may actually lie in
its perpetual irresolution, that only an unfinished memorial process
can guarantee the life of memory. For it may be the finished monu-
ment that completes memory itself" (Young 1999, 5). Referring not
only to the ongoing attempts to reconceive the past, this unfinished-

ness also bears upon the future, asking us to remember what may yet come, reminding us that the past can always be repeated.

In this way, counter- or anti-monuments represent the future as a kind of haunting. Although they do not function in the same repressive fashion as the examples from Nazi Germany or the Soviet Union, these structures require an engagement with futuricity. With their self-conscious deliberations regarding the purpose and deployment of official memorialization, counter-monuments shift the public burden from blind obedience to active concern with current government policies and military action. The haunting initiated by such monuments is at least double: although they foreground the impossibility of representing past horrors, they also forecast the future as an unknown and potentially horrible repetition of the past.

Echoing Derrida's argument regarding the repetition to come, counter-monuments seek to provide a thinking of the future as a force haunting the now. As a warning, the contract is still repressive, but it no longer provides a truth to claim or a leader to follow. Counter-monuments rewrite the Nietzschean contract, transforming it from an obligation to be the same across time into a more Derridean sense of perpetual indebtedness to both the past and the future.

This description suggests an uncanny similarity to Heidegger's *alētheia*, telling us over and over again that we do not know what we are looking at; we do not know how to remember or what we are forgetting. *Tumbling Woman* reiterates this monumental ambiguity, her unfinishedness signalling a double anxiety for remembrance: what will the future look like, and how will we manage to remember it? As a counter-monument, *Tumbling Woman* does not extend its grip into the future as a grasp for control and mastery but rather compresses the past and the future into the now as a sign of warning. It does this by articulating an indebtedness, or contractual obligation, to the living, the dead, and the unborn.

Two Falling Man

He was caught falling.

Upside down. Straight down. He looks like a gymnast in the middle of a dismount, so perfectly in line is he with his surroundings. Oblivious to anyone or anything else around him, he looks to be expertly negotiating the laws of gravity. "He is," as Tom Junod writes, "in the clutches of pure physics, accelerating at a rate of 32 feet per second squared. He will soon be traveling at upwards of 150 miles per hour" (2003). It took about ten seconds for each jumper to hit the ground; this eerie photograph isolates a fraction of this time, freezing it for eternity (fig. 6).

Shot by Associated Press photographer Richard Drew, the image has since been named *Falling Man*. Although he took a sequence of twelve shots, only this one was selected for publication. Of the twelve, *Falling Man* alone exposed such haunting composure: "That picture just jumped off the screen because of its verticality and symmetry. It just had that look" (Junod 2003). The remaining eleven didn't come close.[1]

On 12 September newspapers around the world published Drew's photograph. In the United States, it ran only once. Charged with "turn[ing] tragedy into leering pornography," newspapers were forced to defend themselves for printing the image (Junod 2003). In the face of such overpowering civic opposition, the most effective defence was to give the American public what it wanted: the freedom not to look (Junod

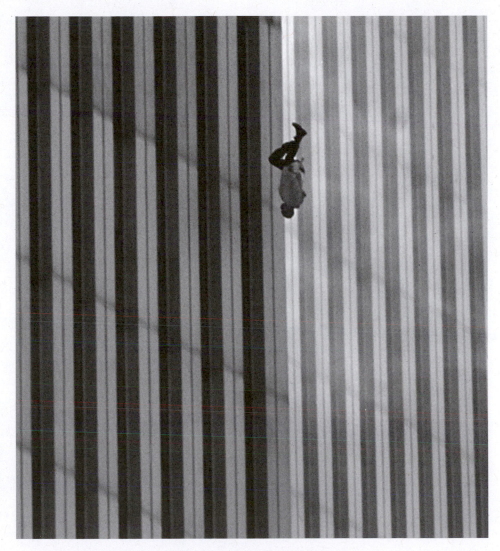

Fig. 6 A man falls from the north tower of New York's World Trade Center on 11 September 2001, after terrorists crashed two hijacked airliners into the WTC twin towers. Television networks have been reluctant to show such scenes since the days after the attacks. AP photo by Richard Drew – #01091108483.

2003). Like the video images of the second plane crashing into the south tower, which initially saw compulsive play in the first hours following impact, *Falling Man* was pulled in the interest of common decency, as an attempt to protect viewers from any further visual trauma.

The comparison to pornography is not idle, particularly given David Levi Strauss's assertion, cited in my introduction, that "On September 11th, more people clicked on documentary news photographs than on pornography for the first (and only) time in the history of the Internet" (2003, 184). A kind of metonymic substitution took over that day; disaster photographs replaced Internet sex shows. Resurrecting an age-old intimacy between sex and death, the substitution of one for the other is hardly surprising.[2] However, this was no simple replacement; certain images from the death and disaster category were reidentified and resituated in the other – pornographic – category.[3] The jumpers, as they came to be known, were the primary focus of this moral outcry and pornographic reidentification: "In the most photographed and videotaped day in the history of the world, the images of people jumping were the only images that became, by consensus, taboo – the only images from which Americans were proud to avert their eyes" (Junod 2003).[4] It was not simply the sight of death that was deemed obscene; it was the image of death-on-the-way that became transmogrified into pornography and secreted away from public view.

Obscenity and pornography concern the improper – that which is deemed unsuitable for public viewing.[5] But the judgment that something is obscene does not result in the absolute disappearance of a condemned object; rather, the objectionable *thing* is evicted from so-called mainstream representation, only to emerge in a different venue within the same social system. As Jacques Derrida might say, the obscene element functions as an interior exteriority, or an exterior interiority – paradoxically enabling and eroding discourses of the proper within a given system of language and law.

In the case of Drew's photograph, a simple Google search resurrects both the image and the accompanying tale of its disappearance. Yet something has taken place in the photograph's relocation from broadsheet to Internet: the transformation of the spectator from sympathizing mourner into lewd voyeur. Rather than being freely offered, interested viewers must search the image out alone.[6] A morality of looking is established, and those wishing to witness the particular fate of a significant number of victims are identified as lacking in respect and common decency.[7] Searing the eyes, this photograph (or light writing)[8] of a body immobilized between life and death – a body no longer in a state of self-possession – is relegated to the category of prurience.

This morality of looking extended to photographers as well, resulting in extraordinary state-sponsored attempts to control the media during the aftermath. Although photography did become the most important medium of witness, it was regarded from the outset with unmistakable ambivalence. Mayor Giuliani unsuccessfully attempted absolute prohibition, "declar[ing] photography at the sight a criminal offense" (Conrad 2001). When that decree failed, photographers were either prevented from shooting altogether or forced to pool their film. Several photographers were stripped of access passes to the scene; some were even arrested (Reporters without Borders 2002).

Don Emmert, the New York photo editor for Agence France-Presse, contends that the organization of Ground Zero was akin to the conduct of a police state: "We are only allowed to film what they want us to film ... Those free to move around are military photographers of the US Navy and those from the Federal Emergency Management Agency (FEMA), who give the agencies some very nice pictures, but none that showed bodies" (Reporters without Borders 2002).[9] Undoubtedly, the chaos, wreckage, and dangers within the site demanded some degree of organization and control by authorities. Rescue attempts, after all, were underway, and the stability of remaining struc-

tures was as yet undetermined. But the confiscation of film and the enforced pooling of images signalled intensive regulation by the state.

Highlighting uncertainties of what we, as spectators from afar, have not seen, the myriad accounts of image control illuminate a strange paradox that emerged in the immediate aftermath. Photography was at once the most pervasive and popular form of witness and an activity regarded with extreme suspicion. Like the perimeter fence that was erected shortly after the collapse of the towers, photographers repeatedly ran up against certain limits in their shooting. One of these limits – identified as the presence or absence of bodies in an image – became a focal point for journalists commenting on the regulation at Ground Zero.

Foreign journalists remarked immediately on the absence of corpse photographs in documentary images of the attack: "5,500 people died or disappeared on the black day of 11 September … but practically no image of the bodies has been shown on the television or published in the press" (Reporters without Borders 2001). Whereas some reporters attributed the lack of corpse photographs to an inconsistency in American journalistic policy – "western media … don't hesitate to show massacres when they happen in Rwanda" – others merely remarked that "during wars you never show your own dead, only those of your adversaries. The Americans want to limit the images of trauma they have suffered, of defeat, the affront and the mortification" (Reporters without Borders 2001).[10] Some further argued that the lack of cadaver photographs resulted directly from the overwhelming absence of dead bodies.

Crushed, incinerated, and turned to ash, very few bodies remained to photograph. As one French correspondent suggested: "I quite honestly doubt there is much left to show" (Reporters without Borders 2001). Nevertheless, records of images rejected by the filters do exist: "terrible pictures started arriving … There was blood, there were dis-

membered bodies" (Reporters without Borders 2001). These photo-
graphs, present only through their absence, have been almost entirely
rejected by newspapers, commemorative anthologies, and even inde-
pendent Internet sites. As Mark Wigley writes: "The few bodies that
were found were kept invisible. Despite all the intense and endless
media coverage, no bodies were shown. No broken, bloody, burned,
or fragmented people" (2002, 73).[11] Instead, endless photographs of the
towers' collapses began to operate metonymically for the absent bod-
ies (73). Although network executives were responsible for the deci-
sion not to reproduce these now apocryphal images, the exclusion or
eradication of these shots from public consciousness was far from a
hierarchical operation of censorship from above. Like the jumper pho-
tographs that became taboo, the corpse photographs provoked in both
journalists and American citizens a widespread desire not to look.[12]

Identification 1

Not all photographs of bodies were excluded. Other photographs –
heroic, triumphant, defiant photographs – have been elevated in their
stead, deployed in official ceremonies, and heralded by government
and citizenry alike as examples of American valour, triumph, and
courage. Set against all the remarked upon absences of corpse photo-
graphs, those bodies that were put on view become especially signifi-
cant. Images of survivors – ash- and debris-covered bodies of the living
–abound and have been anthologized in every major photographic
publication of the event (figs 7 and 8).[13] They are terrified, confused,
wounded – but alive.

The body of Father Mychal Judge, a famed New York City Fire
Department chaplain, was photographed as it was carried out of the
wreckage (fig. 9). Judge died administering last rites to an injured fire-

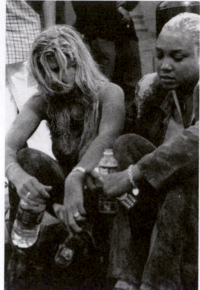
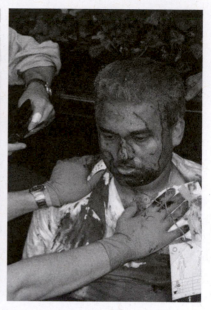

Fig. 7 From George et al., eds, *Here Is New York: A Democracy of Photographs*, 124. Zurich, Berlin, and New York: Scalo, 2002.

Fig. 8 From George et al., eds, *Here Is New York: A Democracy of Photographs*, 330. Zurich, Berlin, and New York: Scalo, 2002.

fighter in the lobby of the north tower; he had removed his helmet to perform the ritual. Killed in the line of duty when the south tower collapsed, filling the north tower lobby with debris, he brought a face – a known face with a function and a purpose – to the disaster scene. His death, although tragic, retains an element of choice – he chose to enter the north tower in the hopes of bringing peace to the dying. The image was published to great acclaim all over the United States.

But the bodies that have seen by far the most exposure are alive and engaged in purposeful work. They are firemen searching for victims. Official city workers, trying in vain to recover some hope from the horror, they pause from their task to raise the American flag atop a pile

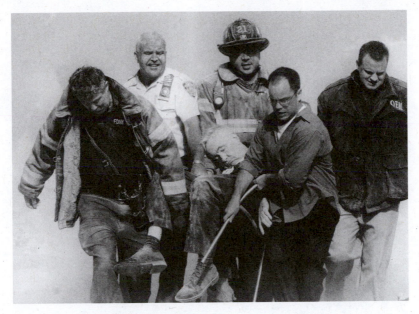

Fig. 9 From George et al., eds, *Here Is New York:*
A Democracy of Photographs, 237. Zurich, Berlin,
and New York: Scalo, 2002.

of rubble (fig. 10). In this extraordinary photo-op, they are trans-
formed from city functionaries to servants of the nation, bringing a
message of triumph and hope to desperate civilians.

Shot by Thomas Franklin, photographer for the New Jersey news-
paper *The Record*, this image of three firemen hoisting the flag on Sep-
tember 11 stands as an important counterpoint to public responses to
the jumper photographs. Selected for its almost perfect replication of
Joe Rosenthal's famed Iwo Jima photograph from the Second World
War, the image has been copyrighted, sold, repackaged, and commer-
cialized beyond belief. From snow globes to miniature 3-D replicas,
posters, and key-ring designs, the photograph has been reproduced in

almost every imaginable way. And, in 2002, it became a commemorative postage stamp.

Whereas Friedman's image opens up the space for a narrative of hope and triumph through the promise of national revenge and allusions to past victories in war, Drew's *Falling Man* resists all such linkages with American glory. The jumper is not a proper object for identification: alienated from the national community, he tumbles

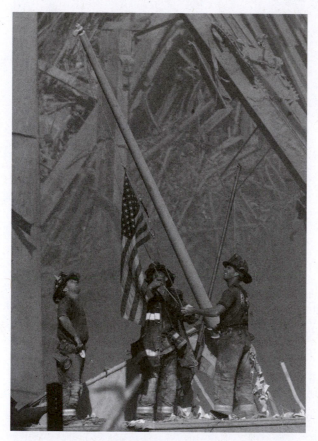

Fig. 10 Thomas E. Franklin/The Bergen Record. *Firefighters Raise a U.S. Flag at the Site of the World Trade Center.* Getty Images News. 11 Richard Press, *Tooth*, 2002.

alone and out of control, death his sole and inevitable fate. Stripped of all options himself, the *Falling Man* leaves behind only one possibility for survivors: a future of mourning.

The charge of obscenity, poor taste, lewdness, voyeurism, and so on in photographic representation must be understood as fundamentally ideological. For in its essence, a photograph "possesses meaning ... only in potentia: meaning does not fill the image like water in a glass, but rather, resides in the knowing and decoding activity of the viewer" (Solomon-Godeau 1991, 100). Obscenity or its other – propriety – is superimposed onto an image after the fact; each is a narrative generated according to a larger political context. In the case of those body photographs deemed "proper" in the wake of September 11, narratives of identification are primary – identification as a way to make sense (*he died in the line of duty*), to make hope (*we can overcome this*), to make a future for the nation.

Depicting neither body nor survivor, jumper photographs resist identification; they are essentially liminal.[14] Frozen between life and death, Drew's image effects a terrible collapsing of time; always about to die, the jumper is already dead: "I read at the same time: *This will be* and *this has been*; I observe with horror an anterior future of which death is the stake. By giving me the absolute past of the pose (aorist), the photograph tells me death in the future. What *pricks* me is the discovery of this equivalence" (Barthes 1981, 96, original emphasis). *Falling Man* hurtles eternally toward certain death, like Tantalus forever reaching, yet never realizing, his desire. The obscenity of Drew's image lies in its depiction of an eternally incomplete, yet certain, death. The violence, as in ancient Greek drama, is offstage – *ob-scenus* – a future perpetually on the way. In such a state of deferred arrival, we are left to ask: How is mourning possible when death has not yet been accomplished – when the victim is not yet identifiable as dead, when the victim is no longer identifiable?

Mourning, says Freud, is a process of gradual detachment: "its function is to detach the survivors' memories and hopes from the dead" (1991c, 82). Unless the survivor regresses into the hysteria of melancholia – "an identification of the ego with the abandoned object" – he or she will eventually complete the grieving process and once again be able to form attachments with new love-objects (1991b, 258). The resurrection of memory, for Freud, is pivotal to this process: "Each single one of the memories and expectations in which the libido is bound to the object is brought up and hypercathected, and detachment of the libido is accomplished in respect of it" (1991b, 253). Neutralizing the charge of memory, mourning is conceived as a process to get through and death as a thing to get over.

Derrida complicates matters, suggesting that mourning resembles melancholia more than Freud allows, that true mourning, if such a term can be used, never arrives at completion. What is mourning, after all, if not the preservation of the other within me? "If death comes to the other, and comes to us through the other, then the friend no longer exists except *in* us, *between* us. In himself, by himself, of himself, he is no more, nothing more. He lives only in us" (Derrida 1989, 28, original emphasis). But the *he* of whom Derrida speaks – the mourned other – comes to us, in memory, as an image. It is as an image that the dead returns and is recognized by us – is identified as the one to be mourned: "When we say 'in us,' when we speak so easily and so painfully of inside and outside, we are naming space, we are speaking of a visibility of the body, a geometry of gazes, an orientation of perspectives. *We are speaking of images.* What is only *in us* seems to be reducible to images, which might be memories or monuments, but which are reducible in any case to a memory that consists of *visible* scenes that are no longer anything but *images*" (Derrida 1996, 188, original emphasis). Drew shot a photograph of a man on his way to

death. But the image he gave us interrupts as it perpetuates the mourning process.

Like all images, it does not answer the ontological question *What or who is it?* But its nonanswer is literal: it is a photograph of an unknown man, a *memento mori* without a referent.[15] Operating as a photographic tomb to an unknown jumper, the image becomes iconic for all who jumped that day. But something is lost in the attribution of iconicity, and that is the specificity of the loss documented by Drew's photograph.

Derrida tells us that mourning and memory are inextricably tied to the proper name: "The name ... this is the sole object and sole possibility of memory ... This means then that any name, any nominal function, is 'in memory of' – from the first present of its appearance, and finally, is 'in virtually-bereaved memory of' even during the life of its bearer" (1989, 55). The image, which never exposes an ontology, here doubles up in its uncanny resistance to name the subject. The work of mourning – for this man, for this day – is permanently disrupted by the impossibility of recognition, the failed identification of a victim. This failure cannot be overemphasized, for it is through this failure that the profundity of *Falling Man*'s iconicity begins to emerge.

Identification 2

The attempt to identify him formally was made. After viewing Drew's photograph, a *Globe and Mail* editor set reporter Peter Cheney the task of uncovering the *Falling Man*'s true identity. Taking photography back to its classificatory roots via new technology, Cheney had the image enlarged and enhanced.[16] The information that emerged, uncannily enumerated in the style of criminal description, gave focus to the reporter-detective's quest: "the man was most likely not black but

dark-skinned, probably Latino. He wore a goatee. And the white shirt billowing from his black pants was not a shirt but rather appeared to be a tunic of some sort, the kind of jacket a restaurant worker wears" (Junod 2003). Despite the clues yielded by this exercise, the only certain facts to emerge from the photograph's enlargement were black high-tops and an orange t-shirt.[17]

Armed with these few details, Cheney studied the list of businesses listed in the towers. He concluded that the *Falling Man* must have been a food service worker, probably employed by the restaurant at the top of the north tower, Windows on the World. One by one, Cheney checked out several leads. Norberto Hernandez, Sean Singh, Wilder Gomez, and Jonathan Briley were among the list of possible candidates.[18] After talking with various friends and family members, not all of whom wanted to participate in this hunt, he was able to reject all but one name from the list: Jonathan Briley.

Briley fit the profile: his skin colour, height, facial hair, and place of employment – Windows on the World – all tracked with the details gleaned from Drew's image. Moreover, once Cheney interviewed family members, he learned that Briley not only wore black high-tops, black pants, and a white shirt to work but also owned an orange t-shirt, a t-shirt he loved and wore frequently. But nobody saw what Briley wore to work that morning, and his clothing has long since been packed away and discarded (Junod 2003).

In the end, Cheney's search turns up nothing but *maybe*. Maybe the *Falling Man* is Briley, but maybe it's someone else. After all, how many orange t-shirts and black high-tops are there in New York? *Falling Man* proves unidentifiable. Despite photography's apparent capacity to resolve identity – it is an Associated Press documentary photograph after all, ostensibly the most objective, most reliable form of evidence we have today – traces are all that remain. All the technology of enlargement and heightened resolution cannot bring us a proper name.

We are left with nothing but the ephemera of an orange shirt, black high-tops, a white jacket, and dark skin.

All of this goes to show that, in the end, a photograph is no substitute for a body. Without a body – the necessary forensic material for the production of a name postmortem – all that remains of the *Falling Man* is absence and uncertainty. If memory always comes to us as an image, then the memory of Drew's photograph is only one of pure loss, its iconicity achieved at the expense of recognition. Just as his journey toward death remains photographically incomplete, this man is condemned to anonymity, never to be claimed by blood relations. The man in the picture, whomever he is, is mourned as a ghost without a home, without a proper burial. What remains is not the certainty of a body or a name but only the photograph of a man about to die.

The hunt for his true identity recapitulates an essentially Antigonean quest to claim and bury the lost other. Its failure epitomizes one of the most obscene results of September 11: survivors and relatives have not yet been able to bury their dead, for the dead do not exist *as such* but only as so much dust, ash, and debris. Names, in most cases, are all that remain of the victims, but they remain isolated and detached from the scene of destruction – frozen in time and space like the *Falling Man*. Like Antigone, sentenced to live-burial by the king for her attempts to mourn her brother, surviving relatives of 9/11 are entombed in their own perpetual mourning weeds, left only with names to repeat – names to make it real.

Identification 3

It is this obscenity of absence – the absence of remains – that helps to explain the significance ascribed to proper names in officially sanctioned mourning projects. In place of nonexistent corpses, names have come to confirm death. At the annual recitation of names at the Ground

Zero commemorative ceremonies, the name of each official victim is read aloud. And for the 9/11 memorial design competition, entries were required to include: "individual recognition for 2,982 victims: six from the attack in 1993, 224 from the Pentagon and United Flight 93 in Pennsylvania, and 2,752 at the World Trade Center, according to the City's most recent count" (Keenan 2003). *According to the city's most recent count* – and the city has been counting names, furiously counting them, ever since 8:46 A.M. that September morning. Initial tallies indicated the number of dead at over 6,300. Two years after the attacks, the number had dropped significantly to 2,792. The most recent figure, reported in October 2003, subtracted another 40 names from the list, bringing the official count to 2,752 (Barry 2003).[19]

Although attempts to tally the dead accompany all major disasters, investigators claim that the time and energy devoted to determining the correct number of victims from the World Trade Center attacks has far exceeded all previous efforts (Barry 2003). Conducted in part for posterity, the quest to compute each name also aids in the distribution of death benefits. But there is another, more elusive motive behind the city's compulsion: the concretization of memory.

The name, as Derrida has said, is essential to memory. When naming becomes a massive accounting program, a particular kind of memory is at work. The Germans refer to it as *Gedächtnis*; it is "both the memory that thinks ... and voluntary memory, specifically the mechanical faculty of memorization" (Derrida 1989, 51). As opposed to the more Proustian *Erinnerung* – involuntary and interiorizing memory – memorization operates less as remembrance than as recitation. A technological will to learn the disaster statistics by heart takes over, "hinting that the vicissitudes of merely human memory are not to be trusted" (Keenan 2003). All this technical memory work is then transformed into an aid to mourning. Affirming that the dead are both dead and

accounted for, the recitation of names at Ground Zero ceremonies signals both identification and recognition.

Identification, as a form of affirmation, is essentially forensic: "Yes, that is the name which belongs to this body." It is an utterance based on the examination of physical evidence. For some grieving relatives, this scientific affirmation of death became the only proof, the only occasion when an absent body was matched with a name. No wonder, then, that the city undertook a mammoth recovery operation, spanning nearly ten months, to identify as many human remains as possible.

The name of the place is Fresh Kills – located across the water on Staten Island.[20] Specially commissioned ferries took on the role of so many Charons, transporting the rubble and remains from Ground Zero to this landfill-cum-graveyard. Fresh Kills. Denoting at once preservation and murder, the site was set up on 12 September 2001 to operate as a massive forensic laboratory. Encompassing 175 acres, the operation included refrigeration trucks for the preservation of found organic material, sorting trucks to process remains and rubble, and of course, the landfill proper. Present at the scene were police, forensic specialists, FBI agents – and several museum representatives.

The entire project was photographed. Sanctioned, eventually, by the authorities, a group of museums were granted access to the site in order to document the process for history. The permission they received was unprecedented: "We never normally let outsiders see a crime scene, let alone take photographs or touch anything. We were a tough sell … You remember we were here to find human remains. We were so focused we didn't realize we were part of history" (New York State Museum 2002). For history, photographers took pictures of recovered objects and remains, sorting trucks, and workers sifting through fields of rubble. They provided documentation of the procedures, evidence of the evidence.

An exhibition, *Recovery: The World Trade Center Recovery Operation at Fresh Kills*, emerged out of the documentation of the Fresh Kills operation. Whereas Drew's photograph was decried and condemned, images of a recovered tooth in a test tube, frozen tissue samples, and workers sifting through remains were framed and hung on museum walls (figs 11, 12, and 13). Sponsored by high-powered individuals and groups such as New York governor George Pataki, the New York State Senate, the New York State Assembly, and the New York State Museum, the exhibition travelled across the United States. Why is the image of a man tumbling to his death deemed obscene, whereas photographs of body parts recovered postmortem are judged important historical evidence and given an exhibition?[21] What is the difference between the documentary work at Fresh Kills and Drew's *Falling Man*?

To document is to prove or support, to teach, or to furnish evidence. In photography, so-called documentary work "occupies a privileged place within the rhetoric of immediacy" (Tagg 1988, 8). But documentary is a category, an "interpretive structure" superimposed onto the image, attributing to it the character of truth (Bolton 1989, xvi). Moreover, documentary is conventionally regarded as "animated by some kind of exhortative, ameliorative, or, at the very least, humanistic impulse" (Solomon-Godeau 1991, xxvii). Of course, for "documentary" to have meaning as a category, its Other must also be given a name. Typically, "the name resembles terms like *expressive, aesthetic, abstract* … whatever can be said to oppose the so-called objective or indexical content of a documentary photograph" (xxviii, original emphasis).[22] Evidence, in this discursive formation, is not aesthetically pleasing.

In the mainstream media, photography continues to enjoy the roles of evidence giver, reliable witness, and faithful recorder of history, despite an impressive body of critical work arguing otherwise.[23] But this status is unstable, for if a photograph documenting an atrocity is de-

termined to contain too much of something called "art," it becomes unacceptable – improper. As Susan Sontag writes: "For the photography of atrocity, people want the weight of witnessing without the taint of artistry, which is equated with insincerity or mere contrivance. Pictures of hellish events seem more authentic when they don't have the look that comes from being 'properly' lighted and composed" (2003, 26-7). In other words, a photograph's determination as "appropriate" or not continues to be linked with its classification as either objective evidence or expressive composition.

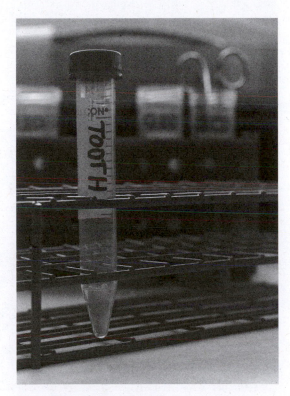

Fig. 11 Richard Press, *Tooth*, 2002.

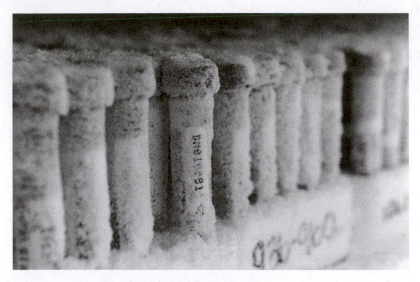

Fig. 12 Richard Press, *Tubes in Freezer*, 2002.

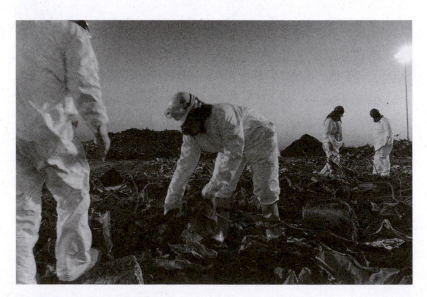

Fig. 13 Richard Press, *Area C*, 2002.

But what determines the presence or absence of this thing called art? If, as Solomon-Godeau (1991) argues, a photograph is nothing but meaning in *potentia*, then the identification of artistry – or obscenity – occurs after the fact of exposure, within a particular socio-political framework accustomed to reading certain visual signs as *art* or *obscene*. It is just another meaning, superimposed onto an emulsion of paper and light.[24]

Recall Drew's remark, cited earlier, regarding the "look" of that one photograph as opposed to the other eleven he shot in the *Falling Man* series: "That picture just jumped off the screen because of its verticality and symmetry. It just had that look." Explaining that "you learn in photo-editing to look for the frame," Drew punctuates the myth of the documentary category (Junod 2003). What appears like a conventional documentary image (a news photograph shot by an official Associated Press photographer) is described in artistic language: verticality, framing, the "look." Dissolving the borderlines dividing these discursive categories, Drew's photograph resists categorization as either aesthetic or documentary. This resistance to classification in turn complicates the superimposition of meaning – or identification – onto the image.

For a photograph to acquire the status of documentary evidence, not only must it adhere to the aesthetic requirements of objectivity, but its meaning must also appear clear and obvious: *these fireman are bringing hope to the nation; this man died an honorable death*. Its identification is profoundly instrumental. In the photography of 9/11 bodies, to be appropriate, a body must be able to be named. The photographs of Fresh Kills describe an operation devoted to naming, to bringing some certainty and affirmation to mourning survivors. Drew's image does not lend itself to patriotic or hopeful narratives. Its subject and style being equally unclassifiable, the photograph suspends the

viewer between what-has-been and what-will-be, offering only uncer-
tainty and death.

In this sense, Drew's image operates much like an architectural
counter-monument: refusing closure and mythic tales of heroism, it asks
the spectator to be active in the experience of looking. Troubling the
operations of memory and identification, it is as much preoccupied with
the still-to-come as it reflects the effects of the immediate past. The call
for decency and tastefulness in the documentation of this disaster is not
innocent. *Show respect for the dead*, we are told. But the dead are not
troubled by images of death and dying. It is the living who experience
disruption, or rather, it is the memories of those lost, held onto desper-
ately by the living, that are interrupted by the scenes of violence and
death recorded on that day. Our task is to interrogate the narratives
imposed on these images in the wake of their development.

Despite the exhaustive efforts of investigators, no balance sheet will
ever double as a technique for *making sense* of the event. Identification
and recognition do not indicate comprehension. Moreover, the final tally
remains elusive; after more than two years of searching, the exact num-
ber of victims was still uncertain. Although 19,936 remains have been
found, they have not all been matched for positive identification. We
will never know how many other remains were never recovered.[25] The
failure to recover, the failure to name, the failure to account – all of these
instances epitomize the experience of what has come to be called "9/11,"
the name itself operating more as a compulsive repetition than as a sign
of recognition or comprehension of the event.

To comprehend denotes not simply understanding but also posses-
sion. And possession, as Derrida articulates, is allied with phallogo-
centric valuations of the proper: possession, self-possession, proximity
to Being, being recognizable and identifiable, being certain. These are
all qualities deemed not simply desirable but also necessary to the func-
tioning of Western nations. When these qualities are absent in a thing

or being, a crisis of classification ensues.[26] Georges Bataille elaborates on this crisis, arguing that the category of *obscenity* arises wherever the proper as self-possession fails to function (1986, 17–18). When possession – or comprehension – fails on such a massive scale as it has since 11 September 2001, *obscenity* emerges less as a charge of bad taste and more as a series of failures to identify and understand. *Obscenity*. Another word for absence, another word for failure.

If failure categorizes so much of this day and its ongoing aftermath, then failure must be acknowledged and given a place in our attempts at commemoration. As so many contemporary artists have suggested, the goal of memorialization is not comprehension but meditation. Like mourning, meditation is a process without end, one by which those who wish to grieve and to remember seek active reflection. Remembrance, moreover, encompasses failure: what I remember, whether through active recall or involuntary return, is always a jigsaw of presence and absence. What recurs as memory are only so many pieces – fragments of remains – from a picture that was never whole to begin with.

Counter-Memory

The winning memorial design for the World Trade Center site remembers the significance of absence and failure to the events of September 11. Named *Reflecting Absence*, the plan takes advantage of the voids left by the towers' collapses, transforming them into deep reflecting pools. Visitors will descend into the memorial through a passageway that leads them away from the city. Then, "at the bottom of their descent, they find themselves behind a thin curtain of water, staring out at an enormous pool. Surrounding this pool is a continuous ribbon of names. The enormity of this space and the multitude of names that form this endless ribbon underscore the vast scope of the destruction. Standing there at the water's edge, looking at a pool of water that is

flowing away into an abyss, a visitor to the site can sense that what is beyond this curtain of water and ribbon of names is inaccessible" (Arad and Walker n.d.). The names designate a limit – both of knowledge and of memory. All that we cannot understand of the event itself, and all that remains to come in the form of the future, lies just beyond our sightlines. The memorial encourages us to remember that we do not see all these absences, and it provides a space where the drive to identify can be relinquished in the face of absolute loss.

Three Postcard Memories

Imagine the visual currency of souvenirs – how a lion becomes an empire, or the other way around; how a foreign land one has never been to embodies a memory. Yoke-Sum Wong (2002, 352)

Poeisis

In bold red letters, "You Never Walk Alone" is stamped across the top of a postcard featuring a collage of 9/11 images (fig. 14). Directly beneath the caption, the inscription "*New York, September 11th, 2001*" marks the date never to be forgotten. Positioned top-centre, a giant American flag nearly dwarfs the smoking towers of the World Trade Center that frame it. Two images of the towers are pictured here: the first depicts the towers before they fell, spewing smoke from the impact sites; the second captures the aftermath – a smoky pile of rubble with twisted steel girders rising out of the ash. Framed by these sets of tower photos, as well as by the flag, President Bush is shown standing at a lectern, presumably delivering a message of hope and a promise for justice. In the postcard's foreground, images of rescue workers and spontaneous memorials complete the picture.

"You Never Walk Alone" is a message of togetherness, of banding together under difficult circumstances and going forward into the unknown. It's also a reference to a standard show tune from a 1945 Rodgers and Hammerstein musical, *Carousel* (King 1956). The song is called "You'll Never Walk Alone," and the lyrics are unabashedly sentimental. They tell us that, despite the darkness of life, we must cling to hope:

Tho' your dreams be tossed and blown.
Walk on, walk on with hope in your heart
And you'll never walk alone,
You'll never, ever walk alone.
Walk on, walk on with hope in your heart
And you'll never walk alone,
You'll never, ever walk alone.

Hope keeps us from despair. Hope guarantees that the individual is never solitary.

In both the musical and the film (released in 1956), "You'll Never Walk Alone" is sung during a graduation scene at the very end of the production. And in an example of life imitating art, the song has become a standard at high school graduations across the United States. Elvis, Sinatra, Judy Garland, Doris Day, Ray Charles, and Tom Jones are just some of the artists who have recorded their own versions; and in 2003 the *Guardian* newspaper published an article purporting to settle the debate over which football team – Liverpool or Celtics – sang it first (Aldred and Ingle 2003). It was Liverpool. The song's lyrics, like the postcard, speak to a *you* in need of courage. In the film, two characters take heart from the song's message of hope as it becomes intertwined with the memory of their dead father and husband, Billy Bigelow.

Bigelow returns from heaven to make amends for mistakes he made during life, but in the fashion of Dickens's *A Christmas Carol*, he remains invisible to the living. During the final graduation scene, Bigelow implores his daughter to believe in the future, and he assures his wife of how much she was loved. Although they cannot see or hear him, a kind of alchemy takes place when the song begins, and they become imbued with newfound faith. Mother and daughter at last join in the chorus, and the film ends with Bigelow, his work complete, beginning the return to heaven. Bigelow's gift is a kind of clairvoyance; his post-

Fig. 14 Postcard. You Never Walk Alone.
http://www.thismodernworld.org/gra/WTCcard5.jpg.

mortal condition allows him to see beyond the immediately painful
present and into a future of possibility. Posted from heaven, this mes-
sage can be received only indirectly, through verse.

The song strikes a chord. Its chorus constitutes the human harmony
to the Christian God's "Fear not, for I am with you." Its poetry is sen-
timent; its theme is relief. Hearkening back to that famous Christian
poem *Footprints in the Sand*, the chorus sends a message of endurance
and succour within chaos and death. On the 9/11 commemorative

postcard, this message emanates from a similarly omniscient voice. Unheard, unseen, the voice is positioned above the people, above the towers, above even the flag. Is it any wonder that, in 2001, Barbara Streisand performed "You'll Never Walk Alone" as a tribute to the victims of September 11?

Poetic sentiment and war go back a long way, so perhaps it should come as no surprise that poetry found its way onto war postcards in the nineteenth and twentieth centuries. "Poem cards," small cards with printed poems and room for personal inscription, have been in use in one form or another since before the Civil War (Nelson 2004, 267). During the First World War they were used by all nations, and the poems inscribed on their surfaces were not necessarily reproductions of famous lines. Most were written by little-known authors; some were anonymous (273). Some were supportive of the war; others protested for peace. There were thousands in circulation.[1] Wallace Stevens's "Postcard from a Volcano" (1990) alludes to this constellation of war, the postcard, and the poem. Written at a great distance from the war – from Hartford, Connecticut – Stevens's postcard injects temporal distance into the equation, rendering the communication of war as the echo of so many ghosts on a hill. It begins thus: "Children picking up our bones / will never know that these were once / as quick as foxes on the hill." Bones are like runes – ancient symbols waiting to be deciphered. The language is foreign: it is the past. And the bones, the messages left behind, are only partial: "And least will guess that with our bones / we left much more, left what still is / The look of things, left what we felt / at what we saw" (158). Smell and speed and blood come to us as bone and ruin. The quiet fragments of experience are all that remain of volcanic eruption.

Poem cards were used as weapons against the enemy during the Second World War. Russia engaged antifascist exiles like Erich Weinert to read poems "over loudspeakers [which had been] trucked to the front-

line trenches at night" (Nelson 2004, 278). Poems were air-dropped over Germany in hopes of infecting troop morale.

Finally, the Soviets devised a remarkable shaming scheme: they planted these poems inside nonexploding artillery shells and launched them into German-controlled territory (Nelson 2004, 278). The poem "Denk an Dein Kind!" – accompanied by the image of a weeping toddler (fig. 15) – orders the German soldier to think of the suffering children at home. Surrender and become a prisoner of war, the poem suggests, as this is far better than being reduced to mere memory – and a fading one at that – in the minds of your children. Amazingly, the shells hit their mark; numerous German soldiers reported that this poem in particular had infected their psyches. And so the Russians printed more (278).

In 2005 the journal *Prairie Schooner* published a series of poems by Samuel Green. All are entitled "Postcard" and subtitled with a date. The first postcard poem is dated 9 September 2001; the last is dated 8 January 2002. The second poem in the series is dated 11 September 2001:

Postcard: September 11/01

The rain-split plums
have been falling
in the orchard, the ground
so littered now the numbers
no longer have meaning. (130)[2]

Citing William Carlos Williams's plums, but transforming them into bodies scattered over the earth, Green traces a different yield.[3] Too much water has infected them, split them open, and made them too heavy to wait for harvesting. The meaning they held for Williams's

Fig. 15 Postcard. Denk an Dein Kind.
Personal collection of Cary Nelson.

narrator – sweet, cold, and delicious theft – is gone. Green's plums
have been falling – in the passive sense – and there is nothing to be said
about it. These are not bones to be deciphered or poem-filled bombs
to be fired; they are bodies raining down like rotten fruit.

 The poet tells us that calculation in this case is meaningless, that
the loss cannot be quantified. As though to underscore this message,
he writes it out for us on a miniature medium – one that, historically
speaking, has ever been a sign of the superficial. As London journal-

ist James Douglas wrote in 1907: "There are still some ancient purists who regard Postcards as vulgar, fit only for tradesmen … The Postcard is, indeed, a very curt and unceremonious missive. It contains no endearing prefix or reassuring affix. It begins without a prelude and ends without an envoy. The Picture Postcard carries rudeness to the fullest extremity" (cited in Staff 1966, 81). The postcard functioned as a kind of shorthand for travellers. Rather than waste hours writing long epistles describing the scenery for those back home, Douglas explains, "Now [the sightseer] merely buys a picture postcard at each station, scribbles on it a few words in pencil, and posts it" (79). Deftly using this abbreviated medium, Green posts a message that opens out onto an endlessly piling up scene of disaster. Poetry takes control of this pseudo-reductive form; it disarms us – literally – and thereby forestalls conventional methods of tabulating damage. Once again, we're in the position of Walter Benjamin's angel, impotently watching the disaster pile up at our feet while we're blown farther away from Paradise. It's a different kind of landscape.

Martin Heidegger tells us that poets matter because their "method" – poeisis, or "bringing-forth" – traces an alternative to enframing (1993, 307-41). To put it crudely, we as humans seem to possess two different ways of making meaning: through calculation and reduction or through a complex interplay of concealing and revealing, of suggesting without determining. Heidegger admires poets for their capacity to participate in this latter kind of generation. Poetry, he says, "is the saying of the unconcealment of beings" (198).[4] Poetry, in other words, is rooted in *alētheia* (318).[5] Could postcards not function in a similar way? Despite, or perhaps because of, their tiny scale, they open out onto vistas that extend forever. Lynching postcards, for example, are not simply souvenirs from a failed Reconstruction; they highlight the magical capacity of objects to carry the weight of the past (see Allen 2002). They confront us with a violence we can calculate (who, what,

where, how, why, etc.), but they are also historical punctums. These postcard mediums bring the repressed back to us; they offer some answers but no solace.

Condensations and Displacements

Dated late 2007, the newspaper article is entitled "Postcard Sales Reflect a City Moving On" (Nathan 2007). It is the combination of words that catches my eye: postcards-reflect-movement. Reading on, I find something curious: tourists in New York City have changed their purchasing habits, slowly but surely, since September 11. And these changes have to do with photo-postcards. In the immediate aftermath of the towers' destruction, tourists wanted to remember the scene as though it had never happened, so they purchased postcards depicting the towers serene and strong on a New York summer's day (fig. 16). Now, it seems, nobody wants these images, and shop owners can't move these cards off their racks. There's been talk about resurrecting an old postcard, from before the towers were built. "You'd never know," said Eric Schwarz of Alfred Mainzer, Inc. "It looks exactly like the skyline today. It's beautiful" (cited in Nathan 2007).

 Does the skyline today look exactly like the pre-World Trade Center postcard? Do the absent towers haunt the landscape of memory at all? Or have they vanished, without a trace (fig. 17)? In *Civilization and Its Discontents* (1962), Freud has a dream about memory. He compares the structure of the mind with that of ancient Rome and suggests that "nothing which has once been formed [in the mind] can perish, that everything is somehow preserved and that in suitable circumstances ... it can once more be brought to light" (16). But Freud quickly abandons this archaeological analogy, stating that cities are frequent victims of destruction and subject to rebuilding, whereas the past can be preserved only so long as the mind "has not been damaged by trauma or inflam-

Fig. 16 Postcard. New York City Skyline.

Fig. 17 Postcard. New York City Skyline modified.

mation" (18). A city, therefore, does not present a suitable example of memory work. Looking at the 9/11 postcards, I wonder at Freud's denial; memory seems as entangled with destruction as it is with building. The toppling of a political regime, for instance, is often accompanied by a destruction of the monuments of the previous ruling power – a tectonic manipulation of history and remembrance. What returns as the same in a reissued postcard? Does history look different now, through an old frame?

Fig. 18 Kurtz Studio, *Uncle Sam and 9/11*, 2001.

In another postcard Uncle Sam takes up a position in the footprints of the towers (fig. 18). Uncle Sam is at his post, and he's already looking toward the East, rolling up his sleeves in preparation for sending a message. He has grown up out of the towers; it looks as though they constitute him. He grows out of them – or through them. One cannot tell where his legs end and the towers begin. He dwarfs the city, and if he weren't so rooted to his post, one can almost imagine him striding across the Atlantic to exact retribution himself.

But look again: history is doubling up on itself (fig. 19). As one addressee remarks in Jacques Derrida's *The Postcard* (1987), "Look closely at this card, it's a reproduction" (9). It's an uncanny dissolution of time: "Finally one begins no longer to understand what to come [*venir*], to come before, to come after, to foresee [*prévenir*], to

Fig. 19 Ron Menchine, *Uncle Sam and WW2*, n.d.

come back [*revenir*] all mean – along with the difference of the generations" (21). The reproduction of an icon, the condensation of time, the interchangeability of cards for wars, superimpositions and the layering of history within the image – these postcards are eternally rerouted.

From technical reproductions of images on postcards, to the mass production of cards featuring the same images, to the millions of cards

with their infinity of messages and images circulating around the globe, postcards operate simultaneously according to logics of reduction, replication, and multiplication. Bearing an uncanny resemblance to the movements of viral transmission, postcards expose a fundamental instability within the system of language and the tradition of linear history. Their magic resides in their capacity to tie up time. Walter Benjamin called it dialectics at a standstill (1999c). Picture these philatelic infections running roughshod over history, mixing up icons and wars, tangling us up with no hope of a vaccine.

Steven Shaviro argues that a "virus is nothing but DNA or RNA encased in a protective sheath; that is to say, it is a message – encoded in nucleic acid – whose only content is an order to repeat itself" (1995, 40). The distinction, moreover, between host and virus "is only a matter of practical convenience. It is impossible actually to isolate the organism in a state before it has been infiltrated by viruses, or altered by mutations" (41). Operating simultaneously as both carrier (host) and virus (message), postcards disseminate contamination. They erode the divisions between host and parasite, medium and message; they post the impossibility of locating "pure interiority ... even before language" (40). Their role as "souvenir" opens out onto a scene of infinite regression where the future haunts our vision of the past. In Derrida's language, postcards are iterations – products of citation that demonstrate the absence of an original context for their production. Subject to reproduction, retransmission, and reiteration, these messages post the eternal return of history: "Everything becomes a post card once more, legible for the other, even if he understands nothing about it" (Derrida 1987, 23). As an event, 9/11 has become its own postcard through historical reduction and large-scale dissemination.

Burning towers are superimposed with memorials for the dead (fig. 20). The American flag floats just beneath the surface of the water, just beneath the date of attack. Smoke has overtaken the city. "The Un-

Fig. 20 Postcard. Attack on Manhattan: The Unthinkable.
http://www.thismodernworld.org/gra/WTCcard2.jpg.

thinkable," reads the postcard's subtitle; this is the occurrence of the impossible. America has always been immune, hasn't it? Note the forgetting required for such a statement: even before Pearl Harbor or the burning of the White House, what of the indigenous populations, the indigenous, as they say, "Americans"? How are we to read this message? Is it one of commemoration, of meditation and sadness? Or is it propaganda – a way to galvanize the people for war? The visual reduction of an event does not result in its clarification.

We are given two frames in this postcard (fig. 21) – so many of these cards have multiple frames. The eagle and the American flag flank the card; the eagle watches, while the flag waits for a wind to give it direction. The eagle is patient; it has seen a lot since assuming its iconic

Fig. 21 Postcard. Attack on Manhattan.
http://www.thismodernworld.org/gra/WTCcard6.jpg.

role in 1782. Chosen for its long life, inspiring strength, and regal bear-
ing, the bald eagle became a symbol of freedom during the Revolu-
tion. "It screams for freedom," the patriots are reputed to have said,
when the eagles cried above a battle raging below them. Yet that image
of the eagle is only the most popular one, the most official one. Ben-
jamin Franklin didn't like it one bit. This eagle is patient, he wrote his
daughter in 1784, for an altogether different reason:

> For my own part I wish the Bald Eagle had not been chosen the
> Representative of our Country. He is a Bird of bad moral Charac-
> ter. He does not get his Living honestly. You may have seen him
> perched on some dead Tree near the River, where, too lazy to fish

for himself, he watches the Labour of the Fishing Hawk; and when
that diligent Bird has at length taken a Fish, and is bearing it to his
Nest for the Support of his Mate and young Ones, the Bald Eagle
pursues him and takes it from him. With all this Injustice, he is never
in good Case but like those among Men who live by Sharping &
Robbing he is generally poor and often very lousy. Besides he is a
rank Coward: The little King Bird not bigger than a Sparrow at-
tacks him boldly and drives him out of the District. He is therefore
by no means a proper Emblem for the brave and honest Cincinnati
of America who have driven all the King birds from our Country.
(Franklin 1784)

Look again at this postcard: two frames, two narratives of the eagle,
two ways to read this message. The question "Who or what speaks on
a postcard?" is, ultimately, undecidable.

The Traffic in Experience

The earliest picture postcard, printed by A. Schwartz and postmarked
16 July 1870, depicts "a little figure of a soldier and a cannon" (Staff
1966, 50). In the same year, both France and Prussia made use of pic-
torial cards during the Franco-Prussian War; the French emphasized
patriotic themes, whereas Prussian troops were issued "humorous and
suggestive" field postcards (50). And when the Prussians entered Paris
later that year, private printers produced lightweight cards for early
airmail – messages sent up to the sky via air balloon. What destina-
tions? What routing protocols for these postcards released like pigeons
into the sky carrying ciphers for distant allies? Since postcards first ap-
peared on the scene of history, war has found a use for them.

Multiple purposes for these little postcards abound, of course, and
are entangled with both war and peace: advertising, propaganda, and

the commemoration of "experience" are among the many uses for cards in circulation. For Britain in particular, capturing colonialism on a postcard was part and parcel of subject formation during the Age of Empire (Wollaeger 2006; Wong 2002). Making all of this possible was the post: centres and stations of sorting, relay, redirection, returns to sender. And the intensity in traffic is overwhelming – when the first postcard appeared in Austria, in 1869, nearly 3 million were sold in the first three months (Staff 1966, 47). Like a virus, the craze popped up all over the world; frenzied circulation and collection ensued. In 1899 the word "cartophilia" was coined to describe the obsessive collecting practices that spanned classes and countries. Women in particular were known to have been infected by the philatelic bug (Staff 1966, 81; Wollaeger 2006, 80).

London journalist James Douglas imagines archeologists from the thirtieth century pouring through an immense archive of picture postcards, looking to decode the Edwardian era: "It is impossible to gaze upon a ruin without finding a Picture Postcard of it at your elbow. Every pimple on the earth's skin has been photographed, and wherever the human eye roves or roams it detects the self-conscious air of the reproduced" (cited in Staff 1966, 79). The camera has been roaming, taking the world apart bit by bit through its magnifying lens. Already, in the early twentieth century, photography and the post ensured that nothing new remained to be seen: "The aspect of novelty has been filched from the visible world. The earth is eye-worn. It is impossible to find anything which has not been frayed to a frazzle by photographers" (79). It sets one up for a lifetime of déjà vu.

Depending on the exposure time, postcards of an event might appear, variously, to be stupid, funny, strange, uncanny, inappropriate, or obscene. They are a medium of the popular, and as Michael Taussig reminds us, "The popular is the spinal column of the nation" (1997, 115). Along with snow globes, calendars, t-shirts, and coffee mugs, postcards

commemorating the events of 11 September 2001 appeared on tourist tables within days of the attack. Despite the overwhelming assortment of such cards, their similarities, suggesting variations on a theme, are unmistakable. Typical offerings, available everywhere from Ground Zero vendors to uptown souvenir shops, presented a collage of images combining photographs of the disaster with such iconic symbols of America as the bald eagle and the flag. Captions referring variously to New York or America situate the event as both local and national, and that now infamous date, 11 September 2001, is almost always included. Over the past several years, these postcards have appeared to me, variously, as crass, bizarre, poignant, and mysterious. They seem to mean more than they say, but this meaning is always evasive.

Susan Stewart (1993) suggests that this, in part, is the source of a souvenir's power. The postcard, for instance, represents a slice of life, but its representation is only ever partial. It serves as "a sample of the now-distanced experience," and its partiality requires narrative supplementation for the cycle of meaning to complete itself (136). The souvenir becomes a souvenir only once it is possessed and given a narrative existence by its individual owner (136). Souvenirs gratify the nostalgic hunt for authenticity; they verify an experience. For Stewart, souvenirs orient us toward the past – only the past: "The souvenir speaks to a context of origin through a language of longing, for it is not an object arising out of need or use value; it is an object arising out of the necessarily insatiable demands of nostalgia. The souvenir generates a narrative which reaches only 'behind,' spiraling in a continually inward movement rather than outward toward the future" (135). But these commemorative 9/11 postcards are not only about the past; they also bear the future within them. "You Never Walk Alone" (fig. 14) is a message of hope; Uncle Sam rolling up his sleeves (fig. 18) bespeaks preparation for a coming assault; the Pledge of Allegiance (fig. 23, discussed below) is a promise to remember oneself in

the future. Through their allusion to death, pictured only in the streams
of smoke spiralling through each frame, these postcards forecast a fu-
ture of war and patriotic urgency. Just as the victims' bodies were re-
duced to ash upon incineration, they are displaced here into smoke
waves pushing us out of the frame. During the First World War, me-
morial postcards went into production as soon as men began to die.
These cards "[look] back with grief and forward with new purpose …
New resolve had to balance grief … death could not get in the way of
duty" (Frantzen 2003, 193). The future matters here; it is stitched into
the past with a thread of smoke and blood.

Infections

During the First World War, Britain printed Field Service postcards for
soldiers to use in lieu of longer letters (fig. 22). Historically, these post-
cards represent the first widespread use of the "Form" – "that docu-
ment which uniquely characterizes the modern world" (Fussell 1975,
185). Looking back, we could say it was the first example of the bu-
reaucratization of terror. Rules were strict for these cards. For them to
get beyond the censors, soldiers were required to cross out whatever
did not apply to them and then sign their names. Whatever had not
been crossed out was supposed to indicate the truth of their situation
to those back home.

 Paul Fussell (1975) notes the infinite space between these options.
What is the meaning of "I am quite well" when one sits in a trench on
the front lines? How come "I am being sent down to base" is the only
direction in which the soldier can travel? If one is in hospital, yet
"going on well," what meaning is to be extracted (184–7)? The state
exerted tight control over these messages, deindividuating the senders
by reducing all war experience to a series of strangely optimistic
choices reproduced on millions of replicated forms. The Field Service

postcard was nicknamed the "whizz bang" or "quick firer" by the soldiers who used it (183). "Whizz bang" was also a term referring to "a light shell fired from one of the smaller field-artillery guns" (cited in Booth 1996, 15). In a flash, the innocuous card becomes a weapon attacking the home front. Did those at home know what hit them when these messages arrived?

Yet those messages that arrived back home were not necessarily those the censors thought they understood. Soldier Wilfred Owen had an arrangement with his mother: a double line crossing out "I am being

NOTHING is to be written on this side except the date and signature of the sender. Sentences not required may be erased. If anything else is added the post card will be destroyed.

I am quite well.

I have been admitted into hospital
{sick} and am going on well.
{wounded} and hope to be discharged soon.

I am being sent down to the base.

I have received your
{letter dated _____
{telegram " _____
{parcel " _____

Letters follows at first opportunity.

I have received no letter from you
 {lately
 {for a long time.

Signature}
 only. }
Date _____

Fig. 22 British Field Service Postcard, First World War.
Photo courtesy of the Imperial War Museum, London.

sent down to the base" indicated the opposite. By doubling up the affirmation, Owen communicated his reposting to the front (Fussell 1975, 186). Recto/verso. Brilliantly, the bureaucratic form is used to generate a cipher: through the public face of the postcard, his mother receives a private message. Soldiers like Owen accomplished the infection of the state's message, and as Derrida writes: "What I like about post cards is that even if in an envelope, they are made to circulate like an open but illegible letter" (1987, 12). Highlighting the disconnect between communication and comprehension – the proper possession of fixed meaning – the ostensible accessibility of postcard messages signals a confusion of the public and private for any populace subject to state mechanisms of surveillance.

Post-9/11, subjects residing on American soil were subjected to radical processes of reduction; they became postcards passing through the registration and accounting programs of diverse government outposts, operating under the umbrella structure invented especially for the cause: the Department of Homeland Security. "Imagine a city," Derrida writes, "a State in which identity cards were post cards. No more possible resistance" (1987, 37). Whether it is carried through the viral logic of the postal service to a third party, and held onto as a souvenir, or posted online in a disembodied gallery, the question of the postcard's arrival begs the question of addressee, of audience and of reception (how are the messages read?), of tracking procedures (surveillance), of returned mail (deportation), and of poisoned packages (anthrax).

Although increased measures of surveillance are especially obvious in liminal spaces – border crossings, airports, entrances into government buildings – the time since September 11 has seen a general increase in the observation of so-called private citizens. Putting a different spin on the concept of imagining 9/11, the *spectacularity* of this event refers not only to the reams of images that resulted from the clicking of thousands of cameras but also to the consequential

governmental desires to observe and to categorize its citizens as either potential risks or benign objects.

For it wasn't simply a solidification of geographic lines dividing the United States from its external enemies following 9/11 that required numerous forms of surveillance, detainment, and deportation but also a declaration of war on itself, on citizens and noncitizens, thus giving the lie to Bush's famous edict: *You are either with us or against us.* After all, the highjackers had been living in the United States, had taken flying lessons there, had lived in suburban neighbourhoods, and had fooled everyone around them. They were a kind of virus, eating away at the system from inside. Their previously undetected presence inside the body of the nation suggested the presence of other groups, named "sleeper cells," requiring identification and neutralization. The contamination of the internal body must be detected and eliminated but in such a way as to make its *citizens* grateful.[7] Here the postcard logic resonates: the card's borders are overrun by contamination, and they contain the suspicious elements that require elimination. The message these postcard-terrorists bring is one of dissension within the nation; operating as interior exteriorities the virus-terrorists explode structures on multiple levels. Literally, of course, the collapses of the towers signify one such destruction; but a terrorist presence within the nation's borders disrupts the US administration's rhetoric of a country unified against terrorism.

The Patriot Act, passed in the fall of 2001, constitutes the most obvious example of this breakdown. Its two basic requirements for identifying and eliminating potential threats are: (1) that the private be rendered public; and (2) that the public realm of government be empowered to operate in private. These aims only superficially indicate the complex networking of relays and communications the administration was determined to set up. As Elaine Scarry explains: "The objective of the Patriot Act becomes even clearer if it is understood

concretely as making the population *visible* and the Justice Department *invisible*. The Act inverts the constitutional requirement that people's lives be private and the work of government officials be public; it instead crafts a set of conditions that make our inner lives transparent and the workings of the government opaque" (2004, 16, original emphasis).

Violating alternately the First, Fourth, Fifth, Sixth, Eighth, and Fourteenth Amendments, the Act defines the patriotic citizen as, essentially, a compliant, docile, and public body (Scarry 2004, 16). Nothing pertaining to the individual is secure from potential seizure: federal officers may "enter and search a person's house ... survey private medical records, business records, library records, and educational records, and ... monitor telephone, email, and Internet use" (17). However, the Act not only requires submission but also demands citizen participation. Bankers are asked to report certain transactions to the authorities, and librarians must be willing to turn over records of books checked out by particular patrons. Refusal to comply may result in criminal or civil charges (19). Infiltration was the strategy, and the so-called private citizen would be unaware of the infection until it was already too late. The public was given the "choice only between several police forces" (Derrida 1987, 185). In New York, following the attacks, signs were posted all over the city encouraging citizens to engage in surveillance. Suspicious packages, strange behaviour, unexplained movements – these were all to be reported to a higher authority.

In the wake of all this specularization, the postcard message "You Never Walk Alone" acquires another, more alarming implication. It is a message of infiltration, and one never knows whence it arrives or where it will lead. Citizens, residents, and aliens alike are called to support the war not only by exposing themselves to the technological invasion of their homes and bodies but also by participating in the exposure of others. "You Never Walk Alone" is the state's promise to

its people; it is a gift of constant, caring watchfulness, a paternalistic formulation par excellence. But gifts and promises are never free of charge. In the traditional sense, they designate a binding contract demanding compliance, docility, and participation on the part of its recipients, named here as an ambiguous "You."

The Gift of Togetherness

"Gift," as Marcel Mauss explains, bears two meanings: "present and poison" (Mauss 1997, 28). He traces the connection between poison and present through the customary gift of drink in ancient German and Scandinavian societies. Writing that "the gift of drink … [is] the present par excellence," Mauss notes that the drink as present is always potentially a gift of poison: it "permanently links those who partake and is always liable to turn against one of them if he would fail to honour the law" (30). In the logic of gift giving, "the object received as a gift, the received object in general, engages, links magically, religiously, morally, juridically, the giver and the receiver. Coming from one person, made or appropriated by him, being from him, it gives him power over the other who accepts it" (29–30). Gift giving is an operation that forever binds the receiver to the giver, for to give is also to take something and to receive is to become obligated. The gift establishes a circle of exchange that remains long after the passing of the original gift-event.[8]

Émile Benveniste describes the profoundly ambivalent meaning of gift giving through etymological analysis, writing that "in most Indo-European languages, 'to give' is expressed by a verb from the root *do- … There seemed to be no possible doubt about the constancy of this signification until it was established that the Hittite verb da- meant not 'give' but 'take'" (1997, 34). Wryly commenting that this discovery "caused considerable confusion, which still lasts," Benveniste con-

cludes that "*do- properly means neither 'take' nor 'give' but either one or the other, depending on the construction" (34).

The gift, therefore, operates as a binding contract between subjects; it engenders a promissory structure of obligation and indebtedness. For the contractual cycle to function, however, each participant must pledge to honour the promises made. The promissory subject, the subject of belonging – one might even say the citizen or the community member – is the subject that promises itself as stable, unchanging, and reliable. To accept a gift is to agree to remember one's condition of indebtedness. In order to remember one's debt, the subject in question must first be able to remember him or herself, to recognize him or herself in the future as identical to the self in the past. As Nietzsche argues in his *On the Genealogy of Morality* (1996), memory, a counter-device to forgetfulness, is fundamental to this operation. A promise is always a promise to remember, and the capacity for remembrance lies in the duration of the subject: "That is precisely what constitutes the long history of the origins of *responsibility*. That particular task of breeding an animal which has the right to make a promise includes … as precondition and preparation, the more immediate task of first *making* man to a certain degree undeviating [*notwendig*], uniform, a peer amongst peers, orderly and consequently predictable" (39, original emphasis). The promissory subject, the citizen who promises to *remember* him or herself in the future, when the promise comes due, is necessary to the smooth operations of state surveillance.

Theological in its essence, Orwellian in its practice, the first postcard's message of hope, "You Never Walk Alone," interrupts its own act of consolation, explicitly signalling the operations of surveillance necessary to make good on such a promise.[9] It is the postcard bearing the Pledge of Allegiance (fig. 23), however, that makes explicit the circle of exchange to which Mauss refers in his discussion of gift

Fig. 23 Postcard. Pledge of Allegiance.
http://www.thismodernworld.org/gra/WTCcard4.jpg.

giving. As a promise to the state in the context of post-9/11 America,
pledging allegiance to the flag constitutes no less than a signature on
a contract of perpetual observation. On a postcard, however, the
pledge's transmission acquires a viral quality. Split off from its tradi-
tional contexts of recitation – schools, official ceremonies, sports games,
and so on – its unanchored dissemination highlights a disconnect be-
tween the message (liberty and justice for all) and its arrival (liberty
and justice for some).

A certain ambiguity regarding language – specifically, the language
of community – is essential to the operation of these postcards. Sent
out to a "You" always watched over and to an "I" who pledges, these
postal messages address themselves to an undifferentiated American.

Accompanying the linguistic ambiguity, geographic lines are linguistically and optically drawn, enacting a series of divisions between inside and outside, member and nonmember. Together, the caption and the photograph imagine an indivisible, homogeneous community against the backdrop of 9/11 rubble. However, the "I" and the "You" demand careful interrogation, gesturing as they do toward a myth of national community that obscures the everyday violations of individual rights enacted against the apparently self-evident and protected group: *the American people*. The question is one of identification, and geography, like biology, is not destiny.

Postscript: Destinations/Arrivals

Less than one month after the attacks on the World Trade Center, letters containing anthrax arrived in multiple locations over the course of several weeks. Five people died, at least eighteen others contracted the bacteria, and thousands of others have tested positive for exposure (Staff and Agencies 2001). Although the FBI was able to trace the anthrax-laced letters back through various human carriers and postal depots, conclusive proof of their temporal and geographic origins has never been broadcast.[10] The earliest reported date associated with the anthrax scare is 5 October 2001 – the date of the first death.[11]

Operating literally as a viral carrier, the US postal system's promise to deliver through snow, sleet, wind, and rain acquired a sinister edge. The message that arrived, along with the deadly spores, is one of insecurity and danger: one can never be certain what might arrive through the mail or when it will have been posted. Calling both the past and the future into question, the arrival of contaminated mail promises only that we do not know what is on the way. Two weeks after the first death, the *Guardian* reported that the US government intended to mail postcards "describing how to identify suspicious mail ... to every household in America" (Gillan 2001). The future, as Derrida writes, arrives

as a moment of absolute danger (1997, 15). The post is laced with the past, and we are always late in deciphering its contents.

In 2004 the Staten Island Memorial for September 11 was completed. It is called *Postcards* (fig. 24). Consisting of two fifty-foot-high sculptures by artist Masayuki Sono, and stamped with granite profiles of each of the victims, the memorial is intended to represent giant postcards bearing messages to the dead. The profiles are hundreds of commemorative stamps, taxing us for the losses time and again. The names of the dead are posted, perpetually, and those left behind pay an infinite duty on these messages, as infinite as the sky, toward which these postcards look to be always about ready to take off for flight.

Fig. 24 Masayuki Sono, *Postcards*, 2004.
Photo by Karen Engle.

Four The Face of a Terrorist

If I see someone [who] comes in that's got a diaper on his head and a fan belt wrapped around the diaper on his head, that guy needs to be pulled over. US Representative John Cooksey[1]

From the beginning of all this, or rather, from the moment on 11 September 2001 when we in the West began to understand the realities of our geographical insecurities, there has been a problem with the materialization of invisibility and with the related processes of enemy identification. As Mary Gordon wrote in the *New York Times* within a week of the attacks: "To have an enemy with no name and therefore no face, or even worse, a name and face that can only be guessed at, is the stuff of nightmare" (2001). Composed during the shock of those first days, Gordon's words evoke the uncertainty and the distress experienced by thousands of North Americans who never imagined such an attack possible, never conceived such horrors could occur over "here."[2] It is with Gordon's reference to "nightmares" and "faces" that I would like to begin.

In the opening pages of her book on September 11, *Terror Dream* (2007), Susan Faludi embarks on a cultural analysis by going inside the nightmares of others. Scavenging through the night terrors of post-9/11 New Yorkers, Faludi finds that the unbound theatre of the mind provides direction to the bizarre progression of the past seven years: "In all the disparate nightmares of men and women after 9/11, what accompanied the sundering of our faith in our own indomitability was not just rage but shock at the revelation, and, with the shock, fear, ig-

nominy, and shame. Those disturbing emotions inundated our cultural dream life, belying the bluster of the 'United We Stand' logos. They underlay the anxious commentaries about our 'impotence' and 'weakness' and the talk show and blogosphere rants about our susceptibilities as a 'feminized society' unmanned by feminist dictates" (12).

Faludi tells us that, after the towers fell, numerous websites popped up to record the dreams people had both before and after the event. Overwhelmingly, she says, the message transmitted through these dreams is one of shame, and this shame is powerful: it travels beyond the unconscious to circulate in and through the everyday. It's as though we can't quite tell the difference between the dream state and being awake. It's as though we're walking, eyes wide shut, through a much larger national dream that has led only to more violence, more terror.[3]

The seepage Faludi traces between night terrors and daytime performances allows her to undertake a disturbing analysis of sexism as a perverse response to the fear of terrorism. This sexism is not anything new, she tells us, but part of a much larger national myth about security and danger: "Taken individually, the various impulses that surfaced after 9/11 – the denigration of capable women, the magnification of manly men, the heightened call for domesticity, the search for and sanctification of helpless girls – might seem random … But taken together, they form a coherent and inexorable whole, the cumulative events of a national fantasy in which we are deeply invested, our elaborately constructed myth of invincibility" (2007, 14). In other words, America's coping mechanisms did not simply appear, *ex nihilo*, but were already plugged into what Faludi names America's "monomyth" of security (15).

As night turns into day in Faludi's world, security is articulated in terms of first naming the threat and then expunging it. This involves making sure everyone is wearing the right hat: men are men, women

are women, and the evildoers are not American. But in the immediate
aftermath of the attacks, we did not have much information about the
enemy; this led to the terror of "facelessness" to which Gordon refers.
(The related problem – that some Americans might also be terrorists
– was not even recognized as a possibility.) At the same time, Gordon's
phrasing remains ambiguous with respect to whose nightmare this
nameless and faceless stuff shows up in. At one level, she means New
Yorkers and those others from the Distric of Columbia who suffered
through September 11. She also means anyone who now feels vulner-
able, whereas before such fear was an unknown entity. But the am-
biguous identity of her fearing subjects leads me to think that this dread
of a being masquerading without the proper identification, a being with-
out a recognizable face or name, goes beyond the level of the individ-
ual; this fear of the unknown terrorist is circulating at the state level.

Giorgio Agamben describes the threat posed to the state by the non-
faced being as a kind of absolute threat: "For the State ... what is im-
portant is never the singularity as such, but only its inclusion in some
identity, whatever identity (but the possibility of the *whatever* itself
being taken up without an identity is a threat the State cannot come
to terms with)" (1993, 86, original emphasis). Using the example of
the 1989 Tianenmen Square Massacre, Agamben suggests that the ab-
sence of any concrete set of demands on the part of the demonstrators,
as opposed to a clearly articulated political position, explains the sever-
ity of the state's violent response: "What was most striking about the
demonstrations of the Chinese May was the relative absence of deter-
minate contents in their demands ... In the final instance the State can
recognize any claim for identity – even that of a State identity within
the State ... What the State cannot tolerate in any way, however, is that
singularities form a community without affirming an identity, that hu-
mans co-belong without any *representable* condition of belonging"
(85–6, emphasis added).

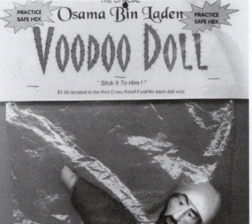
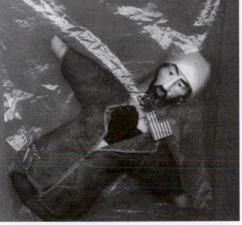

Fig. 25 Osama Voodoo Doll.
http://www.thismodernworld.com.media/
gra/binladen.jpb.

Fig. 26 FBI Most Wanted Terrorists.
http://www.whitehouse.gov/news/
releases/2001/10/20011010-3.html.

Identification, in other words, can take place only via representa-
tion, and the state's capacity to represent its Others is fundamental to
state operations.

All of this reasoning depends, of course, on a clear idea of what the
state actually *is*. I would like to propose, by way of entry into this ques-
tion, two images that in combination illustrate my sense of how the
state of the United States has been operating since 11 September 2001
(figs 25 and 26).

Sympathetically, Contagiously ...

On the left (fig. 25) is an Internet photograph of a toy that may or may not have been for sale somewhere online or in a physical space. On the right (fig. 26) is an official White House photograph picturing members of the Bush administration unveiling a list of the FBI's most wanted terrorists. Uncertain object and official ceremony – this combination matters. At the most basic level, these two images denote play, violence, magic, and organized ritual. Together, they give us a way into Michael Taussig's formulation of the state: "Stately being ... achieves its most profound dimensions where the invisible crowd of the dead mingles with the adults' version of the child's imagination of that crowd. This is where the naïve finds its home, where the stately imagination of the imagination of the child abuts that of the death-space of colonial and anti-colonial violence as represented in some doll-like time out of polymorphously perverse toy-soldier time" (1997, 115–16). The dead, pressing into the living, demand a hearing. Somehow (note the uncertainties of this alchemical process), this hearing emerges through an adult return to childhood. The men in suits impose their sense of how a child understands the dead to make "us" understand the dead and how "we" ought to respond. It's all Disney and superheroes (see Faludi 2007) and nicely packaged (these images are still commodities) Manichean allergories. And then there's the violence. Taussig describes this complex entity – the state – as magical. Like a voodoo doll of Osama bin Laden. In so doing, he traces a path back to Freud.

Freud draws on classic works by E.B. Tylor and James Frazer to examine animism and magic in relation to psychoanalysis, systems that have been linked from their discursive beginnings with notions of primitivism.[4] Focusing specifically on animism's relation to magic, Freud notes that "magic has to serve the most varied purposes – it must subject natural phenomena to the will of man, it must protect the in-

dividual from his enemies and from dangers and it must give him power to injure his enemies" (1991c, 98). Plugging into neural pathways, the primitive requires only his or her will and imagination to deploy this magic against an enemy; spatial proximity to the figure in question is redundant. Naming this magical thinking a type of "omnipotence of thought," Freud describes both forms of this practice – imitative and contagious magic – as manifestations of the animistic soul (107).

Imitative, or sympathetic, magic works by constructing a copy of the adversary and then damaging it in lieu of the actual enemy body: "Whatever is then done to the effigy, the same thing happens to the detested original" (Freud 1991c, 99). The "official" Osama voodoo doll, colourfully packaged and even ethical – it promises to send a portion of all proceeds to the Red Cross – fits the effigy bill. The message, "Practice Safe Hex," marks an undeniable fetishism; an erotic charge results from pricking the evil doll. *Stick it to him* anywhere you like. Using the pin of Old Glory, the owner of the Osama doll relies on penetration for maximum mutilation.[5] Libidinally driven now, the anti-Osama poker enters a more sinister realm – we'll see much more of this visual obsession with violating and controlling bin Laden's body in the pages to come. Reenacting imitative magic to perfection, the imagination goes primitive with these dolls and aptly illustrates Theodor Adorno and Max Horkheimer's (1972) contention that the West does not annul magic but relies on its repression and return. The Osama voodoo doll is an imitative version of wish fulfilment, or as Taussig might phrase it, the rehearsal of death through mimesis (1997, 78). This means that the state is much more than a group of men in suits.

According to the Freudian narrative, children and neurotics are the primary practitioners of magic. Writing that "children are in an analogous psychic situation," Freud argues that "it is in obsessional neuroses that the survival of the omnipotence of thoughts is most clearly

visible and that the consequences of this primitive mode of thinking comes closest to consciousness" (1991c, 104, 108). Wrapped up in brightly advertised packages, these dolls are just that: dolls. Objects for child's play.[6] Hence Taussig's insistence that the adult-child plays a crucial role in state formation, that the naive-cum-kitsch imagination is necessary to the operations of political power.

Freud's second type of magical thinking – contagious magic – requires an actual piece of the enemy: hair, nails, effluent, and so forth. The primitive inflicts damage on the object, and "it is then exactly as though one has got possession of the man himself; and he himself experiences whatever it is that has been done to the objects" (1991c, 102). In our case, a set of photographs and names stands in for the missing objects. As Freud writes: "In the view of primitive man, one of the most important parts of a person is his name. So that if one knows the name of a man or of a spirit, one has obtained a certain amount of power over the owner of the name" (102). The giant board of mug shots in figure 26 is like magic: it defines the theatre of operations, it provides goals, it seems to explain the violence that came and the violence to come. Set next to the Osama voodoo doll, we have little bits of the enemy paired with childish (or primitive) fantasies of revenge: this is the state of the state.

Facial Developments

A face, of course, is never simply a face. That anatomical structure located at the crown of the body with multiple orifices and capacities for sensory perception has come to operate as a limit, or border zone, dividing outside from inside. The face carries the weight of presence; it is a marker of identity, an event of Being perceived as more or less readable by observing eyes.[7] Taussig describes conventional readings of the face as "the figure of *appearance*, the appearance of appearance,

the figure of figuration, the ur-appearance, if you will, of secrecy itself
as the primordial act of presencing. For the face itself is a contingency,
at the magical crossroads of mask and window to the soul, one of the
better-kept public secrets essential to everyday life" (1999, 3, original
emphasis). Both formulations, mask and window, imagine a subject
hiding somewhere, a subject that can be penetrated and known. As
mask, the fact of deception indicates a concealed interior truth. As win-
dow, the surface of the face is presumed to indicate the truth of a being's
internal essence.

Michel Foucault has traced for us the modern episteme of scientific
inquiry and its dependence on vision and observation to define the
human subject and explain the myriad similarities and differences
within the species. In *The Order of Things* (1994) he identifies the
emergence of comparative anatomy as indicative of a shift away from
natural history's objective observational focus on the surface of things
in favour of the production of an interior bodily space (269). This in-
teriority became the object of biological investigation, and the scien-
tific attempt to define differences in race, class, sex, and so on became
invested in the notion that surface differences – for instance, in skin
colour – were rooted in essential ontological and organic differences
between various members of the species (Wiegman 1995, 30). Surface
and depth, in other words, were produced as significant categories,
each of which could be shown to reflect the truth of the other. A seam-
less dream of identity.

Facialization refers to this historical practice of linking surface with
depth. More specifically, it refers to the process of making unseen in-
terior truths visible by projecting them onto the surface of the body
using the medium of photography. Facialization operates as a method
of identification whereby the face of a subject, which is believed to re-
veal an interior truth, or deep essence, comes to stand for the narra-
tives a nation tells about itself. In 1931 Walter Benjamin wrote that

"sudden shifts in power such as are now overdue in our society can make the ability to read facial types a matter of vital importance. Whether one is of the left or right, one will have to get used to being looked at in terms of one's provenance. And one will have to look at others in the same way" (2005c, 520). Could Benjamin have dreamt the extent to which his observations would prove true?

With the invention of photography in the mid-nineteenth century, this equation between surface and depth acquired new perspective. Deployed by artists, race scientists, and criminologists, photography has been used to "inscribe the body's surface with an imagined depth – an ephemeral essence, a gendered and racialized character" (Smith 1999, 5). Massive photographic archives were assembled for the purposes of identifying criminal types since, as the theory went, "it was only on the basis of mutual comparison, on the basis of the tentative construction of a larger, 'universal' archive, that zones of deviance and respectability could be clearly demarcated" (14). As Roland Barthes has written, "photography ... began, historically, as an art of the Person: of identity, of civil status, of what we might call, in all senses of the term, the body's *formality*" (1981, 79, original emphasis). Although bodily measurements of all kinds were recorded – foot size, ear shape, fingerprint – the face and the head were of special importance.[8]

The history of the "mug" shot provides one such example of this imbrication of face with lens. First brought to the United States from France in the late nineteenth century, the mug shot radically transformed the American penal system and its practices of social surveillance (Smith 1999, 70). Keeping in step with the supposed "democratizing" force of photography via its potential for reproduction, the mug shot was not limited to police stations or government files; it was actively disseminated to the broader public. The Rogues Gallery of criminal types was one such site established for public viewing. Dependent on observers gazing hard at the images in order to (mis)recognize the displayed faces as indicative of an internal criminal essence, the practice operates fun-

damentally as a disciplinary technique. What these archives produced, however, was an equation of criminality with non-Caucasoid features. Criminals were identified as primitive beings, thereby "conflating the terms of race and criminal behavior into the same position along an imagined biological time line" (85).

And what of the aesthetics of the mug shot? Or its affective significance? Although photographic technologies of production and dissemination have changed radically since the early days of Rogues Galleries, mug shots have not lost a certain feeling of crudity, of dirt and danger. The lighting, direct and cheap, is always harsh, the close-up is unflattering (no photoshop here, unless it's a blackening of O.J. Simpson's face on the cover of *Time* magazine), and the subject is posed to emphasize angles and edges. The bodies are cut off from the faces, as though to emphasize a lack of humanity, a castration that runs much deeper than a surface image could ever capture.[9] These are conventions just as surely as are the *contrapposto* of classical sculpture or Caravaggio's use of chiaroscuro. Armed with this history, our FBI list of most wanted terrorists now resembles a contemporary Rogues Gallery. Unveiled on 10 October 2001, the photographs, names, and physical descriptions of twenty-two men were proudly displayed as the administration's "new line of attack against terrorism" (White House 2001c). A new line but an old story.

Faces of Terror

Hailing the list as a modest but crucial initiative in his war against terror, Bush deployed the language of darkness and light – a discourse inflected with Judeo-Christian visualizations of good and evil – as well as the language of photography to illuminate its significance: "Terrorists try to operate in the shadows. They try to hide. But we're going to shine the light of justice on them. We list their names, we publicize their pictures, we rob them of their secrecy. Terrorism has a face, and

today we expose it for the world to see" (White House 2001c).[10] *Terrorism has a face*. No longer simply an activity or a concept, terrorism is a material surface discernible in the photographic representations of twenty-two men. The board of mug shots looks like a grown-up version of Pin the Tail on the Donkey.

Even in 2001 these wanted men were no great revelation either to the US security officers or to the politicians.[11] The sole American on the list, for example, is wanted in connection with the 1993 World Trade Center bombing. Bin Laden, the first on the inventory, has been charged with a long list of crimes predating September 11 (Her Majesty's Government 2001). The now infamous intelligence report delivered to President Bush on 6 August 2001 entitled "Bin Laden Determined to Strike in U.S." indicates his pre-9/11 notoriety. And if terrorists need to hide in the shadows, the likelihood that one of these men will be spotted at a local supermarket by a vigilant citizen is extremely low. For what purpose, then, was this list prepared?

Twenty-one of the twenty-two men on the FBI list hail from various countries in Africa and the Middle East. When complexion is noted on these rap sheets, it is alternately *olive*, *dark*, or *black*. Caucasian terrorists either do not exist or do not pose a serious threat to US security, an occlusion that actively supports the administration's rhetoric of "Us" versus "Them," while veiling the attacks on civil liberties daily launched against citizens and noncitizens alike.[12] In this sense, the FBI list operates as a template for "proper" terrorist identification: nonwhite, non-English-speaking, usually non-American, and always male. This makes everything clear, like the difference between inside and outside, like lines in the sand.

But what happens to those lines if one of these men turns out to be American? Operating under the aliases Abdul Rahman Said Yasin, Abdul Rahman Yasin, Aboud Yasin, Abdul Rahman S. Taha, and Abdul Rahman S. Taher, the remaining man on the FBI list is an American

citizen. Born in Bloomington, Indiana, this man is a son of the Midwest, of steel and manufacturing and mining – a son of the crossroads of America. And he is wanted in connection with the 1993 bombing of the World Trade Center. This man changes the landscape of the search; he threatens to dissolve the difference between inside and outside. But the science of detection tells us that there must be a way to know, to predict these things. After all, Bush had received notification of an attack over a month before its occurrence; it's just that nothing was done to prepare. The logic follows: if the intelligence is good, and we are vigilant, then all of this is surely preventable. The key is being able to spot the danger – there must be a way to see it. There must be a way to detect the difference between an American and an un-American American.

The FBI mug shots tell us that these questions of difference are a matter of surface and depth. Just look at him, pinned up there on the board (fig. 27).

Fig. 27 American Terrorist. Detail of FBI Most Wanted Terrorists.
http://www.whitehouse.gov/news/releases/2001/10/20011010-3.html.

ABDUL RAHMAN YASIN

Aliases: Abdul Rahman Said Yasin, Aboud Yasin, Abdul Rahman S.
 Taha, Abdul Rahman S. Taher

DESCRIPTION

Date of Birth Used: April 10, 1960	Hair: Black
Place of Birth: Bloomington, Indiana	Eyes: Brown
Height: 5'10"	Sex: Male
Weight: 180 pounds	Complexion: Olive
Build: Unknown	Citizenship: American

Languages: Unknown

Scars and Marks: Yasin possibly has a chemical burn scar on his
 right thigh.

Remarks: Yasin is an epileptic.

He may be from Bloomington, but his skin is olive, his hair black,
and none of his names is rooted in an Indo-European language. The
surface, in Western cosmology, must match the essence, and all of these
nailed-up bits of the man – names and faces – give us the magical for-
mula for an alien American. In essence, he is a kind of changeling –
someone who could be anywhere at anytime, nominally unknowable
and frighteningly untraceable. But not really an American.

 The hardest case of all may be the Caucasian terrorist. With Cau-
casian Americans like John Walker Lindh who threaten the conven-
tional imagination of terrorists as brown-skinned men who live "over
there," the solution is to rename and recharacterize the subject in ques-
tion. Thus the American citizen who converts to Islam and supports
the Taliban becomes the "American Taliban," whose connection to
"suburban hip hop and exposure to black literary classics" is cited as
explanation for his otherwise unfathomable behaviour (Driscoll 2004,
69). As supplement, the addition of "Taliban" to "American" both sub-

stitutes for and adds to this identity, radically transforming the unintelligible antipatriot into a would-be terrorist.[13] Lindh's transformation from American Midwesterner into Middle Eastern terrorist is effected by his linkage with the trope of African American male violence. His connection to hip hop, stereotypically regarded as a cultural form dominated by black male fantasies of violence, coupled with the absurdly nonspecific reference to "black literary classics," accomplishes this uncanny metamorphosis of Lindh as Arab terrorist via his identification with African American violence. As this story of his not-so-lily-white character was developed, so too was the surface of things altered.

In photographs published of Lindh following his capture, the generic conventions of racial typing are unmistakable (figs 28–30). Looking alternately psychotic, dirty, and dark-skinned, the transformation of a white American into an unclean Eastern savage is near perfect. Lindh is pictured not simply as deranged and foreign but also as a neutralized threat. The images of Lindh in captivity emphasize his impotence as they establish his Otherness. Here, the significance of Benjamin's observation that images arrive at legibility only at particular historical moments becomes apparent.[14] Lindh's supplemental identities are layered one on top of the other, and their combined historical significance ensures their contemporary intelligibility. His predilection for hip hop and, presumably, texts like Richard Wright's *Native Son* or Ralph Ellison's *Invisible Man* establish his "whiteness" as always already tainted, and his transformation into Middle Eastern terrorist gives the images their current relevance. Depth comes up to meet surface, and for a moment, those lines in the sand come into focus once again.

How similar the Lindh photographs are to those images of the captured Saddam Hussein we saw in 2003. Dishevelled, dirty, and publicly subjected to the authority of medical examiners, Hussein was stripped of his former authority and exposed to humiliating treatment.

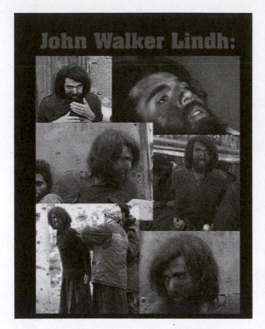

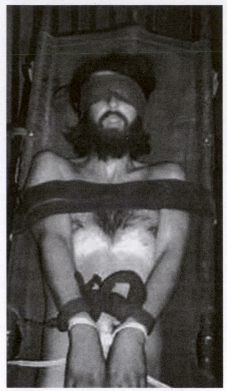

Fig. 28 John Walker Lindh montage. Created
by Rhawn Joseph, PhD. This is the book cover of
John Walker Lindh: American Taliban, published
by University Press in 2002.

Fig. 29 John Walker Lindh on stretcher. In Mark
Kukis, "Life at Camp Jihad," 3 October 2002.
http://dir.salon.com/story/news/feature/2002/
10/03/lindh/index.html

Fig. 30 John Walker Lindh photoshopped.
In Joshua Mortensen, "I studied in Yemen
with John Walker," 4 January 2002.
http://dir.salon.com/story/news/features/2002/
01/04/walker/index.html.

Time and again, we saw doctors combing through his hair, looking for lice or ticks or other signs of contagion. By concentrating the spotlight on these medical procedures, television and print media simply reinforced the pathologization of both Hussein and Lindh as insane, or at the very least, mentally unstable. No surprise that the depiction of mental imbalance proved so successful in each instance, for we in the West have a long history of linking psychological illness with so-called primitive man. Freud's analysis in *Totem and Taboo* (1991c) takes as its starting point the assumption that "a comparison between the psychology of primitive peoples, as it is taught by social anthropology, and the psychology of neurotics, as it has been revealed by psychoanalysis, will be bound to show numerous points of agreement and will throw new light upon familiar facts in both sciences" (3). Reflecting a repetition compulsion similar to the production of Lindh's blackness, these images depend on a recognizable historical precedent in order to signify.

The final image of Lindh (fig. 30) illustrates this repetition compulsion literally. Sitting on a pillow against a stylized pseudo-Islamic background, with his dark, dirty face partially covered by turban and robes, the inside has come out. No longer simply a case of implied resemblance, he now *is* this Other. Here we have metamorphosis through photo-doctoring, a commonplace practice among the computer literate involving selection, cropping, pasting, moveable colour bars, and myriad special effects. Doctoring images: not quite a discipline nor properly the return of the repressed but an operation plugging into latent fantasies and ideas, letting them run amok in the virtual universe. As Taussig writes: "It is the cut of de/facement that releases this [revelatory] surplus, the cut into wholeness as holiness that, in sundering, reveals, as with film montage, not only another view via another frame, but released flows of energy ... If it is the cut that makes the energy in

the system both visible and active, then we should also be aware of cuts in language, strange accidents and contingencies" (1999, 3).

And, I am arguing, we should observe the cuts in manipulated photographs. These cuts occur in different ways. The images of Lindh from a book cover (fig. 28) are cropped and positioned to suggest madness from all sides, whereas the cartoonish Lindh-goes-Arab paints an altogether different picture. The finished image is technically rudimentary. Despite the ability to make modified images appear untouched (to whit, any magazine cover these days), this image retains its crudity. Although the primitivism of the subject mimes the primitive techniques that render it, the obvious fakeness also gives the image a cartoon-like quality. And cartoon laughter is never innocent laughter.

The FBI board of mug shots constitutes merely an official version of this same cartoon. Manufacturers, journalists, and ordinary citizens have also weighed in, providing their own versions of the face of terrorism. And when all of this was a bit fresher in our minds, I decided to try writing about some of the ways that we visualize terrorists, so I went to Google Image and typed in "Osama bin Laden." Hundreds – thousands even – of images depicting sex, body parts, and gender trouble lit up my screen. These were images that many would undoubtedly label pornographic – although I would not, for the simple reason that such ontological determinations have a way of closing thought down. There was Osama practising bestiality with goats, Osama stuck under an obese naked white woman screaming for help, Osama-printed toilet paper, Osama and President Bush getting it on in various positions …

I was amazed (naively so, it seems now) at the permutations and combinations of sexual activity and even more struck that Osama had become such a popular target for anonymous Internet users' eroticized imaginations. As I selected certain images to write about, I began to detect common themes, and a constellation emerged that directed my reading. Repeating the same search several years later, I see that most

of those images remain, and that they are joined by new variations on these themes: Osama's niece naked in a bathtub, a photograph of Barack Obama, a man carrying a sign with the following words: "If Osama was a piece of ass, Clinton would have nailed him."

These images animate the primitivism within the FBI's seemingly respectable catalogue. Alternately violent, always masculinist, they depict the game of Hide and Seek with terrorists as fundamentally a game between men. The very existence of these images, combined with their dwarfing of other forms of nonsexualized representations, reflects a longstanding obsession with producing a connection between the face, identity, and the genitals. Freud's theory of repression, for instance, asserts that once primitive humans learned to stop urinating on the fire every night, the potential for their development into civilized humans was at last born (1962, 37). The face of culture and civilization, in other words, was radically changed by denying genital desire. Georges Bataille famously revised Freud's notion of repression through his stories of the solar anus and the pineal eye. Writing that the primitive's transition to an erect posture redirected his bodily energies from travelling horizontally through the anus to exploding vertically through the head, Bataille laments this evolution: "the pineal eye, detaching itself from the horizontal system of normal ocular vision, appears in a kind of nimbus of tears, like the eye of a tree or, perhaps, like a human tree. At the same time this ocular tree is only a giant (ignoble) pink penis, drunk with the sun and suggesting or soliciting a nauseous malaise, the sickening despair of vertigo" (1985c, 84).

In both theories, the presence of the primitive is key, and writers like Sander Gilman (1985), Shawn Michelle Smith (1999), and Robyn Wiegman (1995) have variously detailed how the West has historically produced and identified its primitives as embodying an essentially primal and monstrous sexuality. From the exhibition of the Hottentot Venus in the nineteenth century (believed to exemplify the protruding

buttocks and "monstrously sized" clitoris of black women every-
where) to the myth of the black man's giant penis (supposed to reflect
an inherent animality and overwhelming sexual appetite), the historic
identification of the West's chosen Others *as* primitive has relied in
large measure on the pseudo-scientific assertion of their sexual abnor-
mality. Sympathetically, magically, genitals are imagined – and then
imagined to stand in for a particular identity.

The official and the popular are sutured into one another, combin-
ing to produce, as Taussig describes it, "the magic of the state" (1997).[15]
Thus, when Faludi notes that "Cartoon declarations about 'evil-do-
ers' masqueraded as foreign policy" (2007, 14), she is simply respond-
ing to the sanctification within official government speeches of images
like those on the facing page.

Imperialism and anal rape (Osama is penetrated by the Empire State
Building), effeminization ("You like skyscrapers, huh bitch?"), and the
sprouting penis-head (dick-head) are consistent themes in modified
images of Osama – the official *head* of terrorism since 11 September
2001.[16] This hypersexualization makes bin Laden into a modern prim-
itive: a being driven by a libidinal, phallic instinct that has overpow-
ered all rational thought. Evoking Bataille's famous solar anus, bin
Laden's penis-head resembles nothing so much as a giant pineal gland
dwarfing all potential for civilization.[17] His emasculation by the Em-
pire State Building, an appropriate symbol for American imperialism,
underscores that the threat bin Laden poses is read not simply as a gen-
eral threat to the state's safety but also as a specific threat to the state's
sexual purity.

The compulsive repetition of Osama's anal preoccupations and his
overwhelming connection to queer libidinal energy plug into long-
standing anxieties over civilization (read: Western Enlightenment) and
its Other – the primitive savage from the East. In each of these images,

You like skyscrapers, huh bitch?

Top left: Fig. 31 Osama t-shirt. From a now defunct Internet site.

Above: Fig. 32 Osama and the Empire State Building. http://www.laugh.com/main_pages/comicpage.as?cid=346.

Left: Fig. 33 Osama phallic head. http://www.laugh.com/main_pages/comicpage.asp?cid=346.

historically US and imperial anxieties about racial purity are transferred onto the body of the terrorist, and the project of giving a name and a face to terror exposes a fundamental fascism at work beneath the mask of patriotic right and virtue.[18] Moreover, by making explicit the discourses of hypersexualization and effeminization, these unofficial mug shots give face to the historically implicit function of official "Wanted" posters. Like the FBI's "Most Wanted Terrorists" poster, the purpose of the mug shot is to produce and display an internal and deviant essence via the body's surface.

Gangsta Bush: white face with the desires and dick of a black man, proving his weapon to be longer and stronger than his bitch's (fig. 34). Strictly between men, but not exactly a straight homosexual coupling, what we have are two men, one penis, and one gun standing in for a

Fig. 34 Bush rapes Osama.
http://www.rajuabju.com/elat/osamabinladen.htm.

penis that, presumably, isn't up to the job. Race is confused in this image: Bush is depicted as white on top and black underneath, whereas bin Laden remains the quintessentially bearded and turbaned Middle Eastern man, and the emasculating "bitch" is one of our clues to this essence. Harnessing the mythic libidinal power of the black man, Bush puts bin Laden in his place – a specifically passive and feminine position. Once again, the graphics are crude: heads too big for bodies, the mixture of photography with the graphic, and the graffiti-style penis. The text placed inside a telltale cartoon bubble tells us that sexual violence contains an element of the comic. Taussig tells us that this strange playing-out of the "comic-absurd ... this adult-executed childish iconography that propels the spirit-possession theatrics of caricature and literalization ... [brings] metaphor and national history into the gesticulating human body" (1997, 127).

Fig. 35 Osama=O.J.?
http://www.bobaugust.com/osamabinladen.htm.

O.J. Simpson, one of the most notorious black men of the twentieth century, is famous in part for his alleged violence against a white woman. Or to restate: the fascination lies in the fact that O.J. is largely believed to have gotten away with murdering a white woman – surely an unusual feat for a black man in the United States. One cannot think of O.J. now without seeing that smiling image of Nicole in the mind's eye; she is an absent presence attached to his name. In the above odd coupling of Bin Laden with O.J. (fig. 35), African American and Arab become indistinguishable, begging the question: where is Nicole in this fantasy? Why does this image in particular get made – why does it "make sense?" At the risk of sounding Freudian, it's all about the penis here, more specifically about the American obsession with the black man's penis as a threat to racial purity: the terror of miscegenation.

This is not a new terror in the story of America; it predates the African slave trade. Faludi reminds us that the captivity narrative, the only genre "indigenous to American literature," dates back to Puritan times (2007, 214). In these tales of Indian bondage and rescue, white girls and women are kidnapped by savages but eventually rescued by brave American men. Closer in time to our history, racial mixing signified not simply the loss of racial purity but also the threatened loss of supreme white political and economic power through Emancipation and Reconstruction.[19] The dramatic increase in lynching cases during these years has led scholars to see a direct link between the threat of miscegenation and white power: "Operating according to a logic of borders – racial, sexual, national, psychological, and biological as well as gendered – lynching figures its victims as the culturally abject – monstrosities of excess whose limp and hanging bodies function as the specular assurance that the racial threat has not simply been averted, but rendered incapable of return" (Wiegman 1995, 82). The most common rationalization for the castration and lynching of black men during the era of Reconstruction was the accusation of rape. The threat to white

womanhood functioned as the ultimate emblem of border dissolution: biracial babies contaminate the (pseudo) purity of the white race.[20] As Hazel Carby notes, however, the charge of rape "became the excuse for murder" (1997, 335). Not only were white women unnecessary to the accusation process, but rape also became a mere linguistic event – resurrected in speech if necessary but otherwise secondary to the white male mob's desire to violate the black man.[21]

Like a silent echo, the white woman is an absent presence in the mug shots of O.J. and Osama. But these two men, merged here into one, inflate beyond all proportion. Their crimes intermix, and Osama now resembles a black man threatening the racial purity of white America through his violent sexuality (hence the image in figure 36), while O.J. resembles a terrorist threatening the borders of America. The danger lurks on both sides of the border, and America becomes the white woman, the absent ground stabilizing the image and reiterating that old trope of the nation as a woman in need of protection. The slippery coupling of O.J. with Osama intimates that the most significant danger America faces is penetration. Is it any wonder, then, that popular imaginings of Osama's punishment reproduce historical tactics to delimit and disempower black male Americans?

It's another kind of magic, this equation of two moments and two men, and it supplements the nation's story of itself as just conqueror. As Taussig tells us, the state is not merely the body holding "monopoly of the (legitimate) use of violence," nor is it simply the product of an uber-efficient bureaucratic rationality (1997, 121). To understand the state, we must combine the former two definitions with "ghosts and images and *above all ... formless, nauseating, intangibility*" (121, original emphasis). Spectres of history are with us still, circling and cycling in the atmosphere. They can be plugged into the system of representation at any time. This is repetition with a difference, and its banality is maddening.

Fig. 36 Osama lynched.
http://www.khmerclub.com/Funnypix/12103/
OsamaBin.jpg.

The Spectacle of Woman 1: Giving Face to the Nation

So far in this story, terrorism has been a game primarily between men, and "bitch" has been our only signifier of woman. In the above Bush-Osama rape fantasy, she is supplanted by the asshole of the terrorist, and she's a mere spectre in the Osama-O.J. mug shot. What are we to make of her decorporealized status in the virtual imagination? Klaus Theweleit identifies the desire for the eradication of woman as the foundation of fascism: "real men lack nothing when women are lacking ... Relationships with women are dissolved and transformed into new male attitudes, into political stances, revelations of the true path, etc." (1987, 33, 35). Women's bodies reproduce, are penetrated, and dissolve boundaries between male and female; all the conventional tropes of woman as grotesque flesh return in the fascist dream, which aspires, above all, to clean lines and solid borders. Add to that the potential for miscegenation through racial mixing, and (the white) woman becomes

the threat to national purity par excellence: "It is this physical power, this potentiality of transmission, confusion, and reproduction through actual bodies, that could break down all boundaries and thus disrupt social order in the most fundamental fashion" (Chow 1988, 61).[22] In all these virtual imaginings of encounters with Osama, woman disappears from view while a fantasy of a men-only space gets played out, mimicking fascist desires of control and subjugation.

Despite the absence of women represented in my "Osama" image search, women are still very much a part of the current wars and their controversies. But those individual women who have become signifiers in this pseudo "war on terror" – such as Jessica Lynch, Lynndie England, and latterly, Sabrina Harman – do so within the limits of narratives carefully mobilized to bolster the US administration's policy of perpetual warfare. This does not contradict the fascist dream of eradication: in this real-world game of Battleship, real women have been disciplined, managed, sacrificed, and domesticated.[23] It's a softer version of the same dream.

The difference between a dream and a nightmare may be nothing more than a matter of perspective. Just ask Private First Class Jessica Lynch, the homegrown American hero famous for being captured in late March 2003 during the Iraq invasion and later rescued by US forces from the Saddam Hussein General Hospital in Nassiriya. Her ordeal, very likely experienced as a kind of nightmare, was told and retold to the point where it became a new version of an old dream of national heroism. In the first account, published in the *Washington Post* on 3 April 2003, Lynch is described as a truly heroic American soldier: "she fought fiercely and shot several enemy soldiers ... firing her weapon until she ran out of ammunition ... Lynch ... continued firing at the Iraqis even after she sustained multiple gunshot wounds and watched several other soldiers in her unit die around her ... She was fighting to the death ... She did not want to be taken alive"

(Schmidt and Loeb 2003). Soon enough, the validity of this account came under fire, and was replaced by the story of a vulnerable young woman caught in a barbarous land.

As details clarifying her capture emerged – her gun jammed and she never fired a single shot – new accounts of Lynch's mistreatment by the Iraqis began to surface. Stories of her being "slapped around" in hospital were soon overshadowed by allusions to a horrific rape, one specifically including anal penetration. The story of her rape galvanized the nation. It continued to play despite conflicting medical reports, staunch denial from hospital workers in Iraq, and even a refusal by Lynch to confirm the event (Faludi 2007; Russell 2003).

Lynch claims not to remember a thing. In an interview with Diane Sawyer, she states: "When we were told to lock and load that's when my weapon jammed … I did not shoot a single round … I went down praying to my knees. And that's the last I remember" (ABC News 2003). Nevertheless, the narrative of the rape continued to circulate, emphasizing at the same time her broken body and vulnerability prior to rescue: "The scars on Lynch's battered body and the medical records indicate she was anally raped … The records do not tell us whether her captors assaulted her almost lifeless, broken body after she was lifted from the wreckage, or if they assaulted her and then broke her bones into splinters until she was almost dead" (Colford and Siemaszko 2003). Lynch's memoir, *I Am a Soldier Too: The Jessica Lynch Story*, written by former *New York Times* reporter Rick Bragg, included the rape story against her wishes: "'I definitely did not want that in there,' she [said.] But … Bragg eventually wore her down. 'He told me that people need to know that this was what can happen to women soldiers'" (cited in Faludi 2007, 191). Pay attention: *This is what can happen to women soldiers.*

Remember Judith Butler's deconstruction of a rape trial in "Contingent Foundations: Feminism and the Question of 'Postmodernism'"

(1992). "If you're living with a man, what are you doing running around the streets getting raped?" asks the prosecutor (18). Butler advises us to pay attention to the verbs. The active and the passive tenses matter: they tell us that the woman doing the running has no business running. For if she's running around (active) outside her home and her marriage, she's gonna get it (passive). The story of Lynch's rape had nothing to do with Lynch's own memories or with her own desires of how the event got told. It was first and foremost an object lesson: women are at risk and therefore should not be over there. If they go over (active), this can happen (passive). And as her portrayal in the national narrative proceeded from stoic soldier going down fighting to vulnerable "crying all the time" waifish victim, Jessica Lynch became the perfect image of the white woman totally out of her depth and in need of rescue from the evil Arab Other (Priest, Booth, and Schmidt 2003).[24]

This "rescue" scenario has a long historical precedent that dates back to at least the seventeenth century "when Native Americans were accused of kidnapping white women in order to justify genocide" (Faludi 2007; Kumar 2004). These accusations were rooted in historical events, for raids on American settlers were not uncommon. Men, women, and children were taken captive during raids and wars, leading early settlers to describe their lives as terror-filled (Faludi 2007, 211). The literary genre borne from these experiences – the captivity narrative – alters the historical data that we have on a number of points. Although more men may have been taken captive during colonial years, the "captive was most frequently portrayed as female" (211). She was virtuous but weak, and she dreamt of rescue. Right on time, the white hero rides in, kills the savages, and takes her home for a life of domestic bliss.[25] What the captivity narratives failed to mention were all those instances when women escaped by themselves or when men bumbled their rescue attempts. Although white women

were depicted in the literature as victims in need of rescue from the savages, the archives suggest that as many as one-third of kidnapped women chose to stay with their Native captors-cum-families (212). It seems as though the media have been in the business of simplifying the story for some time. Seen in this light, the account of Lynch's capture and rescue is just a glossier version of this historical trope, providing the US media – and the Bush administration – with a perfect public relations story to boost waning support for the war at home.[26]

The centrality of Lynch's whiteness in this narrative emerges even more forcefully when we remember that two other American women were present with Lynch during the attack: Shoshana Johnson, an African American soldier, captured and wounded by gunshots through both legs; and Lori Piestewa, a Native American soldier killed when a rocket-propelled grenade hit the Humvee she was driving (Brittain 2006; Davidson 2004; Faludi 2007). Unlike Lynch, these women have not been lauded as American heroes, nor have they had television miniseries produced about them, nor have biographies been written of their lives. The overwhelming absence of concern for their stories, in relation to the media frenzy over Lynch, marks the pivotal role played by the tendency to imagine American womanhood (read: white womanhood) as imperilled by terrorism.[27] Similar to the slippage from Osama to O.J., here we have the imagination of a horrific violation perpetrated by barbaric "fiends" against a good (white) American, whereas the memory of other American women is violently effaced.

Disappearance matters. In Faludi's account (2007), the writing and rewriting of Lynch's story becomes a way of linking the Jessica Lynch rescue to the captivity narrative. The absence of Lynch's own words mirrors the erasure of resistant women's voices from the stories of Indian raids. The "real" Jessica Lynch disappears into the texts of others. It is her iconicity – and the spectacle generated through this iconicity – that signifies. The actual occurrence or nonoccurrence of

the rape is of little import to this cultural discourse; it is the *image* of violation, and of her rescue, that matters.[28] This is why soldiers charged with rescuing Lynch were supplied with night-vision video recorders (167).[29] Imagine watching this rescue a mere 180 minutes later.[30] Imagine watching Jessica Lynch watch the soldiers enter her hospital room and say, "Jessica Lynch, we're the United States soldiers and we're here to protect you and take you home." Imagine watching a frightened, lone woman answer, "I'm an American soldier, too" (168). It's the stuff movies are made of.

As Rey Chow argues, fascism must be understood in terms of spectacle; it is a technology of projection founded in love and idealism: "it is a search for an idealized self-image through a heartfelt surrender to something higher and more beautiful" (1995, 26). Fascism, in other words, is not simply about the annihilation of something deemed ugly and impure but also about the visualization and quest for an ideal. Hence the significance of film to Hitler's Germany.[31] Thus far, the role of the mainstream media has been to contrast idealized images with horror stories of the evil terrorist Others identified by the US government. Giving face to the God-given mission in Iraq, the production of Lynch as a rescued woman provided a powerful ideal image onto which the watching public could latch and which the government could use as a defence for its invasion. Lynch's image became purified through all this writing, as though the repeated textual violations of her body – the adamant insistence on one of the United States' most feared and taboo sex acts, anal penetration – enacted a kind of Sadeian purification by fire.

Lynch was packaged as a woman worth saving: a pure, white, helpless victim. Giving the US military a much-needed image boost of its own during an obviously failing operation, Lynch became an imagined mirror for her country, reflecting its dominant values and ideologies so that its inhabitants could, in turn, imagine themselves in her place:

"the public knows what the cynics won't acknowledge: Lynch indeed is a 100 percent American hero because she's become a living symbol of every man and woman in uniform who answered their country's call, and left family and friends to do their duty" (Brown 2004, 82).

The spectacle of fascism is not simply about projection but also about introjection – about internalizing the idealized image: "If individuals are ... 'interpellated,' they are interpellated not simply as watchers of film but also as film itself. They 'know' themselves not only as the subject, the audience, but as the object, the spectacle, the movie" (Chow 1995, 30). Jessica Lynch's capture was narrated as though America herself had been captured, and her rescue – filmed by the military and rebroadcast countless times – was celebrated as the recovery of this America, recasting the nation as a woman's body in need of defence and protection. Here facialization emerges as a process not of differentiation but of identification whereby the nation sees itself reflected in Lynch's apple-cheeked face. Needless to say, Shoshana Johnson's rescue, which took place eleven days later, was not filmed. Her face was not suitably heroic for the American military.

The violence that purifies Lynch's image thus serves to reinforce the purity and righteousness of the American campaign to "liberate" Iraq, and the US violation of another sovereign body gains additional reasons for being: justice, liberty, democracy, and Jessica Lynch's body. At this point, Lynch's body paradoxically dematerializes and becomes, like liberty and democracy, one more powerful abstraction worth fighting for. The success of the abstraction depends on her silence, or else on her tacit agreement to have her story told by others. When her version does not accord with the official version, she disappears from media space. Like magic. Spectacle, woman, purification, and disappearance – all of this begins to sound a lot like Theweleit's (1987) discussion of women and fascism. If woman is the threat to national purity, she must be returned and domesticated. Her purity, which

emerges out of sexual violence, must be carefully managed and constantly reproduced. Jessica Lynch's role is to be violated, repeatedly violated, in order to give the men back their soldier duties: to fight and rescue the white women from the evil horde.

The Spectacle of Woman 2: Defacement

Unlike Jessica, Lynndie England is no angel. The story of the American private, infamous for her role in the Abu Ghraib prison scandal, highlights the necessary role that defacement plays in the nation's quest to give and sustain its idealized face. Taussig characterizes defacement as a kind of desecration that brings us closer to the sacred: "When the human body, a nation's flag, money, or a public statue is *defaced*, a strange surplus of negative energy is likely to be aroused from within the defaced thing itself. It is now in a state of *desecration*, the closest many of us are going to get to the sacred in this modern world" (1999, 1, original emphasis). Etymologically, Taussig contends that "defacement" exposes an intimate connection between the face and sacrilege – and therefore also between the face and sacrifice (3-4). Sacrifice and desecration, then, are part of the process of facialization. The representation of Lynndie England as an antihero, as an anomaly of all for which the US military stands, exemplifies this dual interplay of sacrifice and giving face.

Abu Ghraib threatened to deface the American military and, by extension, to sully the myth of US heroism. Senior government and military officials were momentarily at risk of having to explain this seeming culture of abuse. This didn't happen. Mainstream pundits like Rush Limbaugh dismissed the images as evidence of a mere "hazing" ritual, and with alarming rapidity, the issue disappeared from public view. As Nicholas Mirzoeff observes, the Abu Ghraib torture images did not register as an election issue in the 2004 presidential campaign,

nor have senior administrators ever been charged with wrongdoing (2006, 23). Despite the acknowledged existence of thousands of photographs, as well as video footage, which together imply the involvement of far more than a few rogue soldiers, Lynndie England became the dominant figure, thereby redoubling her role in the images as perverse dominatrix. Since the scandal first broke, images of male soldiers involved in the abuses have all but disappeared from view, whereas the now infamous photographs of Lynndie holding a leash attached to a naked prisoner or laughingly pointing at the genitals of a hooded prisoner have become the identifying images of things gone terribly wrong in Iraq.

Soon after the scandal broke, scholars argued that the mainstream media's emphasis on England provided another brilliant public relations opportunity for the US administration: "The images of Arab men being broken, subdued, shamed and disciplined by a white woman allow for the realization of the 'American dream' of the total demasculation and humiliation of Arab men, while white masculinity remains outside the category of 'depravity'" (Brittain 2006, 82).

At the time, it was important to highlight the deflection that this Lynndie England spectacle enabled. For a short while, the public's attention was diverted from the deeply troubled campaign and, of course, from the continued absence of Osama. And in an earlier version of this chapter, I concluded my analysis of these events by remarking that the Lynndie England saga plays out its fascist spectacle in remarkably similar fashion to Lynch's story, that England's role is that of the phallic female who horrifies and must be subdued. Her apparently deviant sexuality – the press had given overwhelming attention to her pregnancy, to her less than respectable boyfriend of the time, Charles Graner, to her tendency not to be in her bed at curfew, and so on – marked her as abject and thus as an interior exteriority ostensi-

bly rejected by the nation but salaciously embraced for every detail she provided of illicit activity (Parker 2004; Staff Writers 2004). The spectacle of England enabled the media and its public to consume the image of perversion while pretending to reject it. Although this is all still true, I now think there is more to say.

England's scapegoating – her sacrifice – by the military and the media has effectively enabled the Bush administration to actively deny its role in perpetrating violence and terror and, thereby, to avoid its own defacement. Philip Gourevitch and Errol Morris (2008) show us that the horrors of Abu Ghraib actually helped the war in a perverse way because they prevented investigation of other abuses. Accordingly, the Abu Ghraib saga should be seen not as an unfortunate event that the government needed to manage but as the ritual and predictable playing-out of a sacrifice enabling the perpetuation of state power. I used to think that all of these developments constituted a perfect Lacanian moment – we know very well that these are not isolated or anomalous events, but we will continue to pretend that they are – I would now like to rephrase my analysis. It does not matter whether we know that these are simply representative moments extracted from a series of systemic violations; in the face of powerful and deeply rooted national mythology, knowledge alone is not sufficient. The state moves in the bloodstream.

Final Thoughts: Facing Up

In the ass-fucking fantasies that have circulated far and wide since September 11, America the retaliator manages to fuck the evil terrorist while remaining the heroic hetero-male. Never "perp" nor "perv," America puts Osama squarely on the bottom in this homo-revenge scene, pricked, poked, and burned in hell by a straight and just nation.

From grocery store tabloids to countless Internet sites to the vaunted *New York Times*, the category "terrorist" has been imagined in surprisingly similar ways. Osama, as the face of terrorism today, is a brown-skinned queer who likes to take it up the butt or to stick his penis in a goat's hole. Terrorism wears a turban, smells bad, has black lovers, and lives to screw white power. Yet, despite all these visual clues, the US administration tells us that the terrorist lives an elusive and shadowy existence. We can never be certain of his whereabouts, so the technologies of surveillance imposed since 9/11 are rationalized as a means of locating this paradoxically excessive and invisible figure.

Ironically, his elusiveness has proven far more useful to the US government than his capture and trial ever could have been. Identified as the unlocatable figurehead of an untraceable, constantly growing global network of terror, the face of bin Laden emerges as a signifier supporting the US administration's commitment to perpetual warfare: there will always be more terrorists coming at us from parts unknown. It is his image, circulated from time to time on our television screens and accompanied by pictures of Afghanistan's famously brutal and treacherous mountain terrain, that matters far more than his flesh – his captured person – ever could. These faces – of a pathologized John Walker Lindh, of an elusive Osama, of a wholesome Jessica Lynch, and of a perverse Lynndie England – flash up for a time, only to be disposed of, quietly and efficiently, in the dustbin of history. And for those of us still watching, can we feel anything other than a fundamental impotence as we witness the sacrificial rubbish heap grow ever larger before our eyes, ever more putrid as we're blown, blindly, further into this nightmarish morass?[32]

Five Mourning at Work, or Making Sense of 9/11

Stop making sense. Talking Heads (1999)

Children are the future not because they will one day be adults but because humanity is becoming more and more a child, because childhood is the image of the future. Milan Kundera (1996, 257)

President George W. Bush wanted Americans to feel close to 11 September 2001. He wanted them to feel close so that they would understand the necessity of war. Bush's message to the world was similar, if less cushioned by sentiment: *You are either with us or against us*. Stated otherwise: feel our pain, or else. As Milan Kundera writes: "When the heart speaks, the mind finds it indecent to object. In the realm of kitsch, the dictatorship of the heart reigns supreme" (1991, 250). Bush's line in the sand worked hand in hand with his direct line to God and with his televised meetings with widows and children following the collapse of the towers. It was a way of giving a face to grief, of bringing mourning close to a nation. It was also a carefully orchestrated theatre of kitsch. The question of kitsch, in this case, is a question of proximity, distance, and mourning.

Freud (1991b) tells us that mourning is work. More precisely, he describes grief repeatedly as "the work of mourning" and explains "the work which mourning performs" as the process by which the ego gradually splits from the lost object or other (254, 253). In his earlier writings, mourning is a finite process; once completed, "the ego becomes free and uninhibited again" (253). When mourning goes wrong, it does so because it refuses to finish the job, becoming addicted instead to remembering the loss of the other. This perversion of the normal work of mourning results in melancholia, a complex that "behaves

like an open wound" (262). The ego feeds on loss and desires nothing other than to "incorporate this [lost] object into itself," thereby setting off a perpetual attachment to absence within (258). For Freud, melancholia differs from mourning in that its work is never done.

As Judith Butler (1997) has argued, this early distinction between mourning and melancholia becomes complicated as Freud continues to work through his own concepts. Referring to his later writing in *The Ego and the Id*, she asserts that mourning in a sense becomes subsumed by melancholia: "If in 'Mourning and Melancholia,' Freud thought that one must sever one attachment to make another, in *The Ego and the Id*, he is clear that only upon the condition that the lost other becomes internalized can mourning ever be accomplished and new attachments begun" (195). Jacques Derrida (1996) has taken this further still, suggesting that the work of mourning is an interminable condition or operation: that all life mourns ceaselessly and without end.[1] For Derrida, mourning's work challenges us to acknowledge the alterity of lost others as we incorporate their images and memories within. It is an operation that seeks not to reduce or erase these others but to let them be in their absence and to let ourselves be traced through with death, with absence, and with irreducible difference.

What binds us together, as friends, lovers, or even – as troubled a concept as it is – communities, is the experience of mourning: "We know, we knew, we remember – before the death of the loved one – that being-in-me or being-in-us is constituted out of the possibility of mourning. We are only ourselves from the perspective of this knowledge … we come to ourselves through this memory of possible mourning" (Derrida 1989, 34). Butler (2004) rephrases this in her meditation on mourning post-9/11, proposing that the experience of loss and grief is shared by all humans and that this common experience of loss – despite important contextual differences – suggests that the "subject" is

only a "subject" through its relations with an other. She writes: "This means that each of us is constituted politically in part by virtue of the social vulnerability of our bodies … Loss and vulnerability seem to follow from our being socially constituted bodies, attached to others, at risk of losing those attachments, exposed to others, at risk of violence by virtue of that exposure" (20). In as much as *we are*, *we are* by virtue of others passing through our lives, memories, and bodies. If, as both Derrida and Butler suggest, we are all exposed and vulnerable, and are all engaged with bereavement, how are we to understand the concept of work in the context of interminable mourning?

"Work" typically signifies according to classical utilitarian convention. Work is productive; goal-oriented and useful, its purpose is to enable the continuation of the species. All work requires a degree of consumption – humans require sustenance in order to continue producing and reproducing. Georges Bataille (1985b) argues that two different forms of consumption are operative in modern Western societies. Utilization of "the minimum necessary for the conservation of life and the continuation of individuals' productive activity" represents the first form (118). The second type, characterized by uselessness, he names "unproductive expenditure … activities which, at least in primitive circumstances, have no end beyond themselves" (118). Significantly, Bataille lists mourning as one example of nonutilitarian expenditure.[2] Mourning contributes nothing to the continuation of the species; it is nonproductive and anti-utilitarian. Mourning, in other words, is the wasteful consumption of our energies.

How can mourning be both work and waste? If it is a process that does not contribute to the economic and political progress idealized within modernity, then the work of mourning must be envisioned as a kind of antiwork. Derrida articulates this kind of nonwork as "a work working at its own unproductivity" (1996, 174). Characterized

by renunciation – by the resistance to transforming mourning into use-
ful activity – the work of mourning resists being transformed into force
by any act of will: "here comes a work without force, a work that
would have to work at renouncing force, a work that would have to
work at failure" (174). Failure, that is, in the sense of modern utilitar-
ian discourse. Consequently, this profoundly radical renunciation con-
stitutes a refusal to engage in the quest for mastery and power that has
preoccupied the West for as long as its history has existed. Far from
referring exclusively to the grieving process one undertakes in the face
of a specific death, mourning names a principle of resistance to partic-
ipating in the will to power.

But what does this principle of resistance look like politically? Is
antiwork, or Maurice Blanchot's (1988) notion of *désoeuvrement*, syn-
onymous with passivity? In Giorgio Agamben's (1993) terms, the work
of mourning embraces impotence – the ability to not be able, the abil-
ity to renounce violent force. Despite its capacity for mastering loss
through action, mourning remains committed to finding and follow-
ing a different path.

Resurrecting Emmanuel Levinas's (1987) articulation of the ethical
relation, Butler (2004) suggests, tentatively, that recognition of our
own vulnerability to loss may open up the potential for recognition of
all humanity as vulnerable. By remaining within mourning – by not
charging into action – "are we left feeling only passive and powerless,
as some might fear? Or are we, rather, returned to a sense of human
vulnerability, to our collective responsibility for the physical lives of
one another?" (30). According to Gillian Rose (1996), the work of
mourning demands a reconsideration of concepts of activity and pas-
sivity altogether. Grief should not require us to remain passive in the
traditional sense of inert, inactive, or submissive. Instead, the work of
mourning consists of an "activity beyond activity, not passivity beyond
passivity. For power is not necessarily tyranny" (121). For Rose, this

"activity beyond activity" translates into the recognition that whatever we do, however we react, there are always consequences (122). Echoing Derrida's argument, Rose and Butler articulate the work of mourning as the work of recognizing one's relation to an other – one's essential intersubjectivity. But in the wake of September 11, the mourning prescribed by both the government and the mainstream media did not engage these challenges. Forced into action, the work of mourning was harnessed to the cause of making sense of what happened.[3]

Making Sense through History

Over the course of November 2001, on five occasions the *New York Times* published digitally altered versions of paintings by Norman Rockwell, using them as advertisements for the newspaper's ability to engage meaningfully with the attacks and their aftermath.[4] Drawn in part from his *The Four Freedoms*, a Second World War series first published in the *Saturday Evening Post*, the doctored Rockwells enable identification with images of pre-9/11 – pre-*collapsarian* – American innocence. Positioned immediately following the newspaper's special "Portraits of Grief" section, dedicated to running photographs of the World Trade Center victims, the doctored Rockwells were accompanied by the slogan "Make Sense of Our Times." Playing on "Times" as signifying both the newspaper and the current historical epoch, the ads capitalized on grief as a selling mechanism.[5]

Rockwell's *The Four Freedoms* series appeared in the *Saturday Evening Post* in 1943, two years after its initial rejection by the US government.[6] Inspiration for the series undoubtedly came from President Roosevelt's speech to Congress in January 1941, known now as the "Four Freedoms" speech. Attempting to garner support for intervening in the war, Roosevelt invoked "four essential human freedoms," all of which, he argued, had been placed in jeopardy by the

governments of the Axis nations: freedom of speech and expression, freedom of worship, freedom from want, and freedom from fear (1950, 672). His articulation of these basic freedoms gathered momentum in the ensuing months and operated as a touchstone in numerous addresses to both foreign and domestic audiences (Olson 1983, 20–1).

Although initially "justifying increased financial support of Britain," the Four Freedoms served an important disciplinary function for the American people (Olson 1983, 20). Funnelled down through official rhetoric, the freedoms were further disseminated through "speeches, essays, stories, paintings, conversations, press reports, and generally into public awareness" (20–1). Magazines as diverse as *Parents Magazine, Catholic World, Education,* and *Annals of the American Academy* all published articles concerning the Four Freedoms. Artists also joined the fray, producing various works based on the freedoms. In an anecdote that hauntingly evokes Walter Benjamin's discussion of the aestheticization of politics by fascism, sculptor Walter Russell recounts a meeting with Roosevelt during which "the President suggested to me that through the medium of arts, a far greater number of people could be brought to understand the concept of the Four Freedoms" (cited in Olson 1983, 21). Significantly, the US government itself was responsible for a portion of this mass dissemination, commissioning "murals, photographs, paintings, pamphlets, woodcuts, and displays ... [as forms] of public outreach" (Frascina 2003, 104–5). By the time Rockwell's illustrations appeared in the *Post,* the Four Freedoms were therefore already functioning as recognizable statements of American democracy and patriotism.

Rockwell's *Freedom of Speech,* featuring a male speaker in a schoolroom surrounded by listening townspeople, was the first of Rockwell's freedom series to be published. Invoking democratic ideals through its representation of a town meeting, the image is just one example of

what critics have labelled Rockwell's homogenization of American experience (Greenberg 1961; Staff Writers 1943).[7] Although he is noted for attempting to engage the issue of race in paintings such as *The Problem We All Live With*, white, middle-class heterosexual families abound in Rockwell's work. Nostalgia, harmony, and idealization are themes frequently attributed to his particular vision of America. The remaining three paintings in the freedom series illustrate these themes.

In *Freedom from Fear* (fig. 37), two children are being tucked into bed by their mother. The father, participating only as an observer of this nighttime ritual, holds a newspaper in his left hand; the front page headlines read: "Horror," "Bombings," and "Women and Children Slaughtered by Raids." Emphasizing at once American security and European insecurity (the image was intended to invoke the bombing raids raging across the Atlantic), *Freedom from Fear* paints a picture of geographical thanksgiving: thank God we're safe over here.[8] *Freedom from Want* makes this thanksgiving explicit, picturing a joyful white family seated around the dinner table. Fulfilling their traditional gender roles, the mother brings the turkey to the table so that the father can carve.[9]

Finally, *Freedom of Worship* pictures several faces of the devout either bowed in prayer or solemnly attentive to an unseen sermon. A sole black face anchors a sea of white worshippers – perhaps Rockwell's attempt to imagine desegregated religious practice? Despite the image's caption, "Each According to the Dictates of His Own Conscience," each figure appears engaged in specifically Christian devotion – the freedom to worship not yet pictured across faiths. Rockwell's idealized freedoms imagine a serene and peaceful life, in which families (read: white and heterosexual families sanctified both legally and religiously) are safe from the terrors of war and secure from all physical needs. The initial appearance of Rockwell's freedom series in the

Fig. 37 Norman Rockwell, *Freedom from Fear*, 1943. Works by Norman Rockwell. Printed by Permission of the Norman Rockwell Family Agency. Copyright © 2009 Norman Rockwell Family Entities. Photo courtesy of Norman Rockwell Museum, Stockbridge, Massachusetts.

Saturday Evening Post – each painting placed opposite a text by a well-known author decrying the evil Axis powers and elevating the glories of American freedoms – was met with tremendous acclaim.[10]

Not long after the *Post* ran the four images, the Roosevelt administration became interested in the fundraising potential it saw in Rockwell's work. Reversing its earlier refusal, the government chose *The Four Freedoms* paintings in 1943 as "the official posters for the second War Bond Loan Department" (Frascina 2003, 102). The Treasury Department printed four million posters, and both Rockwell and the original paintings went on tour for the bond drive in the spring of 1943. The drive raised nearly $133 million. Freedom, in other words, had become a commodity. And as Rockwell's original title of the series indicates – *The Four Freedoms for which We Fight* – the price of purchase was war. As an abstract concept put to work – ideologically quilted as Slavoj Žižek (1995) might say – "freedom" was specifically equated with American democracy and with white, heteronormative, bourgeois values, both of which were threatened by the evil Axis Other.[11] Rockwell's paintings, in other words, *made sense* of Roosevelt's aspirations.

Making Sense: 9/11

Appearing in the *New York Times* on 2 November 2001 and again on 4 November, the first altered Rockwell is based on *Freedom from Fear*. Here, the father still watches as the mother prepares their children for bed, but this time his newspaper has been modified. Generating a clever *mise-en-abyme*, the father holds a copy of the *New York Times*' 12 September 2001 edition, featuring a photograph of the burning World Trade Center and the headline "U.S. Attacked: Hijacked Jets Destroy Twin Towers and Hit Pentagon in Day of Terror." The slogan "Make Sense of Our Times" runs on the bottom left of the page. Capitalizing

on the nostalgic power of Rockwell while promising readers the salve of elucidation, the ad paints a picture of America as a family under threat and sells the *Times* as the path to understanding.

Although these modified Rockwell ads are situated in the context of mourning (as noted, they appear immediately following the *Times*' "Portraits of Grief" section), their location after these obituaries suggests that mourning is to be followed by reason (sense, in this sense, is not aesthesis).[12] At a certain point, one turns the page on grief. This reason comes to us through a domesticated, nostalgic picture of history in general and through the victory of the Second World War in particular. From the memory of Iwo Jima, resurrected through Thomas Franklin's flag-raising photograph, to the déjà vu postcards of Uncle Sam battling fascism and now terror, to the comfortable sentiment of a Rockwell scene, the message of an obvious evil (fascism) that we must fight is entangled with this current and much more ambiguous context. It's a kind of perverse supplementation, one that seeks to clarify our understanding of a new kind of enemy by aligning it with a simplified version of good and evil.

Descending into a vertigo of semantic self-referentiality – use our newspaper to understand our newspaper – the campaign's slogan also invites an immediate identification with an entity labelled *our*. "Make Sense of Our Times" thus refers both to the editors as nominal representatives of the newspaper and to a more general reading public, grouped together under the umbrella *our*. In other words, Rockwell can help an identifiable reading community – *us* – to understand the *New York Times*' reporting of the times in which *we* live. But who constitutes this imagined reading public? The answer is at once murky and clear: there is an "us" and, by implication, a "them"; beyond that, all certainty evaporates. Still, it was a popular method of containing the event and its aftermath; *Why do they hate us so much?* became one of

the most parroted questions during those early days. The phrase even appeared in Art Spiegelman's graphic novel *In The Shadow of No Towers* (2004), uttered by a bald eagle whose throat has just been cut by Dick Cheney, gleefully riding on its back (4).

Critics immediately pointed out the violent reduction perpetuated through this binarism: "Behind the undefined 'they' lurks a racist pigeonholing of Arabs and Muslims, of course, but less obvious is the radical homogenization implied by 'us.' The 'us' here assumes a seamless if simplistic correspondence between the people of the United States and the U.S. government that under any other conditions would be thought ludicrous" (Smith 2002, 102). The form of the question predetermines the answer: to accept the question as sensible requires that one first accept the binary structure of identity that it implies. Or as Derek Sayer reminds us through a resurrection of Ludwig Wittgenstein at Ground Zero: "If a question can be framed at all … it is also possible to answer it" (2008, 17). This is one reason why Derrida (1982a) was at pains to emphasize that the question *qua* question was of such significance: we must take account of how the future can be activated through language.

Beyond this obvious reduction lurks another consequence of the us-them formulation, one that has come into focus only recently: this line in the sand moves. As Žižek reminds us, "*precisely in such moments of apparent clarity of choice, mystification is total*" (2002, 54, original emphasis). Soldiers who signed up to hunt down Osama bin Laden, and then found themselves at Abu Ghraib, did not see how that line would extend into abuse and torture. One has only to read a few pages of Philip Gourevitch and Errol Morris's (2008) recent investigation of Abu Ghraib to learn that mass confusion on multiple levels, disorganization, and deception were hovering just below the surface of this clear, hard line of loyalty. Now, American soldiers are requesting

refugee status in Canada to avoid returning to a fight they cannot in good conscience continue. Does this mean they occupy the side of the line that hopes the "evildoers" win? Hardly. But the "us" and the "our" do not allow for gradations and degrees. Žižek reminds us that, in the aftermath, taking sides for or against terrorism was the only optional response: "And since nobody is openly for, this means that doubt itself, a questioning attitude, is denounced as covert support for terrorism" (2002, 54). The *Times* fell into step with this march toward justice, promising to "make sense" by making America into its own image of righteous conqueror.

Given the educational role America's newspaper of record assigned itself after 9/11, its modification of another famous Rockwell – *Happy Birthday Miss Jones* – nicely imagines the newspaper-reader relationship in terms of a disciplined classroom environment.[13] In the original 1956 Rockwell, the viewer is positioned outside of the frame, looking in from the back of a grade-school classroom and watching a birthday celebration unfold (fig. 38). In the foreground of the frame, children sit dutifully at their desks with their backs to the viewer. The teacher stands in the painting's background, next to a blackboard covered with wishes for a happy birthday. In the version published by the *Times* on 9 November 2001, the blackboard is partially covered by a map of Afghanistan (fig. 39). A lesson so simple, a child can understand.

Readers are positioned as children, learning that the map of Afghanistan provides answers to the confusion of September 11. At first glance, the message seems simple. Typically objectified in political rhetoric as "the future," children are seen, among other things, as icons of hope, as repositories of energy to be harnessed for productive work, and, of course, as future consumers. Here, a complex substitution and doubling take place, whereby adult readers become children (What class is this? History? I wonder), and children come to resemble future soldiers receiving a lesson in geopolitical relations. The answers are clear

– elementary enough for school children to learn, their bodies docile as they incorporate the new information. By emulating the receptacle-like attention of Rockwell's pupils, readers are encouraged to make the grade and discipline themselves to identify Afghanistan as the answer to terrorism.

But look again. Invert your perception. Remember Roland Barthes's analysis of advertising images as polysemous. Read another way, the *Times'* version of *Happy Birthday Miss Jones* presents a bizarre and potentially more disturbing picture. With the exception of the map of Afghanistan, everything in the *Times'* version remains the same as the original Rockwell: still holding her hat and coat, Miss Jones has presumably just arrived in the classroom, only to be presented by her students with the birthday "gift" of Afghanistan.[14] Is this the future presenting the past with the lessons it has incorporated? The future writing over the past – giving itself a space to become through a violent supplementation?[15] How does the map change the children's/readers' understanding of history? I'm reminded of Michael Taussig, again, and his formulation that "The magic of the state lies not only in the space of death … but in a far more sinister fashion in varying combinations of inarticulable fear and absurdity uniting death and the children, as a glance at the daily newspapers of any country today will show" (1997, 116).

Ironically, the visualization of enemy territory, captured within the frame of a modified Rockwell, and within the frame of the *New York Times*, makes sense of Derrida's concept of the interior exteriority. A kind of virus necessary to the functioning of the system, the map of Afghanistan works to shore up the identity of the good as it gives face to evil. However, by imagining evil in terms of a territory, rather than the face of the supposed enemy (bin Laden), the image effectively abstracts the civilian lives at stake in Operation Enduring Freedom, the official name for the US invasion of Afghanistan. The map has a dis-

Fig. 38 Norman Rockwell, *Happy Birthday Miss Jones*, 1956.
Works by Norman Rockwell. Printed by permission of the Norman
Rockwell Family Agency. Copyright © 2009 Norman Rockwell
Family Entities. Photo courtesy of Norman Rockwell Museum,
Stockbridge, Massachusetts.

tancing effect that corresponds to the first modified Rockwell's insis-
tence on our proximity to the domestic scene of security. We are in-
side, together, reading about the dangers without. These dangers can
be located far away from here, and they are best thought of in terms
of territory rather than flesh. Proximity and distance. Together, these
advertisements raise the question of positionality: where does one lo-
cate oneself in this theatre of operations?

Fig. 39 *New York Times*, 9 November 2001. Modified version of 03/17/56 Norman Rockwell/*Saturday Evening Post* illustration, "Happy Birthday Miss Jones." Copyright © 1956 SEP: Licensed by Curtis Publishing, Indianapolis, IN. All rights reserved. http://www.curtispublishing.com.

Making It Personal: Identification

Identification with the event becomes a means of making sense of it – of crafting narratives of explanation. Judith Butler identifies the private, personal narrative as one moment of slippage in the post-9/11 world: "In the U.S., we start the story by invoking a first-person narrative point of view, and tell what happened on September 11th ... We have to shore up the first-person point of view, and preclude from the

telling accounts that might involve a decentering of the narrative 'I' within the international political domain" (2002a, 58). The danger of these narratives, she warns, lies in their potential for unchecked narcissism, an all too real consequence of the US government's official policy of retaliation: "We relegate the United Nations to a second-order deliberative body, and insist instead on American unilaterialism" (59). Sure. But the first-person narrative also reveals an affective connection to the event, and we would be overly hasty to conclude that "the media" was the sole source of this sentiment. Are we to deny the emotional content of these narratives simply because the administration wanted to reduce the distance between Ground Zero and the rest of America? At what point does feeling beget violence?

First-person accounts enable those not present at the scene of the trauma to identify with the event and thereby to be placed within a grander historical narrative, much like we remember where we were when O.J. Simpson was chased down a Los Angeles highway or my parents' generation remembers what they were doing when John F. Kennedy was shot. These narratives are further bolstered by pilgrimages to the site, during which time the acquisition of souvenirs and memorabilia becomes another means of identification. When President Bush and Mayor Rudy Giuliani called on the nation shortly after September 11 to visit New York and spend their money shopping, the tourist industry responded with reams of collectibles for sale. Now, visitors to Ground Zero, and to New York more generally, not only fulfil a national duty through their economic support but are also enabled to purchase a piece of the event, like modern-day relic hunters. Such affective responses are often derided as mere evil kitsch. But if, as Taussig suggests, "The popular is the spinal column of the nation" (1997, 115), then popular sentiment should be taken dead seriously.

Souvenirs are vessels of narrative potential. A kind of Ariadne's thread, they are traces linking the possessor to a lost origin; connection

to that origin is accomplished through the construction of narrative: "The souvenir must be removed from its context in order to serve as a trace of it, but it must also be restored through narrative and/or reverie" (Stewart 1984, 150). Shrinking the distance between collector and event, souvenirs have "as their vocation the continual re-establishment of a bridge between origin and trace" (Frow 1997, 94). This desire for *nearness* – for the reduction of distance – is tantamount to a desire for possession. Souvenirs "represent distance appropriated … through the souvenir, [for the subject] possesses the lost and recovered moment of the past" (93–4).

Taking home a piece – the bits, remains – of the trauma, tourists incorporate 9/11 into their lives in classic melancholic fashion: they identify with the lost object (the towers, the victims, American innocence) through a kind of ingestion. As Freud notes: "identification is a preliminary stage of object-choice … in which the ego picks out an object. The ego wants to incorporate this object into itself, and, in accordance with the oral or cannibalistic phase of libidinal development in which it is, it wants to do so by devouring it" (1991b, 258). Although Freud often wrote about this ingestion in a literal sense – for instance, the totem meal or the hysteric's giving-up of food – melancholic incorporation assumes multiple forms.[16] Hunting for souvenirs and relics constitutes one such means of identification.

It is heavier than one might expect – cheap, certainly, but not weightlessly so. Miniature monument – a tiny replica-cum-key ring (fig. 40). Now reduced to pocket-size, the twin towers have become an aid to holding the keys that open the doors of everyday life – a clichéd metaphor for memory purchased for two dollars down at Ground Zero. Unlocking doors to house, car, office, the returned tourist is thrown back, momentarily, to a trip taken and a time that has since receded in the face of everyday life. The key ring souvenir functions now as evidence, an object proving I was there.

The bottom, a rectangular pedestal on which the towers stand, resembles the base of a human tombstone complete with epitaph. One side simply reads "New York"; the other side mourns more specifically:

In Memory of
World Trade Centre
1973–2001

This is just as any mother, father, or widow might inscribe the gravestone of a lost love – testifying to a short life, a loss so tragic only ritual words will do, although ritualized text never begins to accomplish the commemoration it desires. The massive buildings are reduced to a miniature grave marker, a tomb uncannily housing nothing at all – certainly not the usual bodily remains those accustomed to Western funerary traditions have come to expect. It is, moreover, a moveable tombstone – but one marking journeys to and from the site rather than the buried presence of victim remains. On the bottom, "Made in China" is stamped into the metal.

Here, we have an uncanny superimposition whereby the time of the trauma and the time of the tourist commingle, becoming equally significant to memory and, perversely, inextricably intertwined. Emptied of any sublime horror, this little tombstone waits on the vendor's table to be picked up and filled by its tourist-collector with new, domesticated memories. Through possession of my souvenir, I forge a connection to the tragedy. Now, I have a story to tell. *I was there* become words belonging to both survivor and tourist. As Benjamin writes: "The *mémoire volontaire* ... is a registry providing the object with a classificatory number behind which it disappears. 'So now we've been there.' ('I've had an experience')" (1999b, 211).

Fig. 40 World Trade Center key ring souvenir. Bought at Ground Zero, March 2003. Photo by Karen Engle.

But, you see, I wasn't there – on September 11, I mean. I bought the key ring so that I might have something to show for my research trip, but I felt stupid visiting the spot. I had made the pilgrimage only because my father had said: "If you're going to write about it, you have to go there." I didn't believe him; I wanted to retort with a statement about the illusion of authenticity, about betraying the real losses from which I was entirely protected by participating in disaster tourism. But I kept silent. I kept silent, and I went and I bought. Now, the key ring's suitability as narrative springboard begins with a commingling of its identification of the story's origin *as* the death of the towers with my reluctant pilgrimage. I use the trinket to retrace a private voyage, erasing the event's absolute alterity in the process.[17] But this erasure is not the only result, for the object also works to make disappearance material. Whereas the administration used the absent towers to produce its own hauntology – the *shadow of no towers* explains the invasions of Afghanistan and Iraq, as well as the nation's domestic policies of surveillance and deportation – my trinket respects a certain distance as it marks the presence of ghosts.[18] I was not there. Is there a difference between this form of negative identification and public avowals of national belonging?

Making Community: Group Psychology

You know, whenever you go on a trip, you've got to bring home a T-shirt.
Lynn Yaeger (2002)

Souvenirs enable far more than individual connections to a traumatic event: they propel group formations, what Freud describes as the binding relations between individuals who detect a significant commonality between themselves and others: "[identification] may arise with any

new perception of a common quality shared with some other person who is not an object of the sexual instinct. The more important this common quality is, the more successful may this partial identification become ... the mutual tie between members of a group is in the nature of an identification of this kind, based upon an important emotional common quality; and we may suspect that this common quality lies in the nature of the tie with the leader" (1955, 108).

Not only did both Bush's and Giuliani's approval ratings shoot up immediately following the attacks, but the media perpetually reiterated how unified the nation had become since September 11. Americans, we were told, were banding together in this time of crisis to focus on the nation's new God-given mission: the fight against terror. This imagined banding together, reminiscent of Freud's repeated insistence on identification as a specifically *binding* force, is presented as a positive, nation-building experience.[19]

In an interview on BBC *Newsnight*, however, CBS journalist Dan Rather referred to this binding patriotism as a particularly oppressive force: "It is an obscene comparison ... but you know there was a time in South Africa that people would put flaming tyres around people's necks if they dissented. And in some ways the fear is that you will be necklaced here, you will have a flaming tyre of lack of patriotism put around your neck" (cited in Engel 2002). Sure enough, anyone attempting to engage a thoughtful debate – one that refused the simplistic conclusion that "they hate our freedom" – was castigated. Sayer cites one particularly apt response to the *London Review of Books'* special symposium on 9/11: "When I visit England sometime I'm going to stop by your offices and shove your loony leftist faces into some dog shit" (2008, 16).[20] Neither silence nor reflection was given a space in those days. Overt patriotism became a necessary part of one's self-presentation, much like President Barack Obama was required to show his love for the nation by wearing a flag pin in public during the presiden-

tial election campaign. This shift in the work of the commodity – from souvenir generating a private narrative to the symbolic object of public declaration – marks, I think, a crucial moment of transition from an "I" who mourns to a "we" who march. One commodity in particular exhibits this slippery relation between private memento and group formation: the t-shirt.

Within a week of the attacks, vendors in Union Square and Chinatown offered t-shirts emblazoned with the US flag and the twin towers and displaying this slogan:

America Under Attack.
I can't believe I got out[21]

Sales were immediately brisk: "They are kind of funny. They appeal to my sick sense of humor," said Greg Gomez, who purchased several for his relatives in Illinois at a bargain price of four for $10. "Everyone at home wants a t-shirt, but I will not wear one," Gomez continues. "It just kind of shows how everyone in America will find a way to make a quick buck, even off tragedy" (cited in Brune 2001). Sick, funny, and quick – how better to sum up what happened down at Ground Zero when the tourist tables went up? Through this slippage between survivor and tourist, the event is lifted from its specificity – a few hundred square metres of downtown New York – to a national incident: *America Under Attack*. In a strange twist, not only does the tourist double as survivor, but the survivor similarly comes to resemble a tourist. Talk about supplemental confusion: America supplements New York, the tourist supplements the survivor, and if "America" was under attack, then where did the escapees escape to? What delineates the boundaries of attack and security? The slogan sets in motion a narrative designed for public response. It advertises that the wearer belongs to the event and has, thanks to the commodity, now

secured a place in the national narrative. Marx talks about the magic of the commodity in terms of its ability to make the labour process disappear. But here, magic emerges in the commodity's ability to generate a new social relation: the national group.

Americans were, after all, told to "go shopping" in order to protect the economy from total devastation. Moreover, this injunction to consume is nothing new in American history. As Dana Heller reminds us in the introduction to *The Selling of 9/11* (2005), the fact that 9/11 has become a trademark repeats a significant tradition within the United States. During the twentieth century, national identity came to be synonymous with the activity of consumption: "the practice of American citizenship became increasingly coextensive with consumer rituals and commercialized myths of self-actualization" (3). What the tourist tables at Ground Zero helped to accomplish was no less than a libidinal connection between downtown New York and the rest of the nation. Despite the protests of people like actor Morgan Freeman that September 11 should not become identified as a national event, this identification nevertheless took place.[22] Freeman was attempting to distinguish between survivors and victims, on the one hand, and spectators, on the other. Surely a relevant distinction to make. Yet what the survivor t-shirt tells us, not to mention the parade of flags, decals, bumper stickers, and more that followed across the country, is that many Americans *felt* themselves to be a part of the event. Žižek (2002) calls this affective response a form of historical return. He suggests that this patriotic "rediscovery of American innocence" blocked the nation's ability to "realize what kind of world it was part of" (45, 47). Patriotism as somnambulism. The dream, or nightmare in Faludi's terms, continues.

The uncanny doubling of tourists as survivors reiterates the event's nationalization at the level of military conformity, for the t-shirt's relatively recent history begins with the army. Credited as an invention

of the British navy, the t-shirt was first designed as a way to prevent royal eyes from spying sailors' armpits (Gross et al. 1993, 39). During the First World War, European soldiers wore them as underwear beneath their uniforms to stay warm. When Hollywood icons like James Dean began wearing them as outerwear in the 1950s, t-shirts became associated with rebellion and anti-establishment attitudes. However, their adoption by sports teams, clubs, rock bands, tourists, and teenagers across Europe and North America, a phenomenon that emerged during the 1960s and has not yet abated, suggests once again their functionality as *uniform* – as a visible means of identifying with a group, an idea, a nation.

Membership has its privileges, but membership has been extended in this case for the purposes of advertising communitarian solidarity. Feeding off of tragedy, the vendors of 9/11 memorabilia sell the possibility of belonging to a greater community united by disaster: "'I wear mine to sympathize with the people who died or lost loved ones; to show that I do care,' said Andrea McDougall, an immigrant from Jamaica, as a tired Fireman with dusty boots walked past. Her t-shirt featured a picture of the Twin Towers behind the Statue of Liberty with the words, 'We will stay together. We will get even stronger'" (Brune 2001). Sympathy as participation. While a fireman walks by, either on his way to or from the site of mass carnage, Andrea McDougall dons her own uniform as a means of identifying with the victims and their grief. It's a statement of sincere sentiment, but it also traces a movement from "I" mourn to "we" shall overcome. This is the realm of kitsch.

In *The Art of the Novel* (1988), Milan Kundera describes kitsch as "the need to gaze into the mirror of the beautifying lie and to be moved to tears at one's own reflection" (135). Kitsch reflects a profound narcissism, but it is a narcissism that links itself to something larger – a sentimental desire to insert oneself into a historical or otherwise significant moment or movement. Remember the absurd march on Cam-

bodia in Kundera's *The Unbearable Lightness of Being* (1991)? As a photographer backs up into a minefield to get a shot of the actress and the singer hoisting their flag, he is blown up by an exploding mine: "The singer and the actress were horrified and could not budge. They lifted their eyes to the flag. It was spattered with blood. Once more they were horrified. Then they timidly ventured a few more looks upward and began to smile slightly. They were filled with a strange pride, a pride they had never known before: the flag they were carrying had been consecrated by blood. Once more they joined the march" (265).

Expressing "all that is spurious in the life of our times," kitsch is usually dismissed as a wholly derivative aesthetic (Greenberg 1961, 10). Reliant on imitation and romantic sensibility, it constitutes a "transvaluation of insincerity into sincerity, of imitation into willful repetition, and thus of forgery into an all too sincere gesture of human good will" (Binkley 2000, 140).[23] Cheap, inauthentic, and mass-produced, the so-called kitsch object is always counterfeiting something, usually sentiment. From aesthetic philosophers to contemporary critics, kitsch is often decried for this quality of artificiality.[24]

Descendants of Kantian aesthetics attempt to describe and dismiss kitsch as material objects produced in bad taste. The *Oxford English Dictionary* defines the word in these terms: "Art or objets d'art characterized by worthless pretentiousness; the qualities associated with such art or artifacts."[25] Noted art critic Clement Greenberg refers to it as "ersatz culture ... vicarious culture and faked sensations" (1961, 10). Kitsch, he argues, is "the epitome of all that is spurious in the life of our times" (10). Yet, as Greenberg's social history of the term suggests, kitsch refers to far more than simply the mass production of cheap trinkets; it designates a dangerous political sentimentality: "The encouragement of kitsch is merely another of the inexpensive ways in which totalitarian regimes seek to ingratiate themselves with their subjects" (19). Referring both to objects produced cheaply and to the

kinds of group identifications enabled via these objects, kitsch emerges as a powerfully pervasive phenomenon.[26]

For Kundera, the dangers of kitsch become most apparent when both senses of the term are operational, for the power of symbols, often replicated in mass-produced objects, operates concomitantly with the romantic sentimentality of kitsch: "The feeling induced by kitsch must be a kind the multitudes can share. Kitsch … must derive from the basic images people have engraved in their memories: the ungrateful daughter, the neglected father, children running on the grass, the motherland betrayed, first love. Kitsch causes two tears to flow in quick succession. The first tear says: How nice to see children running on the grass! The second tear says: How nice to be moved, together with all mankind, by children running on the grass! It is the second tear that makes kitsch kitsch" (1991, 251). And where the unofficial and popular commingle with the official – be it in the form of a t-shirt claiming American solidarity or a Rockwell inviting group identification – the magic of the state does its best, kitschy work (Taussig 1997).[27]

On 20 September 2001 President Bush declared it was time to lay grief to rest and pursue vengeance: "Our grief has turned to anger, and anger to resolution. Whether we bring our enemies to justice, or bring justice to our enemies, justice will be done" (White House 2001a). Mourning translates into sentiment, which translates into kitsch communitarianism, and produces a drive to annihilate those outside the group. Reformulated in Bush's terms, the message is clear: stake your place next to my line in the sand. Grief is subsumed under and harnessed to the larger project of "Infinite Justice" – the original name given to Operation Enduring Freedom in Afghanistan.[28]

Now, seven years after the attacks in New York and Washington, the United States is struggling with the problem of its failed campaign in Iraq, while attempting to convince its citizens that the invasion has accomplished its goals. Veterans are having breakdowns, soldiers are

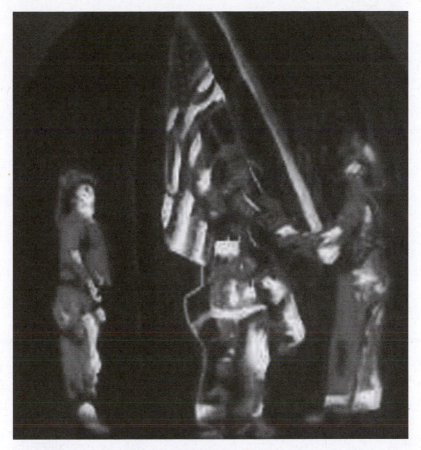

Fig. 41 Jack o' Lantern with firemen raising flag image.
http://www.carvingpumpkins.com.

returning in coffins, and Bush has gone on record to affirm his disin-
terest in Osama bin Laden's whereabouts. And Afghanistan? We hear
very little from the US media about Afghanistan. What we do know
from international news agencies suggests that the Taliban and al-Qaeda
remain relatively untouched, whereas the civilian population has been
utterly devastated. Collateral damage.

The bedtime scene and elementary school lesson provided by the *New York Times'* doctored Rockwells merges one historical moment with our own, "making sense" by reducing the difference between them. The ghosts of history walk these grounds, resurrected in the ashes of Ground Zero, but the entangled threads of descent have been eclipsed by a much simpler story of evil and good. Michel Foucault warns us to be suspect of so-called historical points of origin: "What is found at the historical beginning of things is not the inviolable identity of their origin; it is the dissension of other things. It is disparity" (1977, 142). The events of September 11 in no way represent the origin of this supposed "war on terror," yet this is the storyline we have been given.

To recall the writing of Angela Carter with which I began, the con of the towers consists in their disappearance being made to justify invasion, murder, and torture. It consists in their disappearance being used to perpetuate the American dream of righteousness rather than to effect an awakening to a more complex vision of history and the future. *In the shadow of no towers*, indeed. Our challenge lies, in part, in a never-ending negotiation between the "I" and the "we," for neither is expendable. We walk in the shadow of ghostly absence, but we have so far failed to hear the voices of our shades. They remember the rubble at Ground Zero altogether differently. They remember it as the detritus of history over which Benjamin's angel mourns.

Notes

Introduction

1 Kathleen Stewart's *A Space on the Side of the Road* (1996) is one work particularly attuned to the elusiveness of meaning and the drive to "say something anyway."

2 See Buck-Morss (1992).

3 Allen Shelton gets full credit for this formulation of disappearance and reappearance, as communicated to me in personal conversation. "Magic of the state" is a reference to Taussig's (1997) book by the same title. His analysis is important throughout this text.

Chapter One

1 To restate: because she is not finished, *elle n'est pas finie* in the terminal sense. In French, the use of *être* (instead of *avoir*) with the verb *finir* signifies completion as death rather than simply designating the termination of some task.

2 I mean *comprehension* in the sense of both understanding and containing – not simply because, as a sculpture, she resists reduction through narrative language but also because her story does not end. She has not yet died – *elle n'est pas encore finie*. Thus she bears an essential relation to questions of time, of futuricity, and of what cannot yet be known.

3 Beginning with the Greeks, and continuing on through primarily Rousseau, Saussure, and Peirce, Derrida (1997a) cites a historical tradition of debasing writing or graphic text while elevating the *phonē*, or live speech. Indicated as

an exterior form, hopelessly fallen from self-presence and absolute proximity – the proper – the graphic form is "the outside, the exterior representation of language and of this 'thought sound'" (31).

4 Although not in the scope of this chapter, the borderlines separating naked and nude in traditional art criticism need to be interrogated. Some writers have begun to address this (e.g., Davidov 1998; Pultz 1995).

5 See Gorer (1965).

6 For Heidegger, truth is anything but a recapitulation of the metaphysics of the proper: "Truth means the essence of the true. We think this essence in recollecting the Greek word *alêtheia*, the unconcealment of beings … The essence of truth as *alêtheia* was not thought out in the thinking of Greeks, and certainly not in the philosophy that followed after. Unconcealment is, for thought, the most concealed thing in Greek existence, although from early times it determines the presencing of everything present" (1993, 176, original emphasis).

7 Heidegger writes: "The essence of truth which is familiar to us – correctness in representation – stands and falls with truth as unconcealment of beings" (1993, 177). Susan Sontag makes a similar argument in her manifesto against classical art interpretation: "Interpretation, based on the highly dubious theory that a work of art is composed of items of content, violates art. It makes art into an article for use, for arrangement into a mental scheme of categories" (1966, 10).

8 For a fascinating analysis of Bush Junior's sense of historical obligation to Bush Senior's experiences in the Second World War and Iraq, see Ronell (1994a). Reading this piece now, in the wake of the US government's activities since 9/11, casts an even more harrowing light on the current administration's military projects.

9 From the implicating of Iraq in 9/11, to the subsequent war with Iraq, to the final denunciation of the notion that Iraq was ever involved in 9/11, we see a classic example of the US government's (and its allies') modes of doublespeak.

10 Regarding the current state of permanent war abroad, many critics have remarked on the uncanny relevance of George Orwell's classic *Nineteen Eighty-Four* (1949). Gore Vidal's *Perpetual War for Perpetual Peace* (2002) provides a similar, if more contemporary, analysis.

11 One could argue that Derrida has only ever written about mourning, but some of his more obvious texts on the subject include: *Spectres of Marx* (1994b); *Cinders* (1991); *Adieu: To Emmanuel Levinas* (1999); *The Gift of Death* (1995); and *Of Grammatology* (1997a).

12 James Young writes: "A new generation of cubists and expressionists, in particular, rejected traditional mimetic and heroic evocation of events, contending that any such remembrance would elevate and mythologize events. In their view, yet another classically-proportioned Prometheus would have falsely glorified and thereby redeemed the horrible suffering they were called upon to mourn" (1999, 6). For further reading, see Bataille (1929), Mumford (1940), Nietzsche (1957), Nora (1996), and Krauss (1985), among the many writers who have targeted monumental structures for their production of monumental histories.

13 See Nietzsche's *The Use and Abuse of History* (1957).

14 I use *remembrance* deliberately here, with its echoes of Proust's eruptive Madeleine-eating experience. Two words, from the German, are typically used to explicate and distinguish different forms of memory: *Gedächtnis*, the "thinking, mechanical" memory; and *Erinnerung*, the interiorizing memory of recollection. See Derrida's writing on memory in *Memoires: For Paul de Man* (1989, 28).

15 The following etymological work is not intended to determine the proper meanings and usages of each term. Instead, I wish to suggest that the possibility for what Young (1999) names "counter-monuments" can be traced through the history of these words.

16 *Oxford English Dictionary Online*, s.v. "memorial," http://www.oed.com (accessed 18 July 2008).

17 Ibid.

18 *Oxford English Dictionary Online*, s.v. "monument," http://www.oed.com
 (accessed 18 July 2008).

19 Ibid.

20 Here, "writing" refers to Derrida's articulations of *arche*-writing, not to writing
 in the limited, or *vulgar*, sense of inscribed text. See his *Of Grammatology*
 (1997a).

Chapter Two

1 Unsurprisingly, the other photographs in the sequence present an entirely
 different narrative of the falling man's downward flight: "In truth, however, the
 Falling Man fell with neither the precision of an arrow nor the grace of an
 Olympic diver. He fell like everyone else, like all the other jumpers – trying to
 hold on to the life he was leaving, which is to say that he fell desperately, inel-
 egantly. In Drew's famous photograph, his humanity is in accord with the lines
 of the buildings. In the rest of the sequence – the 11 out-takes – his humanity
 stands apart. He is not augmented by aesthetics; he is merely human, and his
 humanity, startled and in some cases, horizontal, obliterates everything else
 in the frame" (Junod 2003).

2 See Georges Bataille's work on sex and death in *Erotism: Death and
 Sensuality* (1986).

3 As a discursive formation, pornography remains fluid. Although the spurious
 attempt to distinguish between porn and its so-called softer side – eroticism
 – is ongoing, pornography as an ontological category does not exist and so
 evades definition. Civic or moral groups *know it when they see it*, of course,
 and this elusiveness adds to its power in judgment.

4 Junod (2003) refers to still images, for the video clips of the planes crashing
 and the towers collapsing also became taboo.

5 In his seminal essay "The Pornography of Death" (1965), Geoffrey Gorer
 argues that pornography is intertwined with prudery. Like porn, prudery oper-
 ates contextually: "some aspect of human experience is treated as inherently
 shameful or abhorrent, so that it can never be referred to openly, and experi-

ence of it tends to be clandestine and accompanied by feelings of guilt and unworthiness" (171). Although various representations of sex have long been targeted as unfit for public viewing, Gorer argues that in the twentieth century depictions of so-called *natural death* – death resulting from old age, disease, and the like – have overshadowed sexuality as a category of the obscene. He writes: "whereas copulation has become more and more 'mentionable' … death has become more and more 'unmentionable' as a natural process … The natural processes of corruption and decay have become disgusting" (172). The consequences of this taboo against viewing death in the everyday, Gorer argues, is a pornography of exotic death: "violent death has played an ever-growing part in the fantasies offered to mass audiences – detective stories, thrillers, Westerns, war stories, spy stories, science fiction, and eventually horror comics" (173). By repressing representations of *natural* death in the public domain, Gorer contends that modernity has ignited and fed a seemingly insatiable appetite for fantasies of violent, terrible death.

But Gorer's argument hinges on a series of distinctions that remain as untenable as the differentiation between pornography and eroticism. The delineation between violent and nonviolent, or *natural*, death is one such distinction. Although his insistence on pornography as a discursive category is important, the ensuing claim for pornographic emergence out of repression regresses into a monolithic vision of power and censorship, which depends in turn on totalized notions of the *masses*. Finally, his contention that this emergence of violent death in so-called clandestine writing is relatively recent must be complicated by acknowledging a historical precedent for writings of violent and exotic death. Shakespeare's history plays provide an obvious counterpoint, but countless others exist, many of which have never been considered covert or surreptitious. Historical context becomes vital in this kind of analysis, taking into account a given era's conceptions of violence, an understanding of language codes specific to the time, as well as knowledge of printing and publication techniques, readership, and dissemination of materials. For theatrical productions, of course, other factors of style and performance must also

be situated in time and place. Michel Foucault's analysis of censorship and repression in volume one of *The History of Sexuality* (1990) provides one starting point for theoretically complicating Gorer's work; Foucault's essay "Nietzsche, Genealogy, History" (1977) is another.

6 At least one Internet site featuring jumper photographs, Jumpers: September 11 Twin Towers Memorial Photos Videos & News Archive of the WTC Attack, has been set up at: http://www.twintowers.net/jumpers.htm (accessed 2003).

7 As Junod (2003) writes, the number of jumpers on September 11 is far from insignificant: "*The Times*, admittedly conservative, decided to count only what its reporters actually saw in the footage they collected, and it arrived at a figure of 50. *USA Today*, whose editors used eye witness accounts and forensic evidence in addition to what they found on video, came to the conclusion that at least 200 people died by jumping, a count that the newspaper authorities did not dispute … [I]f the number provided by *USA Today* is accurate, then between 7 and 8 per cent of those who died … died by jumping out of the buildings; it means that if we consider only the North Tower, where the vast majority of jumpers came from, the ratio is more like one in six."

8 *Graphē* is the Greek word for "writing"; "photography," from the Greek, translates as *light writing* or *writing in light*.

9 While these actions were taking place inside US borders, attacks on non-American journalistic operations were also being carried out: "In Afghanistan, American forces bombed the Afghan radio and TV headquarters. The offices of Al Jazeera, the BBC and the Associated Press (AP) news agency were also hit during the attack on Kabul. US Special Forces tried to keep reporters away from the Tora Bora region when they suspected Bin Laden was hiding there" (Reporters without Borders 2002). The US government has also extended its control to the skies. In October 2001, just before the attack on Afghanistan began, the Defense Department bought up the "exclusive rights to all available satellite images of Afghanistan and neighboring countries … The agreement … produced an effective white-out of the operation, preventing Western media from seeing the effects of the bombing and eliminating the

possibility of independent verification or refutation of government claims …
The CEO of *Space Imaging Inc.* said, 'They are buying all the imagery that is
available.' There is nothing left to see" (Levi Strauss 2003, 190). What we are
left to write, in the wake of these events, as well as in the midst of those yet
in motion, is absence: what we do not see, are not shown, cannot know.

10 In her essay "Dead Stuff" (1997), Annie Proulx provides a brief summary
of the history of dead bodies in US war photography (30–5).

11 There are two exceptions to this exclusion. First, in the entire anthology *Here
Is New York: A Democracy of Photographs* (George et al. 2002), one photo-
graph of a severed and dismembered leg has been included (264). Second,
an Internet site featuring jumper photographs (Jumpers 2003) contains a link
to a supposedly hoax photograph of the body of a jumper after hitting the
ground. The morality of looking I referred to earlier extends even further in this
instance: because the photo has been determined a fake, it is excluded from
the true photographs of the jumpers.

12 This is why any reductive charge of state censorship in the case of certain
9/11 images must be resisted. Countless stories of government intervention
and suppression have emerged, but they are accompanied by a more gener-
alized display of individually performed acts of censorship. For example, Jules
Naudet, a French filmmaker who documented the towers' collapses, remem-
bers that almost immediately upon entering the north tower, a kind of "auto-
censorship" kicked in. Watching people dying all around him, their bodies
engulfed in flames, Naudet was unable to film the carnage: "As I entered this
building I hear a scream on my right and I just turned and seeing that horrible
image of two people who are still alive and moving but who are in flames and
dying in front of my own eyes. The image was so horrible and so traumatizing
in a way and I didn't film it … it was so bad … there is some kind of respect
that should be shown in death. That kind of auto-censorship, we did it for the
rest of the day and the weeks to come … we always shied away from show-
ing that" (cited in O'Carroll 2002). Naudet's insistence on respectful repre-
sentation, a pronouncement often repeated in the days following the attacks

by journalists, government officials, and civilians alike, marks a chiasmus of image and mourning. But what determines respect in an image?

13 See, for example, *Here Is New York: A Democracy of Photographs* (George et al. 2002); *The September 11 Photo Project* (Feldschuh 2002); *New York September 11* (Magnum Photographers 2001); and *September 11: A Testimony* (Reuters 2001).

14 The now famous faces in the missing-persons posters first erected around Union Square are similarly caught in the passage between life and death. These posters soon became memorials; but in those first, terrible days, their subjects were not yet recognized as dead, only missing. Although the posters eventually became identified as memorial sites, they remain essentially liminal and, as such, undefinable, unnameable.

15 Derrida discusses this resistance to the ontological question at greater length in "By Force of Mourning" (1996).

16 From Jean-Martin Charcot's images of hysterical women patients in the Salpêtrière, to early photographs by police detectives, to photographs attempting to establish physical signs of criminality and insanity, photography has from its birth been concerned with both bourgeois portraiture and its underbelly – profiling and identification. As Barthes writes: "Photography, moreover, began, historically, as an art of the Person: of identity, of civil status, of what we might call, in all senses of the term, the body's formality" (1981, 79).

17 As Junod (2003) writes: "Many of the dead were Latino, or light-skinned black men, or Indian or Arab. Many had dark hair cut short. Many had moustaches and goatees. Indeed, to anyone trying to figure out the identity of the Falling Man, the few salient characteristics that can be discerned in the original series of photographs raise as many possibilities as they exclude."

18 Cheney's attempt to establish Norberto Hernandez as the *Falling Man* is of particular import when considering the difficulties and complexities of such a quest. Torn apart over this very photograph, the Hernandez family, through its various reactions (Junod 2003), gives a face to the question of whether such an attempt at identification should be made.

19 As Barry (2003) writes, the reasons for the decline in these numbers range
 from "finding people once thought dead; duplication; insufficient data; fraud.
 In many cases, investigators could not prove a supposed victim had ever
 existed."

20 The hunt for dead bodies at Ground Zero and at the Fresh Kills landfill was
 paralleled by the hunt undertaken by the United States and its allies for live
 bodies following 11 September 2001. Allied armies were searching for vari-
 ous proper names, among them bin Laden and, latterly, Saddam Hussein. At
 a civilian level, much work remains to be done on all that has happened to
 bodies since the twin towers fell: work on deportation, torture, border cross-
 ings, airport security, and immigration issues. These varied contexts have seen
 many different attempts to fix and regulate bodies in a kind of perpetual terror-
 prevention program.

21 Some suggest time is the answer. After the passage of a certain time, we
 now have museums devoted to the Holocaust. We can meditate on exhibits
 of shoes, tooth fillings, and spectacles because they serve as *aides-mémoire*.
 Visiting museums and making pilgrimages to death camps is a proper and
 officially sanctioned method of remembrance. This has not always been the
 case. As Christy Ferer suggests: "They can show that now … But [the Holo-
 caust] was a long time ago. They couldn't show things like that then." But, as
 Junod counters, "Of course these objects were exhibited after the war, but
 the medium was photography, not gallery display. The stated purpose of
 these images? Evidence … the pictures that came out of the death camps of
 Europe were treated as essential acts of witness, without particular regard to
 the sensitivities of those who appeared in them or the surviving families of the
 dead" (cited in Junod 2003). Time alone cannot account for the different
 treatment of Drew's image compared to that accorded the work at Fresh Kills.
 I suspect part of the answer lies not only in the instrumentality of identifica-
 tion, as I argue further on, but also in the changing conceptions of museums
 and the social work they can perform for spectators.

22 As Abigail Solomon-Godeau writes, "the ability even to formulate the notion of

a documentary mode is predicated on the perceived presence of its Other(s). Which is to say that without the coexistence of alternative models of photography ... the very notion of documentary becomes tautological. This immediately foregrounds the question of documentary's discursive construction: how is documentary thought and what ideological work is it performing?" (1991, xxviii).

23 See, for example, Barthes (1981), Batchen (2001, 2002), Solomon-Godeau (1991), and Sontag (2001a, 2003).

24 Of course, the imposition of these identifications, despite their semiotic arbitrariness, continues to produce material effects, like attempts at censorship.

25 *Reflecting Absence*, the winning memorial design, reproduces both the successes and failures of technological memory. Although the names of the identified victims will be inscribed around two reflecting pools, a stone container holding unidentified remains will stand alongside the acknowledged dead.

26 See Giorgio Agamben's work in *The Coming Community* (1993) on the *whatever being* – his articulation of a subject without identificatory labels – and this crisis of identification.

Chapter Three

1 Earlier turn-of-the-century wars had alerted governments and citizens alike to the possibilities this format held. See Nelson (2004, 281).

2 Reprinted from *Prairie Schooner* 79, no. 1 (2005), by permission of the University of Nebraska Press.

3 See Williams's poem, "This Is Just to Say" (1986), which begins: "I have eaten / the plums / that were in / the icebox" (372).

4 This, of course, is not limited to the literary genre we traditionally define as *poetry* but applies to any mode or medium of bringing-forth. Thus, Heidegger tells us, "Not only handicraft manufacture, not only artistic and poetical bringing into appearance and concrete imagery, is a bringing-forth, *poeisis. Physis*, also, the arising of something from out of itself, is a bringing-forth, *poeisis*" (1993, 317, original emphasis).

5 See chapter 1, on the sculpture *Tumbling Woman*, for a discussion of *alitheia*.

6 Such a state recapitulates the terrors of Franz Kafka's *The Castle* (1998), in which endless documentation provides horrific, bureaucratic control through a system of infernal desire machines – a compulsive repetition of information gathering.

7 How eerily does this resonate with Michel Foucault's discussion in *Discipline and Punish* (1995)? In a French town at the close of the seventeenth century, government officials responded to the threat of the plague with extreme measures: segmentation, inspection, and perpetual surveillance: "The plague-stricken town provided an exceptional disciplinary model: perfect, but absolutely violent; to the disease that brought death, power opposed its per-petual threat of death; life inside it was reduced to its simplest expression; it was, against the power of death, the meticulous exercise of the right of the sword" (207). For the American administration after September 11, terrorism enabled the same level of surveillance, which was met by both protest and gratitude, as enacted during this plague. The movements of 9/11 commemo-rative postcards provide an illustration of Foucault's description of self-subjec-tion, suggesting some of the means by which the terrorist attacks in New York have been internalized and transformed into so much fuel for state discipline and self-surveillance.

8 See also Derrida's analysis of the gift-event in *Given Time: I. Counterfeit Money* (1994).

9 I take the concept of "interruption" from Jean-Luc Nancy's work in *The Inoperable Community* (1991).

10 It would be naive to imagine the FBI has made public all its information re-garding these events. Whereas a number of letters are believed to have origi-nated from somewhere in Florida, others appear to have been mailed from out of country, as far away as Malaysia. Mimicking al-Qaeda sleeper cells, the an-thrax letters have no home base and leave only traces of their history behind. In 2008, however, the FBI reported on an American scientist suspected of sending these letters, but it waited until after his death to do so.

11 As Robin McKie (2001) reports, "Bob Stevens was a journalist for American
Media group at its headquarters in Boca Raton, Florida, when he became ill
last week. At first his flu-like symptoms were thought to be those of menin-
gitis. Only after he died was it realized he had contracted anthrax, the first
person in the US to die of the disease since 1976."

Chapter Four

1 Cited in Puar and Ray (2002, 137).

2 "Here" denotes the Western-centric, and particularly American-centric, sense
of geography as divided between a "here" and a "there," in which what's over
"there" is conceived as violent, dangerous, primitive, and exotic, while the
"here" is constituted as civilized and controlled.

3 Her conceit – the dream state – can only make us remember another thinker
of the dream and his desire that we learn how to wake up well. I am of course
referring to Walter Benjamin and his work on the dream; see, for example,
The Arcades Project (1999a).

4 See, for example, Frazer (1911) and Tylor (1891).

5 Think of it as metonymic for the invasions of Afghanistan and Iraq. And, in light
of photographs that have emerged detailing US treatment of Iraqi and Guan-
tanamo prisoners, the doll replicates an uncanny doubling that signifies far
more than the ironic replication of the unlocatable evil enemy.

6 A few years ago, Polish artist Zbigniew Libera produced his Lego concentra-
tion camps. Evoking commonplace phrases like "war games," these toys raise
complex and fascinating questions about soldiers, infantilization, and violence.

7 The face has fascinated many writers. Bataille calls it a "scandal" (1985d, 8);
Benjamin suggests that all the world "could be thought of as a 'face' to be
read for its inner 'soul'" (cited in Taussig 1999, 230); and Deleuze discusses
it as a combination of micromovements and reflection (1986, 87–8). Lev-
inas's (1981) articulation of the encounter with the face of the Other – the
recognition of the Other as irreducible and impenetrable – as the embodi-
ment of the ethical relation par excellence holds particular interest for this
discussion.

8 As Allan Sekula writes: "The clearest indication of the essential unity of this
 archive of images of the body lies in the fact that by the mid-nineteenth cen-
 tury a single hermeneutic paradigm had gained widespread prestige. This par-
 adigm has two tightly entwined branches, physiognomy and phrenology. Both
 shared the belief that that surface of the body, and especially the face and
 head, bore the outward signs of inner character" (1986, 10–11).

9 Kelly Gates provides a perfect example of the continued relevance of the mug
 shot: "In the days following September 11, President George W. Bush
 invoked an image of Osama bin Laden's face on an old-west-style 'Wanted
 Dead or Alive' poster. This relic of the wild west gives metaphoric leverage to
 the mythic face of twenty-first-century terrorism. More than the crimes he
 committed, the outlaw was created in the transfer of his image to the wanted
 poster" (2002, 238). This framing of bin Laden within the historical tradition
 of the "Wanted" poster also underscores this twenty-first-century moment's
 connections to earlier moments in American history.

10 Bush proceeds to explain: "I say 'the first 22' because our war is not just
 against 22 individuals. Our war is against networks and groups, people who
 coddle them, people who try to hide them, people who fund them. This is our
 calling. This is the calling of the United States of America, the most free na-
 tion of the world" (White House 2001).

11 And they are all men; this must be highlighted from the outset, for both the
 political and popular stereotypes of Middle Eastern terrorists produce feminin-
 ity and masculinity in very particular ways.

12 Neil Smith details some of the ironies emerging from this erasure of the Amer-
 ican terrorist: "Hence the official silence about the identity of the anthrax
 terrorists – presumed, like bin Laden, to have been trained by the U.S.
 government – which contrasts sharply with the demonization of 'foreign'
 terrorists. From Timothy McVeigh (also trained by the U.S. military) to the
 Columbine high school shooters, domestic terrorists are rarely objectified as
 such. And why else would the White House insist, without clarification, that
 Charles Bishop, the Florida teenager who flew a plane into a Tampa Bay
 skyscraper in a 'gesture of support' for bin Laden, was not a terrorist? The

answer lies in the enormity of the ideological stakes: if Americans are also terrorists, why is the 'war on terrorism' exclusively focused on the Middle East or against Muslims?" (2002, 106).

13 I am drawing specifically on Derrida's (1997) articulations of "the supplement" as that operation which both adds to and substitutes for a particular representation. Paradoxically, the supplement "harbors within itself two significations whose cohabitation is as strange as it is necessary. The supplement adds itself ... But the supplement supplements. It adds only to replace ... This second signification of the supplement cannot be separated from the first" (144–57).

14 Benjamin writes: "not that what is past casts its light on what is present [or vice versa]; rather, image is that wherein what has been comes together in a flash with the now to form a constellation ... image is dialectics at a standstill" (1999c, 462).

15 Mike Driscoll phrases it similarly, arguing that we need "to mark the seemingly instrumental suturing of the popular to the globopathic and globocidal U.S. geopolitics" (2004, 68). He adds that "consumers read the tabloids, attend sporting events, surf the Net, peruse *USA Today* and the *Wall Street Journal*, watch TV, and experience this not as a series of epistemological fractures ... but as the veritable media lifeworld of subjects in the global North" (81).

16 Although I do not dispute the gravity of the charges levelled against bin Laden, it is the technologies deployed in his representation that interest me, not his relative guilt or innocence.

17 Bataille's fascinating narratives of these two organs – solar anus (1985d) and pineal eye (1985c) – deftly collapse Enlightenment borders dividing sight from smell. In the process, the human face takes on a modified anality.

18 I see fascism as fundamentally rooted in the body. Taking my cue from writers like Klaus Theweleit (1987), who describes fascism as a conscious desire to rid the body (both individual and collective bodies) of perceived impurities, and Rey Chow (1995), who adds to this desire for purgation an inextricable wish for beauty and perfection, I believe fascism can be found where the

quest for an ideal and the deliberate pathologization of difference are de-
tectable. Michel Foucault's preface to *Anti-Oedipus* (1996) remains one of
the most compelling articulations of this kind of fascism: "Last but not least,
the major enemy ... is fascism ... And not only historical fascism, the fascism
of Hitler and Mussolini – which was able to mobilize and use the desire of the
masses so effectively – but also the fascism in us all, in our heads and in our
everyday behavior, the fascism that causes us to love power, to desire the
very thing that dominates and exploits us" (xiii).

19 Robyn Wiegman provides an important analysis of lynching practice in *Ameri-
can Anatomies* (1995): "In the turn toward lynching ... in the post-Emancipa-
tion years, we might recognize the symbolic force of the white mob's activity
as a denial of the black male's newly articulated right to citizenship and, with
it, the various privileges of patriarchal power that have historically accompa-
nied such significations within the public sphere ... In the lynch scenario, the
stereotypical fascination and abhorrence for blackness is literalized as a com-
petition for masculinity and seminal power" (83).

20 The attendant ironies of this post-Emancipation frenzy – the prevalence of
miscegenation between white slave owners and black slave women prior
to Emancipation is well documented – bear repeating. See, for example,
Wiegman (1995) and Carby (1997).

21 Discussing the work of Ida B. Wells, Carby notes: "Wells demonstrated that,
while accusations of rape were made in only one-third of all lynchings, the cry
of rape was an extremely effective way to create panic and fear ... The North
conceded to the South's argument that rape was the cause of lynching; the
concession to lynching for a specific crime in turn conceded the right to lynch
any black male for any crime" (1997, 335).

22 More specifically, *white* woman embodies this threat, for as Chow proceeds
to argue, "this construction, because it admits women *as* sexuality and noth-
ing more, leaves no room for the woman of color to retain her membership
among her own racial/ethnic community" (1988, 67).

23 There are, of course, an abundance of images of diverse women that have

come to signify in this "war on terror," but it is beyond the scope of this book to explore all of them. Further work needs to be done, for example, on the representations of Afghan women, members of the Revolutionary Association of the Women of Afghanistan (RAWA), the role of the burqa, and women suicide bombers. Here, I am concerned only with the production of white womanhood and its historical linkages to discourses of femininity, miscegenation, and danger within America.

24 Many scholars have made the point that the media's emphasis on Lynch's whiteness and feminine vulnerability exemplifies the continued circulation of both sexist and colonialist rhetoric in the United States' ongoing war campaigns. For instance, Melisa Brittain notes: "In narratives of Lynch's ordeal, her heroism pivoted on her vulnerability as a white woman in the face of Arab masculinity, and the reiteration of the trope of interracial rape was utilized by members of the media eager to naturalize US military violence during a moment of crisis" (2006, 81).

25 As Deepa Kumar notes, the war in Afghanistan retooled this scenario, casting "the Taliban as villain, Afghan women as victims and the US, predictably, the gallant hero/protector" (2004, 298).

26 See, for example, Brittain (2006).

27 Writing about the Shoshana Johnson event, Kumar notes: "While the stories are similar, Johnson could not be Lynch. As a black woman with dreadlocks, she simply does not qualify for the status of 'girl next door' ... The deployment of whiteness in the Lynch hero/victim narrative is essential to differentiating 'America' and the 'West' from 'Islam' and the 'Middle East'" (2004, 302).

28 As Christopher Hanson writes: "Neither a link between Saddam and Osama bin Laden nor Iraqi weapons of mass destruction materialized. Although the Pentagon drummed the idea that our mission was to liberate the Iraqi people, many Iraqis saw our troops as unwelcome. But before doubts could fester, the Lynch rescue story broke. It was a p.r. windfall for the military, the first successful rescue of a U.S. POW behind enemy lines since World War II. The announcement was a godsend to the press corps ... Reporters at last could

deliver the straightforward, emotionally fulfilling saga of good beating evil that America expects" (2003, 59).

29 The rescue was staged in this way despite reports that Iraqi soldiers had abandoned the hospital and that medical administrators had been trying to re-lease Lynch to the US Marines for days (Faludi 2007; Hanson 2003; Russell 2003).

30 Apparently, war correspondents were roused from their beds "before four that morning … to screen a five-minute clip in which a prostrate Jessica Lynch … was hustled by gurney to a waiting helicopter, an American flag draped on her chest" (Faludi 2007, 167).

31 See, for example, Leni Riefenstahl's films *Olympia* (1938) and *Triumph of the Will* (1935), both celebrations of idealized bodies devoted to the state.

32 Like Benjamin's "angel of history" (1968a), we are caught in the storm of progress.

Chapter Five

1 In "By Force of Mourning" (1996), for example, Derrida writes: "whoever thus works *at* the work of mourning learns the impossible – and that mourning is interminable. Inconsolable. Irreconcilable. Right up until death – that is what whoever works at mourning knows, working at mourning as both their object and their resource, working *at mourning* as one would speak of a painter working *at a painting* but also of a machine working *at such and such an energy level*, the theme of work thus becoming their very force, and their term, a principle" (172-3, original emphasis).

2 The complete list of his examples includes: "luxury, mourning, war, cults, the construction of sumptuary monuments, games, spectacles, arts, perverse sexual activity (i.e., deflected from genital finality)" (Bataille 1985b, 118).

3 For more on the relationship between mourning, melancholia, and psycho-analysis, see Kristeva (1982, 1989).

4 In total, three Rockwell images were digitally altered, but two of the images were published twice. I discuss two of these images: *Freedom from Fear* and

Teacher's Birthday. The third image, based on Rockwell's 1927 painting *The Stay at Homes (Outward Bound)*, is not explicitly addressed here.

5 The *New York Times* was certainly not alone in capitalizing on the sentiment of September 11. Kenneth Cole ran several advertisements in magazines like *GQ*. Donna Karan New York, or DKNY, another fashion line rooted in the city, also ran ads after September 11. One of these photographs features a male model buttoning up his jacket as he walks a typical New York street. Flanked by a yellow cab on one side and a construction sign on the other, he appears beneath a neon advertising crawl that runs across a building directly behind him. The message, which extends beyond the frame of the photograph, reads: "One City One World One City One World."

6 At least two different explanations for this rejection exist. Michael Kimmelman recounts that "in 1942 the Office of War Information first rejected the designs … because the government's plan was to use 'real artists,' not illustrators, to rally the nation" (2001). Lester Olson provides a different account: "Secretary of the Treasury Henry Morganthal refused the gift [in 1941], because the Treasury did not dabble in art" (1983, 19). Note not only the discrepancy in dates but also the different departments identified as the rebuffing parties.

7 As Kimmelman notes, "the debate about whether Rockwell was a good artist or not is as shopworn as his art" (2001).

8 It is worth noting that Rockwell was not enthralled with this painting; he later suggested it was "based on a rather smug idea," which arrogantly emphasized American safety in opposition to European insecurity (Hennessey 1999, 102).

9 Apparently, Rockwell had reservations about this painting as well: "He wasn't too happy with *Freedom from Want* either, the beloved Thanksgiving scene with the family at the table ready to eat the big turkey, an image Europeans resented because it suggested American overabundance. Rockwell was sorry about that, too" (Kimmelman 2001).

10 These authors were Will Durant, Booth Tarkington, Carlos Bulosan, and Stephen Vincent Benét (Olson 1983, 19).

11 In *The Sublime Object of Ideology* (1995), Žižek writes: "The 'quilting' per-
 forms the totalization by means of which this free floating of ideological ele-
 ments is halted, fixed – that is to say, by means of which they become parts
 of the structured network of meaning" (87).

12 These portraits, which were accompanied by brief biographical narratives
 about the victims, were published every day from 15 September to 12 De-
 cember 2001. In all, 1,910 photographs were run in the section "A Nation
 Challenged: Portraits of Grief," a title explicitly framing mourning as a national
 undertaking (Miller 2003, 112). The significance of this nationalism emerges
 when we consider which photographic obituaries were published in this spe-
 cial daily insert and which ones have never seen distribution. Despite aware-
 ness that hundreds (thousands?) of Afghan civilians were murdered because
 of 9/11, we receive no significant reporting of those individual lives: they are
 not recognized as mournable losses. As Butler writes, the obituary "is the
 means by which a life becomes, or fails to become, a publicly grievable life, an
 icon for national self-recognition ... we have to consider the obituary as an
 act of nation-building" (2004, 34). Moreover, the exclusion of *other* victims
 "serves the derealizing aims of military violence" (37). Highlighting the failure
 of mainstream mourning to accomplish the unbounded recognition of which
 Butler (2004) and Rose (1996) speak, the "Portraits of Grief" reflect an ex-
 clusionary view of who counts as a victim of September 11. Thus, when the
 Times recognizes only certain victims as victims in its special obituary section,
 the Rockwell ads that follow are further enabled to consolidate an imaginary
 American community justly battling an abstracted and evil Other.

13 This image, too, first appeared as a *Saturday Evening Post* cover, on
 17 March 1956.

14 My thanks to Mark Simpson, who first suggested this as another way of
 seeing the image.

15 See de Certeau (1988) and Derrida (1974).

16 For example, see Freud's discussions of totemism in *Totem and Taboo*
 (1991c) and hysterical identification in "Mourning and Melancholia" (1991b).

17 Emmanuel Levinas's (1981) articulation of the Other as absolute Other
 haunts this section.

18 On hauntology, see Derrida (1994). Among other surveillance techniques
 adopted or in the planning stages are Combat Zones that See (CTS), Terror-
 ism Information Awareness (TIA), and Lifelog. All of these projects have
 emerged from the Pentagon's Defense Advanced Research Projects Agency
 (DARPA). For a basic description of these programs, see for example,
 Schachtman (2003) and Campbell (2003).

19 I say "imagined" because, of course, many dissenters, including a significant
 number of New Yorkers, attempted to make their opposition to the Bush
 administration's aggressive reactions known. For a visual example, see the
 following images from *Here Is New York: A Democracy of Photographs*
 (George et al. 2002): first, a photograph of one slogan – "Our Grief is not
 a Cry for War" – that circulated in the months following the attacks (600);
 second, an image that captures several protest signs featuring both this
 slogan and "New York: Not in Our Name" (611); and finally, a photograph
 that shows one of the many antiwar protests that took place in the city over
 the course of nearly two years (638).

20 See Faludi for an analysis of the specifically antiwoman/antifeminist form
 these attacks took in the United States (2007, 19–45).

21 Although I have no photograph to document this find, several articles online
 refer to these t-shirts. See, for example, Younge (2001).

22 In 2002 Freeman asserted: "We had a trauma, but it's really not a national
 trauma. If you were not in New York on September 11, what you saw was an
 event on CNN" (cited in Trimarco and Depret 2005, 29).

23 Moreover, if automatic imitation is one marker of kitsch, then what can be said
 of our funeral rituals in general? From conventional epitaphic forms to cere-
 monial rites, it is the recognizable, imitative aspect of Western death traditions
 that provides a frame for processing and mourning death.

24 See the following writings on kitsch: Bourdieu (1984), Broch (1970), Cali-
 nescu (1987), Fiske (1989), Greenberg (1961), and Kundera (1988, 1991).

25 *Oxford English Dictionary Online*, s.v. "kitsch," http://www.oed.com
 (accessed 22 July 2008).

26 Discussing Russian peasants' reactions to a particularly egregious example
 of kitsch painting, Greenberg remarks: "It is lucky, however … that the peas-
 ant is protected from the products of American capitalism, for he would not
 stand a chance next to a *Saturday Evening Post* cover by Norman Rockwell"
 (1961, 14).

27 Rather than making an argument against representation altogether, my cri-
 tique of these kitschy objects and mainstream portrayals is rooted in a belief
 that we cannot help but represent, so we must rigorously interrogate the im-
 plications of all commemorative gestures. Gillian Rose maintains that "To
 argue for silence, prayer, the banishment equally of poetry and knowledge,
 in short, the witness of 'ineffability,' that is, non-representability, is to *mystify
 something we dare not understand*, because we fear that it may be all too
 understandable, all too continuous with what we are – human, all too human"
 (1996, 43, original emphasis). The goal, then, of such attempts to depict
 atrocity should not be simply to remember (as in the German sense of rote
 memorization: *Gedächtnis*) but also to unsettle. As Rose suggests, represen-
 tation should not "betray the crisis of ambiguity in characterization, mytholo-
 gisation and identification, because of its anxiety that our sentimentality be
 left intact … [and thus] in a Fascist security of our own unreflected predation
 … It should leave us unsafe" (48). Polish artist Zbigniew Libera's 1996 Lego
 concentration camps provide one such example of "unsafe representation."

28 The slippage from Afghanistan to Iraq cited above – a double displacement
 from the named but nomadic Osama/al-Qaeda enemy – unwittingly evokes
 the continued significance of the Gulf War to contemporary American poli-
 tics. Avital Ronell's (1994a) prescient analysis of Bush Senior's obsession
 with Saddam Hussein and the Gulf, stemming from his Second World War
 plane crash in the Middle East and the inception of a trauma that would con-
 tinue to repeat itself until he reentered the wound with Hussein, resonates
 eerily here. Writing that Hussein was remade in the image of Hitler so that

Bush Senior could replay the operations of 1945 in order to undo his near forty-year emasculation, Ronell argues that "The American unconscious has everything to do with riding signifiers on the rebound which, subject as they are at times to retooling, nonetheless return to haunt the Same" (272). When Bush Junior came to office in 2000, he was determined to pick up where Dad left off. Despite his role as commander in chief – the Law of the Father par excellence – he is doomed to remain the son. Bush Junior's Oedipal fixation on Iraq and his desire to emasculate its leader are well documented. Spliced into Michael Moore's documentary film *Fahrenheit 9/11* (2004), he refers to Hussein as "the guy that tried to kill my daddy."

References

ABC. 2001. "9/11 Profiteering at Ground Zero Called Immoral, Illegal."
 http://abclocal.go.com/wabc/news/print_WABC_investigators_022602p
 rofit911.html (accessed 26 February 2002).

ABC News. 2003. "'Too Painful': Jessica Lynch Says She Can't Remember
 Sexual Assault."
 http://abcnews.go.com/sections/Primetime/US/Jessica_Lynch_0311
 06-1.html/ (accessed 20 January 2004).

Adorno, Theodor, and Max Horkheimer. 1972. *Dialectic of Enlightenment.*
 New York: Continuum.

Agamben, Giorgio. 1993. *The Coming Community.* Minneapolis and
 London: University of Minnesota Press.

Aldred, Jessica, and Sean Ingle. 2003. "Liverpool or Celtic: Who Walked
 Alone First?" *The Guardian.* 12 March.

Ali, Tariq. 2002. *The Clash of Fundamentalisms: Crusades, Jihads and
 Modernity.* London and New York: Verso.

Allen, James. 2002. *Without Sanctuary: Lynching Photography in America.*
 Santa Fe, NM: Twin Palms.

Allison, Rebecca. 2002. "9/11 Wicked but a Work of Art, says Damien Hirst."
 The Guardian. 11 September.

Arad, Michael, and Peter Walker. N.d. "World Trade Center Site Memorial
 Competition." http://www.wtcsitememorial.org/fin7.html (accessed 5 July
 2008).

August, Bob. "Osama Pictures." http://www.bobaugust.com/osama
 pictures.htm (accessed 1 June 2005).

Bakhtin, Mikhail. 1984. *Rabelais and His World*. Trans. Helene Iswolsky.
 Bloomington: Indiana University Press.

Barry, Dan. 2003. "A New Account of Sept. 11 Loss, with 40 Fewer Souls
 to Mourn." *New York Times*. 29 October.

Barthes, Roland. 1977a. "The Photographic Message." In *Image, Music, Text*,
 15–31. New York: Hill and Wang.

– 1977b. "Rhetoric of the Image." In *Image, Music, Text*, 32–51. New York:
 Hill and Wang.

– 1981. *Camera Lucida*. New York: Hill and Wang.

Bataille, Georges. 1929. *Documents*. Paris: n.p.

– 1985a. "The Jesuve." In *Visions of Excess: Selected Writings, 1927–1939*,
 73–8. Trans. and ed. Allan Stoekl. Minneapolis: University of Minnesota
 Press.

– 1985b. "The Notion of Expenditure." *Visions of Excess: Selected Writings,
 1927–1939*, 116–29. Trans. and ed. Allan Stoekl. Minneapolis: University
 of Minnesota Press.

– 1985c. "The Pineal Eye." In *Visions of Excess: Selected Writings,
 1927–1939*, 79-90. Trans. and ed. Allan Stoekl. Minneapolis: University
 of Minnesota Press.

– 1985d. "The Solar Anus." In *Visions of Excess: Selected Writings,
 1927–1939*, 5–9. Trans. and ed. Allan Stoekl. Minneapolis: University
 of Minnesota Press.

– 1986. *Erotism: Death and Sensuality*. Trans. Mary Dalwood. San
 Francisco: City Lights.

Batchen, Geoffrey, 2001. *Each Wild Idea: Writing, Photography, History*.
 Massachussetts: MIT Press.

– 2002. "Requiem." *Afterimage* 29, no. 4: 5.

Baudrillard, Jean. 2002. *The Spirit of Terrorism and Requiem for the Twin
 Towers*. Trans. Chris Turner. London and New York: Verso.

Bauman, Zygmunt. 1992. "Survival as a Social Construct." *Theory, Culture and Society* 9: 1–36.

BBC News. 2002. "'Offensive' Statue Removed." http://news.bbc.co.uk/1/hi/world/americas/2269692.stm (accessed December 2005).

Benjamin, Walter. 1968a. "Theses on the Philosophy of History." In *Illuminations*, 253–64. Ed. Hannah Arendt. New York: Harcourt, Brace and World.

– 1968b. "The Work of Art in the Age of Mechanical Reproduction." In *Illuminations*, 219–52. Ed. Hannah Arendt. New York: Harcourt, Brace and World.

– 1999a. *The Arcades Project*. Trans. Howard Eiland and Kevin McLaughlin. Cambridge, MA, and London: Belknap Press.

– 1999b. "The Collector." In *The Arcades Project*, 203–11. Trans. Howard Eiland and Kevin McLaughlin. Cambridge, MA, and London: Belknap Press.

– 1999c. "N: On the Theory of Knowledge, Theory of Progress." In *The Arcades Project*, 456–88. Trans. Howard Eiland and Kevin McLaughlin. Cambridge, MA, and London: Belknap Press.

– 2002. "The Work of Art in the Age of Its Reproducibility." In *Walter Benjamin: Selected Writings*, vol. 3, *1935–1938*, 101–33. Trans. Edmund Jephcott et al. Ed. Howard Eiland and Michael Jennings. Cambridge, MA, and London: Belknap Press.

– 2005a. "Berlin Chronicle." In *Walter Benjamin: Selected Writings*, vol. 2, part 2, *1931-1934*, 595-637. Trans. Rodney Livingstone et al. Cambridge, MA, and London: Belknap Press.

– 2005b. "Excavation and Memory." In *Walter Benjamin: Selected Writngs*, vol. 2, part 2, *1931–1934*, 576. Trans. Rodney Livingstone et al. Cambridge, MA, and London: Belknap Press.

– 2005c. "Little History of Photography." In *Walter Benjamin: Selected Writings*, vol. 2, part 2, *1931–1934*, 507–30. Trans. Rodney Livingstone et al. Cambridge, MA, and London: Belknap Press.

Benveniste, Émile. 1997. "Gift and Exchange in the Indo-European
 Vocabulary." In *The Logic of the Gift: Toward an Ethic of Generosity*,
 33–42. New York and London: Routledge.

Berger, John. 1972. *Ways of Seeing*. London: Harmondsworth.

Binkley, Sam. 2000. "Kitsch as a Repetitive System." *Journal of Material
 Culture* 5, no. 2: 131–52.

Bird, Jon. 2003. "The Mote in God's Eye: 9/11, Then and Now." *Journal of
 Visual Culture* 2, no. 1: 83–97.

Blanchot, Maurice. 1988. *The Unavowable Community*. Barrytown, NY:
 Station Hill Press.

Bolton, Richard, ed. 1989. *The Contest of Meaning: Critical Histories in
 Photography*. Cambridge, MA: MIT Press.

Booth, Allyson. 1996. *Postcards from the Trenches: Negotiating the Space
 between Modernism and the First World War*. New York and Oxford:
 Oxford University Press.

Borradori, Giovanna. 2003. *Philosophy in a Time of Terror: Dialogues with
 Jürgen Habermas and Jacques Derrida*. Chicago and London: University
 of Chicago Press.

Bourdieu, Pierre. 1984. *Distinction: A Social Critique of the Judgment of
 Taste*. Cambridge, MA: Harvard University Press.

Boxer, Sara. 2002. "One Camera, Then Thousands, Indelibly Etching a Day
 of Loss." *New York Times*. 11 September.

Brittain, Melisa. 2006. "Benevolent Invaders, Heroic Victims and Depraved
 Villains: White Femininity in Media Coverage of the Invasion of Iraq." In *War
 Stories and Camouflage Politics: (En)gendering the War on Terror*,
 73–96. Aldershot, UK: Ashgate.

Broch, Hermann. 1970. "Notes on the Problem of Kitsch." In *Kitsch: The
 World of Bad Taste*, 49–76. New York: Universe Books.

Brown, Bill. 2001. "Thing Theory." *Critical Inquiry* 28: 1–22.

Brown, Charles. 2004. "Where's Jessica? Myth, Nation, and War in
 America's Heartland." *Social Analysis* 48, no. 1: 81–5.

Brune, Adrian. 2001. "Terror and Response: American Flag Shirts and Accessories Line Chinatown Streets." http://web.jrn.columbia.edu/studentwork/terror/sep19/vendors.asp (accessed 2003).

Buck-Morss, Susan. 1992. "Aesthetics and Anaesthetics: Walter Benjamin's Artwork Essay Reconsidered." *October* 6: 3–41.

– 2002. "A Global Public Sphere?" *Radical Philosophy* 111: 2–10.

Butler, Judith. 1992. "Contingent Foundations: Feminism and the Question of 'Postmodernism.'" In Judith Butler and Joan Scott, eds, *Feminists Theorize the Political*, 3–21. London and New York: Routledge.

– 1997. "Psychic Inceptions: Melancholy, Ambivalence, Rage." In *The Psychic Life of Power: Theories in Subjection*, 167-98. Stanford, CA: Stanford University Press.

– 2002a. "Explanation or Exoneration, or What We Can Hear." *The Grey Room* 7: 56–67.

– 2002b. "Guantanamo Limbo: International Law Offers Too Little Protection for Prisoners of War." *The Nation*. 1 April.

– 2004. *Precarious Life: The Powers of Mourning and Violence*. London and New York: Verso.

Calinescu, Matei. 1987. *Five Faces of Modernity: Modernism, Avant-Garde, Decadence, Kitsch, Postmodernism*. Durham, NC: Duke University Press.

Campbell, Duncan. 2003. "Alarm at Pentagon's Email Snooping." *The Guardian*. 21 May.

Carby, Hazel. 1997. "'On the Threshold of Woman's Era': Lynching, Empire, and Sexuality in Black Feminist Theory." In *Dangerous Liaisons: Gender, Nation, and Postcolonial Perspectives*, 330–43. Minneapolis and London: University of Minnesota Press.

– 2004. "A Strange and Bitter Crop: The Spectacle of Torture." 10 November. http://www.opendemocracy.net/media-abu_ghraib/article_2149.jsp (13 November 2008).

Carter, Angela. 1993. *Nights at the Circus*. New York: Penguin.

Chomsky, Noam. 2002. *9–11*. New York: Seven Stories Press.

Chow, Rey. 1988. "The Politics of Admittance: Female Sexual Agency, Miscegenation, and the Formation of Community in Frantz Fanon." In *Ethics after Idealism: Theory, Culture, Ethnicity, Reading*, 55–73. Bloomington and Indianapolis: Indiana University Press.

– 1995. "The Fascist Longings in Our Midst." *ARIEL: A Review of International English Literature* 26, no. 1: 23–50.

Clark, Kenneth. 1972. *The Nude: A Study in Ideal Form*. Princeton, NJ: Princeton University Press.

Colford, Paul, and Corky Siemaszko. 2003. "Fiends Raped Jessica." *New York Daily News*. 6 November.

Colomina, Beatriz. 1998. *Privacy and Publicity: Modern Architecture as Mass Media*. Cambridge, MA, and London: MIT Press.

Conrad, Peter. 2001. "On the Eleventh Day." *The Observer*. 25 November.

Craft, Matthew. 2001. "The Official Story: Government Gives No Information on Detainees." *Village Voice*. 7–13 November.

Crary, Jonathan. 1990. *Techniques of the Observer: On Vision and Modernity in the Nineteenth Century*. Cambridge, MA: MIT Press.

– 1999. *Suspensions of Perception: Attention, Spectacle, and Modern Culture*. Cambridge, MA: MIT Press.

Davidov, Judith. 1998. *Women's Camera Work: Self/Body/Other in American Visual Culture*. Durham, NC: Duke University Press.

Davidson, Osha Gray. 2004. "A Wrong Turn in the Desert." *Rolling Stone*. 27 May.

de Certeau, Michel. 1988. *The Writing of History*. New York: Columbia University Press.

Deleuze, Gilles. 1986. *Cinema*. Minneapolis: University of Minnesota Press.

– and Felix Guattari. 1996. *Anti-Oedipus: Capitalism and Schizophrenia*. Minneapolis: University of Minnesota Press.

Derrida, Jacques. 1982a. "*Ousia* and *Grammē*: Note on a Note from *Being and Time*." In *Margins of Philosophy*, 29–67. Trans. Alan Bass. Chicago: University of Chicago Press.

– 1982b. "Signature Event Context." In *Margins of Philosophy*, 307–30. Trans. Alan Bass. Chicago: University of Chicago Press.

– 1987. *The Postcard: From Socrates to Freud and Beyond*. Trans. Alan Bass. Chicago and London: University of Chicago Press.

– 1989. *Memoires: For Paul de Man*. Rev. ed. New York: Columbia University Press.

– 1991. *Cinders*. Lincoln: University of Nebraska Press.

– 1994a. *Given Time: I. Counterfeit Money*. Chicago and London: University of Chicago Press.

– 1994b. *Specters of Marx: The State of Debt, the Work of Mourning, and the New International*. Trans. Peggy Kamuf. New York and London: Routledge.

– 1995. *The Gift of Death*. Chicago and London: University of Chicago Press.

– 1996. "By Force of Mourning." *Critical Inquiry* 22: 171–92.

– 1997a. *Of Grammatology*. Trans. Gayatri Chakravorty Spivak. Baltimore and London: Johns Hopkins University Press.

– 1997b. "' … That Dangerous Supplement … '" In *Of Grammatology*, 141–64. Trans. Gayatri Chakravorty Spivak. Baltimore and London: Johns Hopkins University Press.

– 1999. *Adieu: To Emmanuel Levinas*. Stanford, CA: Stanford University Press.

Driscoll, Mark. 2004. "Reverse Postcoloniality." *Social Text* 22, no. 1: 59–84.

DuCille, Ann. 1993. *The Coupling Convention: Sex, Text, and Tradition in Black Women's Fiction*. New York: Oxford University Press.

Durkheim, Émile. 1982. *Rules of the Sociological Method*. New York: Free Press.

Engel, Matthew. 2002. "US Media Cowed by Patriotic Fever, says CBS Star." *The Guardian*. 17 May.

Fabian, Johannes. 2002. *Time and the Other: How Anthropology Makes Its Object*. New York: Columbia University Press.

Faludi, Susan. 2007. *The Terror Dream: Fear and Fantasy in Post-9/11 America*. New York: Metropolitan Books.

Federal Bureau of Investigation (FBI). "Most Wanted Terrorists." http://www.fbi.gov/wanted/terrorists/fugitives.htm (accessed 28 July 2008).

Feldschuh, Michael, ed. 2002. *The September 11 Photo Project*. New York: ReganBooks.

Fischl, Eric. http://www.ericfischl.com (accessed 30 July 2008).

Fiske, John. 1989. *Reading the Popular*. Boston: Unwin Hyman.

Foucault, Michel. 1977. "Nietzsche, Genealogy, History." In *Language, Counter-Memory, Practice: Selected Essays*, 139–64. Ed. Donald Bouchard. Ithaca, NY: Cornell University Press.

– 1980. *Power/Knowledge: Selected Interviews and Other Writings, 1972–1977*. New York: Pantheon.

– 1990. *The History of Sexuality*. Vol. 1, *An Introduction*. New York: Vintage.

– 1994. *The Order of Things: An Archaeology of the Human Sciences*. New York: Vintage.

– 1995. *Discipline and Punish: The Birth of the Prison*. 2nd ed. Trans. Alan Sheridan. New York: Vintage.

– 1996. "Preface." In Gilles Deleuze and Felix Guattari, *Anti-Oedipus: Capitalism and Schizophrenia*, xi–xiv. Minneapolis: University of Minnesota Press.

– 2002. "Of Other Spaces." In Nicholas Mirzoeff, ed., *The Visual Culture Reader*, 2nd ed., 229–36. New York and London: Routledge.

– 2003. *The Birth of the Clinic: An Archaeology of Medical Perception*. London: Routledge.

Franklin, Benjamin. 1784. "Letter to Sarah Bache, January 26, 1784 (unpublished)." In *The Papers of Benjamin Franklin*. Digital edition by the Packard Humanities Institute. http://franklinpapers.org/franklin (accessed 28 July 2008).

Frantzen, Allen. 2003. *Bloody Good: Chivalry, Sacrifice, and the Great War.*
 Chicago: University of Chicago Press.

Frascina, Francis. 2003. "*The New York Times,* Norman Rockwell and the
 New Patriotism." *Journal of Visual Culture* 2, no. 1: 99–130.

Frazer, James. 1911. *The Golden Bough.* London: Macmillan.

Freud, Sigmund. 1953. *Two Case Histories ('Little Hans' and 'The Rat
 Man').* In *The Standard Edition of the Complete Psychological Works of
 Sigmund Freud,* vol. 10. Ed. James Strachey. London: Hogarth Press.

– 1955. *Group Psychology and the Analysis of the Ego.* In *The Standard
 Edition of the Complete Psychological Works of Sigmund Freud,* vol. 18,
 65–143. Ed. James Strachey. London: Hogarth Press.

– 1962. *Civilization and Its Discontents.* In *The Standard Edition of the
 Complete Psychological Works of Sigmund Freud,* vol. 21. Ed. James
 Strachey. New York: Norton.

– 1963. *Introductory Lectures on Psychoanalysis.* In *The Standard Edition of
 the Complete Psychological Works,* vol. 15. Ed. James Strachey. London:
 Penguin.

– 1966. *Pre-Psycho-Analytic Publications and Unpublished Drafts.* In *The
 Standard Edition of the Complete Psychological Works of Sigmund
 Freud,* vol. 1. Ed. James Strachey. London: Hogarth Press and Institute of
 Psycho-Analysis.

– 1991a. "The Economic Problem of Masochism." In *On Metapsychology,*
 409-26. London and New York: Penguin.

– 1991b. "Mourning and Melancholia." In *On Metapsychology,* 247–68. New
 York and London: Penguin.

– 1991c. *Totem and Taboo: Some Points of Agreement between the Mental
 Lives of Savages and Neurotics.* New York and London: Penguin.

Friedman, Thomas. 2002. "'Sodom' Hussein's Iraq." *New York Times.*
 1 December.

Frow, John. 1997. "Tourism and the Semiotics of Nostalgia." In *Time and Commodity Culture: Essays in Cultural Theory and Postmodernity*, 64–101. Oxford: Clarendon Press.

Fussell, Paul. 1975. *The Great War and Modern Memory*. New York: Oxford University Press.

Gates, Kelly. 2002. "Wanted Dead or Digitized: Facial Recognition Technology and Privacy." *Television and New Media* 3, no. 2: 235–8.

George, Alice Rose, Gilles Peress, Michael Shulan, and Charles Traub, eds. 2002. *Here Is New York: A Democracy of Photographs*. Zurich, Berlin, and New York: Scalo.

Gillan, Audrey. 2001. "Anthrax Hits Office of Second TV Newsman." *The Guardian*. 19 October.

Gilman, Sander. 1985. "Black Bodies, White Bodies: Toward an Iconography of Female Sexuality in Late Nineteenth-Century Art, Medicine, and Literature." *Critical Inquiry* 12, no. 1: 204–42.

Gilroy, Paul. 2002. "Diving into the Tunnel: The Politics of Race between the Old and New Worlds." www.opendemocracy.net/conflict-globaljustice/article_138.jsp (accessed January 2003).

Glynn, Kevin. 2000. *Tabloid Culture: Trash Taste, Popular Power, and the Transformation of American Television*. Durham, NC: Duke University Press.

Gordon, Mary. 2001. "There were no Sounds of Lamentation." *New York Times*. 16 September.

Gorer, Geoffrey. 1965. "The Pornography of Death." In *Death, Grief, and Mourning in Contemporary Britain*, 169-75. London: Cresset.

Gourevitch, Philip, and Errol Morris. 2008. *Standard Operating Procedure*. New York: Penguin.

Green, Samuel. 2005. "Postcard: September 11/01." *Prairie Schooner* 79, no 1: 130.

Greenberg, Clement. 1961. "Avant-Garde and Kitsch." In *Art and Culture: Critical Essays,* 3–21. Boston: Beacon Press.

Gross, Kim Johnston, Jeff Stone, and Christa Worthington. 1993. *Chic Simple: Clothes*. Bloomsbury, UK: Thames and Hudson.

Hanson, Christopher. 2003. "American Idol: The Press Finds War's True Meaning." *CJR Voices*: 58–9.

Heidegger, Martin. 1993. "The Origin of the Work of Art." In *Basic Writings*, rev. ed., 139–212. San Francisco: HarperCollins.

Heller, Dana, ed. 2005. *The Selling of 9/11: How a National Tragedy Became a Commodity*. New York: Palgrave Macmillan.

Hennessey, Maureen Hart. 1999. "The Four Freedoms." In Norman Rockwell et al., *Norman Rockwell: Pictures for the American People,* 95–103. Atlanta: High Museum of Art.

Her Majesty's Government. 2001. "Responsibility for the Terrorist Atrocities in the United States, 11 September 2001." http://image.guardian.co.uk/sys-files/Politics/documents/2001/10/04/terrorism.pdf (accessed 3 April 2003).

Irigaray, Luce. 1985. *This Sex Which Is Not One*. Ithaca, NY: Cornell University Press.

Jackson, J.B. 1980. "The Necessity for Ruins." In *The Necessity for Ruins, and Other Topics,* 89–102. Amherst: University of Massachusetts Press.

Janson, H.W. 1991. *History of Art*. 4th ed. New York: Harry Abrams.

Jervis, John. 1998. *Exploring the Modern: Patterns of Western Culture and Civilization*. Malden, MA, and Oxford: Blackwell.

Jumpers: September 11 Twin Towers Memorial Photos Videos & News Archive of the WTC Attack. http://www.twin-towers.net/jumpers.htm (accessed 2003).

Junod, Tom. 2003. "The Falling Man." *The Observer*. 7 September.

Kafka, Franz. 1998. *The Castle*. New York: Shocken Books.

Kammen, Michael. 1991. *Mystic Chords of Memory: The Transformation of Tradition in American Culture*. New York: Knopf.

Keating, Gina. 2003. "Larry Flynt Protects Nude Photos of Jessica Lynch." *Reuters*. 11 November.

Keenan, Thomas. 2003. "Making the Dead Count, Literally." *New York Times.* 30 November, final ed.

KhmerClub.com. http://www.khmerclub.com/Funnypix/12103/OsamaBin.jpg (accessed 1 June 2005).

Kimmelman, Michael. 2001. "Flags, Mom and Apple Pie through Altered Eyes." *New York Times.* 2 November.

King, Henry, dir. 1956. *Carousel.* Film. Twentieth-Century Fox.

Kozaryn, Linda D. 2003. "Deck of Cards Helps Troops Identify Regime's Most Wanted." 12 April. http://www.defenselink.mil/news/Apr2003/n04122003_200304124.html (accessed May 2003).

Krauss, Rosalind. 1985. *The Originality of the Avant-Garde and Other Modernist Myths.* Cambridge, MA: MIT Press.

Kristeva, Julia. 1982. *Powers of Horror: An Essay on Abjection.* New York: Columbia University Press.

– 1989. *Black Sun: Depression and Melancholia.* New York: Columbia University Press.

Kumar, Deepa. 2004. "War Propaganda and the (Ab)uses of Women: Media Construction of the Jessica Lynch Story." *Feminist Media Studies* 4, no. 3: 297–313.

Kundera, Milan. 1988. *The Art of the Novel.* New York: Grove Press.

– 1991. *The Unbearable Lightness of Being.* New York: HarperPerennial.

– 1996. *The Book of Laughter and Forgetting.* New York: HarperPerennial.

Lapham, Lewis. 2004. "Buffalo Dances." *Harper's.* May.

Laporte, Dominique. 2000. *History of Shit.* Cambridge, MA, and London: MIT Press.

Laugh.com. http://www.laugh.com/main_pages/comicpage.asp?cid=346 (accessed 1 June 2005).

Levi Strauss, David. 2003. *Between the Eyes: Essays on Photography and Politics.* New York: Aperture.

Levinas, Emmanuel. 1981. *Otherwise than Being, or Beyond Essence.* Hague: M. Nijhoff; Boston: Hingham.

– 1987. "Time and the Other." In *Time and the Other and Additional Essays.*
 Pittsburgh: Duquesne University Press.

Lippard, Lucy. 1999. "Tragic Tourism." In *On the Beaten Track: Tourism, Art,*
 and Place, 118–34. New York: New Press.

Magnum Photographers. 2001. *New York September 11.* New York:
 Magnum Photos and powerHouse.

Mauss, Marcel. 1997. "Gift, Gift." In Alan D. Schrift, *The Logic of the Gift:*
 Toward an Ethic of Generosity, 28–32. New York and London: Routledge.

McCourt, Frank. 2001. *Brotherhood: Images of the FDNY.* New York:
 American Express Publishing.

McKie, Robin. 2001. "The Killer that Comes in the Post." *The Observer.* 14
 October.

Meddeb, Abdelwahab. 2002. "Islam and Its Discontents: An Interview with
 Frank Berberich." *October* 99: 3–20.

Miller, N.K. 2003. "'Portraits of Grief': Telling Details and the Testimony of
 Trauma." *Differences: A Journal of Feminist Criticism* 14, no. 3: 112–35.

Mirzoeff, Nicholas. 2006. "Invisible Empire: Visual Culture, Embodied
 Spectacle, and Abu Ghraib." *Radical History Review* 95: 21–44.

Moore, Michael, dir. 2004. *Fahrenheit 9/11.* Documentary film. Miramax.

Mumford, Lewis. 1940. "The Death of the Monument." *The Culture of Cities,*
 433–40. London: Secker and Warburg.

Musil, Robert. 2006. *Posthumous Papers of a Living Author.* 3rd ed.
 Brooklyn, NY: Archipelago Press.

Nancy, Jean-Luc. 1990. "Finite History." In *The States of Theory,* 149–72.
 New York: Columbia University Press.

– 1991. *The Inoperative Community.* Minneapolis and Oxford: University of
 Minnesota Press.

Nathan, Debbie. 2007. "Postcard Sales Reflect a City Moving On." *New York*
 Magazine. http://nymag.com/daily/intel/2007/09/postcard_sales_ reflect_
 a_city.html (accessed 3 November 2007).

Nelson, Cary. 2004. "Martial Lyrics: The Vexed History of the Wartime Poem
 Card." *American Literary History* 16, no. 2: 263–89.

New York State Museum. 2002. "Recovery: The World Trade Center
 Recovery Operation at Fresh Kills."
 http://www.nysm.nysed.gov/exhibits/traveling/recovery/documents/RecBro.
 pdf (accessed 12 September 2002).

Nietzsche, Friedrich. 1957. *The Use and Abuse of History.* Indianapolis and
 New York: Bobs-Merrill.

– 1996. *On the Genealogy of Morality.* Cambridge, UK: Cambridge
 University Press.

Nora, Pierre. 1996. *Realms of Memory: Rethinking the French Past.* New
 York: Columbia University Press.

O'Carroll, Lisa. 2002. "9/11 Makers 'Refused to Film the Dying.'" *The
 Guardian.* 12 September.

Olson, Lester. 1983. "Portraits in Praise of a People: A Rhetorical Analysis
 of Norman Rockwell's Icons in Franklin D. Roosevelt's 'Four Freedoms'
 Campaign." *Quarterly Journal of Speech* 69: 15–24.

Orwell, George. 1949. *Nineteen Eighty-Four.* Reprint, New York: Knopf, 1992.

Parker, Laura. 2004. "Soldier England Described as Troublemaker at Iraqi
 Prison." *USA Today.* 5 August.

Peyser, Andrea. 2002a. "Shameful Art Attack: Rock Center Showcases
 WTC Leaper." *New York Post.* 18 September.

– 2002b. "Sick 9/11 Art Yanked." *New York Post.* 19 September.

– 2002c. "Tacky Statue Yanked from Rock Center." *New York Post.* 20
 September.

Priest, Dana, William Booth, and Susan Schmidt. 2003. "Bone-Crushing
 Injuries in Crash during Ambush." *Washington Post.* 17 June.

Proulx, Annie. 1997. "Dead Stuff." *Aperture* 149: 30–5.

Puar, Jasbir K., and Amit S. Ray. 2002. "Monster, Terrorist, Fag: The War on
 Terrorism and the Production of Docile Patriots." *Social Text* 20, no. 3:
 117–48.

Pultz, John. 1995. *The Body and the Lens: Photography, 1839 to the
 Present.* New York: Harry Abrams.

The Pumpkin Wizard. http://www.carvingpumpkins.com (accessed 1 June 2005).

rajuabju.com. http://www.rajuabju.com/elat/osamabinladen.htm (accessed
 1 June 2005).

Reporters without Borders. 2001. "Between the Pull of Patriotism and Self-
 Censorship: The US Media in Torment after 11 September."
 http://www.rsf.org/article.php3?id_article=2533 (accessed 22 July 2008).

– 2002. "United States – Annual Report 2002."
 http://www.rsf.org/article.php3?id_article=1421 (accessed 22 July 2008).

Reuters. 2001. *September 11: A Testimony*. Indianapolis: Prentice Hall.

Ronell, Avital. 1994a. "Support our Tropes: Reading Desert Storm." In
 Finitude's Score: Essays for the End of the Millennium, 269–91. Lincoln
 and London: University of Nebraska Press.

– 1994b. "The Worst Neighborhoods of the Real: Philosophy-Telephone-
 Contamination." In *Finitude's Score: Essays for the End of the Millennium,*
 219-35. Nebraska: University of Nebraska Press.

Roosevelt, Franklin D. 1950. *The Public Papers and Addresses of Franklin
 D. Roosevelt.* New York: MacMillan.

Rose, Gillian. 1996. *Mourning Becomes the Law: Philosophy and
 Representation*. Cambridge, UK: Cambridge University Press.

Roy, Arundhati. 2001. "The Algebra of Infinite Justice." *The Guardian*.
 29 September.

Russell, Rosalind. 2003. "Update 1 – Jessica Lynch was not Raped, Iraqi
 Doctors Say." *Reuters*. 10 November.

Sante, Luc. 1999. *Evidence*. New York: Farrar, Straus and Giroux.

Sayer, Derek. 2008. "Wittgenstein at Ground Zero." *Space and Culture* 11,
 no. 1: 12–19.

Scarry, Elaine. 2004. "Acts of Resistance." *Harper's*. May.

Schactman, Noah. 2003. "Big Brother Gets a Brain." *Village Voice*. 9–15 July.

Schmidt, Susan, and Vernon Loeb. 2003. "'She was Fighting to the Death':
 Details Emerging of W. Va. Soldier's Capture and Rescue." *Washington
 Post*. 3 April 2003.

Sedgwick, Eve Kosofsky. 1985. *Between Men: English Literature and Male Homosocial Desire*. New York: Columbia University Press.

Sekula, Allan. 1986. "The Body and the Archive." *October* 39: 3–64.

Shaviro, Steven. 1995. "Two Lessons from Burroughs." In *Posthuman Bodies*, 38–54. Bloomington: Indiana University Press.

Smith, Neil. 2002. "Scales of Terror: The Manufacturing of Nationalism and the War for U.S. Globalism." In Michael Sorkin and Sharon Zukin, eds, *After the World Trade Center: Rethinking New York City*, 97–108. New York and London: Routledge.

Smith, Shawn Michelle. 1999. *American Archives: Gender, Race, and Class in Visual Archives*. Princeton, NJ: Princeton University Press.

Solomon-Godeau, Abigail. 1991. *Photography at the Dock: Essays on Photography, History, Institutions, and Practices*. Minneapolis: University of Minnesota Press.

Sontag, Susan. 1966. "Against Interpretation." In *Against Interpretation and Other Essays,* 3–14. New York: Farrar, Straus and Giroux.

– 2001a. *On Photography*. New York: Picador.

– 2001b. "Tuesday, and After." *The New Yorker*. 24 September.

– 2003. *Regarding the Pain of Others*. New York: Farrar, Straus and Giroux.

– 2004. "Regarding the Torture of Others." *New York Times*. 23 May.

Sophocles. 2003. *Antigone*. Oxford and New York: Oxford University Press.

Spiegelman, Art. 2004. *In the Shadow of No Towers*. New York: Pantheon.

Staff, Frank. 1966. *The Picture Postcard and Its Origins*. London: Lutterworth Press.

Staff and Agencies. 2001. "Army Cautious over Anthrax Match." *The Guardian*. 17 December.

Staff Writers. 1943. "I like to please people." *Time*. 21 June, 41–2.

Staff Writers. 2004. "Prison Scandal Soldier Lynndie England Gives Birth to a Son." *People Magazine*. 25 October.

Stevens, Wallace. 1990. "Postcard from a Volcano." In *The Collected Poems of Wallace Stevens*, 158. New York: Vintage.

Stewart, Kathleen. 1996. *A Space on the Side of the Road: Cultural Poetics in an Other America*. Princeton, NJ: Princeton University Press.

Stewart, Susan. 1993. *On Longing: Narratives of the Miniature, the Gigantic, the Souvenir, the Collection*. Baltimore and London: Johns Hopkins University Press.

Tagg, John. 1988. *The Burden of Representation: Essays on Photographies and Histories*. London: Macmillan.

Talking Heads. 1999. "Girlfriend Is Better." On the CD *Stop Making Sense*.

Taussig, Michael. 1993. *Mimesis and Alterity: A Particular History of the Senses*. New York: Routledge.

– 1997. *The Magic of the State*. New York: Routledge.

– 1999. *Defacement: Public Secrecy and the Labor of the Negative*. Stanford, CA: Stanford University Press.

The White House. 2001a. "Address to a Joint Session of Congress and the American People." 20 September. http://www.whitehouse.gov/news/releases/2001/09/print/20010920-8.html (accessed 14 August 2008).

– 2001b. "President's Remarks at National Day of Prayer and Remembrance." 13 September. http://www.whitehouse.gov/news/releases/2001/09/20010914-2.html (accessed 14 August 2008).

– 2001c. "President Unveils 'Most Wanted' Terrorists." 10 October. http://www.whitehouse.gov/news/releases/2001/10/20011010-3.html (accessed 28 July 2008).

Theweleit, Klaus. 1987. *Male Fantasies*. Vol. 1, *Women, Floods, Bodies, History*. Trans. Stephen Conway. Minneapolis: University of Minnesota Press.

This Modern World. http://thismodernworld.com (accessed 1 June 2005).

Trimarco, James, and Molly Hurley Depret. 2005. "Wounded Nation, Broken Time: Trauma, Tourism, and the Selling of Ground Zero." In Dana Heller, ed., *The Selling of 9/11: How a National Tragedy Became a Commodity*, 27–53. New York: Palgrave Macmillan.

Tylor, E.B. 1891. *Primitive Culture: Researches into the Development of Mythology*. 3rd ed. London: J. Murray.

UniversityPress.info. http://www.universitypress.info (accessed 1 June 2005).

Varnedoe, Kirk, Paola Antonelli, and Joshua Siegel, eds. 2001. *Modern Contemporary: Art at MoMA Since 1980*. New York: Museum of Modern Art.

Vidal, Gore. 2002. *Perpetual War for Perpetual Peace: How We Got to Be So Hated*. New York: Thunder's Month Press and Nation Books.

Warner, Michael. 2002. "Publics and Counterpublics." *Public Culture* 14, no. 1: 49–90.

Wiegman, Robyn. 1995. *American Anatomies: Theorizing Race and Gender*. Durham, NC: Duke University Press.

Wigley, Mark. 2002. "Insecurity by Design." In Michael Sorkin and Sharon Zukin, eds, *After the World Trade Center: Rethinking New York City*, 69–85. New York and London: Routledge.

Williams, William Carlos. 1986. "This Is Just to Say." In *The Collected Poems of William Carlos Williams*, vol. 1, *1909–1939*, 372. New York: New Directions.

Wollaeger, Mark. 2006. *Modernism, Media, and Propaganda: British Narrative from 1900 to 1945*. Princeton, NJ: Princeton University Press.

Wong, Yoke-Sum. 2002. "Beyond (and Below) Incommensurability: The Aesthetics of the Postcard." *Common Knowledge* 8, no. 2: 333-56.

Yaeger, Lynn. 2002. "Time in a Bottle: The Kitsch Vendors of 9–11." *Village Voice*. 9 September.

Yates, Frances. 1966. *The Art of Memory*. Chicago: University of Chicago Press.

Young, James. 1999. "Memory and Counter-Memory: The End of the Monument in Germany." *Harvard Design Magazine* (Fall): 4–13.

Younge, Gary. 2001. "You've Seen the Attacks, Now Buy the T-shirt." *The Guardian*. 18 September.

Žižek, Slavoj. 1995. *The Sublime Object of Ideology*. London and New York: Verso.

– 2002. *Welcome to the Desert of the Real*. London and New York: Verso.

Index

Abu Ghraib, 109–11, 123

Adorno, Theodor, and Max
 Horkheimer, 83

Agamben, Giorgio, 80, 116

alêtheia, 15–16, 25, 27, 57

Barthes, Roland, 7, 86, 125

Bataille, Georges, 13, 49, 95, 97, 115

Benjamin, Walter, 85–6, 118, 130;
 "angel of history," 19, 57, 140;
 dialectics at a standstill, 62, 91;
 method, 6–7; representation/
 mimesis, 4

Benveniste, Émile, 73

bin Laden, Osama, 88, 111–12,
 123, 125, 139; Freud, 82–4;
 Internet, 94, 97, 99, 101–2

Bush, President George W.: Abu
 Ghraib, 106; bin Laden, 94, 98–9;
 postcard, 51; response to
 September 11, 71, 82, 87–9, 113,
 128, 133, 138

Butler, Judith, 114–17, 127

Carter, Angela, 4–6, 140

Chow, Rey, 107–8

de Certeau, Michel, 17

Derrida, Jacques, 7, 48, 76–7, 123,
 125; debt, 27; improper, 13, 14,
 30; memory, 42; mourning, 18,
 38–9, 114–17; postcard, 60, 62,
 70, 72; September 11, 19; writing,
 24

England, Lynndie, 103, 109–12

FBI Most Wanted Terrorists, 82, 84,
 87–8, 94, 98

face/facialization: defacement, 109,
 111; essence, 84–7; September
 11, 78, 80, 87–8, 112

Falling Man, 28–37, 39–41, 47

Faludi, Susan, 78–9, 97, 99, 135

fascism, 98, 102–3, 107–8, 110

Fischl, Eric, 9, 16. *See also*
 Tumbling Woman

Foucault, Michel, 85, 140

Franklin, Thomas, 35, 122

Fresh Kills landfill, 18, 43–4

Freud, Sigmund: animism/magic,
 82–4; identification, 129, 132–3;
 memory, 58; mourning, 38,
 113–14; primitivism, 93; repres-
 sion, 95; trauma, 3–4

gift, 73–5

Gourevitch, Philip, and Errol Morris,
 111, 123

graphic, 12–15

Greenberg, Clement, 137

Ground Zero, 17, 67, 123, 128–9,
 131, 134–5, 140

Harman, Sabrina, 103

Heidegger, Martin, 15–16, 27, 57

history, 17–18, 43, 59, 60, 101

identification/identity, 37, 39–41, 43,
 47–8, 76; face, 84; with
 September 11, 127, 132; state,
 80; terrorist, 78, 88, 91

image, 5–6, 8; fascism, 107–9,

memory, 38–9; mourning, 38–9;
 bin Laden, 94–5, 112

Jackson, J.B., 22

Johnson, Shoshana, 106, 108

kitsch, 7, 84, 113–14, 128, 136–8

Kundera, Milan, 113, 136–8

Levinas, Emmanuel, 116

Lindh, John Walker, 90–4, 112

Lynch, Jessica, 103–9, 112

Marx, Karl, 135

Mauss, Marcel, 73, 74

melancholia, 38, 113–15

memorial/memorialization, 24–5,
 49–50, 62, 77

memory, 25, 27, 49, 59; image,
 38–41, 48; mourning, 39; proper
 name, 42

method/methodology, 6–7

monument, 21–7, 59; 1937 Paris
 Exposition, 22–3; counter-monu-
 ment, 25–7, 48; Fischl, 7, 19;
 Whiteread, 25. *See also* Young

mourning, 19, 21, 37, 41, 122;
 Freud, 38, 113–14; work of,
 114–17, 138

Musil, Robert, 24

name (proper), 39, 41–2, 47–50
New York Times, The, 78, 112;
 Rockwell, 117, 121–2, 124–5,
 127, 140
Nietzsche, Friedrich, 74

obscenity, 13, 30, 37, 41, 47, 49.
 See also Bataille

Patriot Act, 71–2
photography, 3–6, 7, 37, 47, 66;
 documentary, 44–4, 47; Fresh
 Kills landfill, 43; jumpers, 33,
 35–7; Lindh, 91, 93; mug shots,
 86–7; of bodies, 32–6, 41. *See
 also Falling Man*
Piestewa, Lori, 106
poeisis, 6, 51, 57
poetry: Green, 55; Heidegger, 57;
 Stevens, 54; and war, 54–5
pornography, 3, 14, 30–1, 94
postcard: anthrax, 76; history of,
 57–8, 65–6, 68; September 11,
 51, 53–4, 58–60, 62, 67, 71, 74;
 Stewart, 67; theories of, 57, 61–2,
 70
postcards (memorial), 77

Rockwell, Norman, 138, 140; *Four
 Freedoms for Which We Fight,
 The,* 117–22; *Happy Birthday
 Miss Jones,* 124–6
Rose, Gillian, 116–17

Sayer, Derek, 123, 133
Simpson, O.J., 87, 99, 101–2, 128
souvenir, 67, 128–32, 134. *See also*
 kitsch
Spiegelman, Art, 123
state, the, 81–4, 101, 111. *See
 also* Taussig
Stewart, Susan, 129

Taussig, Michael: defacement, 84–5,
 93–4, 109; mimesis, 4; popular,
 66, 128; state, 82–4, 99, 101,
 125, 138
Theweleit, Klaus, 102, 108. *See
 also* fascism
Tumbling Woman, 9, 13–14, 16,
 18–19, 21. *See also* Fischl

Young, James, 21

Žižek, Slavoj, 121, 123–4, 135